Islamic Aesthetics

The New Edinburgh Islamic Surveys
Series Editor: Carole Hillenbrand

TITLES AVAILABLE OR FORTHCOMING

Islamic Aesthetics

An introduction

OLIVER LEAMAN

EDINBURGH UNIVERSITY PRESS

© Oliver Leaman, 2004

Transferred to Digital Print 2012

Edinburgh University Press Ltd
22 George Square, Edinburgh

Typeset in Goudy by
Koinonia, Manchester, and
Printed and bound by CPI Group (UK) Ltd, Croydon, CR0 4YY

A CIP Record for this book is available from the British Library

ISBN 0 7486 1734 5 (hardback)
ISBN 0 7486 1735 3 (paperback)

Contents

Foreword

I wrote this book out of a profound sense of disappointment about the sorts of things which are often said about Islamic art. There are many marvellous books on Islamic art, and the scholarship and connoisseurship which they involve are very impressive. The discussions that can be found in those books on aesthetics are often much weaker, or even absent entirely, and I have spent a lot of time reading material about the aesthetic properties of objects which are just wrong. This book is a modest attempt to put the record straight, and establish a solid foundation for the aesthetics of Islamic art.

People who write books are often in the fortunate position of being able to let off steam in public, which most people are not able to do. I have often been obliged to sit and smile politely while an authority in the field of Islamic art has made some comments which are, in my view, thoroughly misplaced. One might expect that those skilled at writing about art would be the right people to talk about the principles of beauty and sublimity which repose in that art, but this would be naive. In fact an entirely different category of intellectual skills may be required to talk about the aesthetic properties of an object as compared with its composition, historical context, role of the artist and his audience, its provenance and so on. There is a tendency to regard Islamic art as part of Islamic studies, which is perhaps a shame, since the rather historicist methodology of area studies then comes into play, and tends to exclude alternative explanations and approaches.

While I was writing this book I became aware that it was an extended part of a discussion which I had had with my father for many years. We both enjoyed visiting religious buildings such as churches and chapels, and listening to the music of Bach. He would often say that wonderful as he found such buildings and music, had he been a Christian he would have found them even more wonderful, and would have understood things about them which he missed as a non-Christian. I tended to argue the reverse, that the aesthetic features of the buildings and the music are really abstractable from their main religious purpose, and indeed being in tune with the latter would be a distraction not an aid to aesthetic appreciation and understanding. I still

have this view, and have developed it in this book, but as I wrote it I often had the sensation of my father looking over my shoulder and shaking his head vigorously. It is with no lack of respect to him or to the many others who share his view that I present the arguments in this book.

I am very grateful for the help of a number of people, in particular the copy-editor James Croft, the desk editor at EUP Eddie Clark and an anonymous reader. They all saved me from some egregious errors, and those that remain are alas entirely my fault.

Lexington, Kentucky
May 2003

Introduction

Imagine you are standing in a gallery in Dublin, Ireland, where you have come to examine some Arabic manuscripts. While you are waiting for them to be delivered, you wander around the main display area, which has a small but impressive collection of Qur'ans. These are open so that the different styles of calligraphy may be seen. There are also some books with paintings in them, small but vivid. Suddenly the room, which previously had been deadly silent, explodes with noise as a group of large teenage schoolboys comes in with their teacher, evidently on an educational trip from their school. They clearly do not want to be there and grumble as they are told to look at the books and pictures. Then the room falls very quiet as they gaze at the writing and the colours. They are not quiet for long since there is not that much to see, and people today have largely lost the ability to look for a long time at anything. But they are clearly impressed, and a bit shocked that they are impressed, these are not the kind of children who tend to go to galleries and museums, not willingly anyway.

Speaking later with their teacher he confirms what I had suspected. They were from a tough part of North Dublin, of generally low educational ability and certainly with no knowledge of Islam or Arabic at all. Although now there is a strong Islamic presence in Dublin, as in most parts of Europe, then it was restricted to a few immigrant shopkeepers and Embassy officials. Islam was as alien to those boys as anything could be. They certainly could read nothing in the texts they looked at, and as far as they were concerned they could have been written by the Man in the Moon. The pictures that they saw in the books had no meaning for them either as pictures of anyone they could recognize or as existing within a cultural context they understood. These were not children who visited any sort of gallery by themselves, and were unpractised in the rituals surrounding such visits. Yet they were fascinated, for a bit, by what they saw, and not quite sophisticated enough to hide that emotion from each other.

I was impressed by this encounter, and yet also saddened. When one looks at the literature dealing with what has come to be known as Islamic art it makes little attempt to link up with the 'ordinary' viewer, the individual who knows little or nothing about art and Islam, and yet who would enjoy looking at

Islamic art. The main problem is that Islamic art is constantly being explained in terms which are not aesthetic, terms which have nothing primarily to do with art. These may be political, or religious, or mystical, or economic terms, and the common factor that all such explanations share is that they are not aesthetic. They explain away the aesthetic features of Islamic art and replace those features with something else, as though the art is not strong enough in its own terms to be regarded as really art.

Yet on that rainy autumn Dublin morning at least one audience regarded what they were seeing as art, and it knocked their socks off, as the English expression goes. Had they prepared for the visit by reading about what they were going to see their reaction would have been very different. They would have read, for example, that the books from Mughal India were painted for rulers to help extend their hegemony and the cultural influence of their courts. They would be told that calligraphy was developed to such a sophisticated degree because images are forbidden in Islam, difficult to reconcile with the images in proximate display cases, but that has rarely stood in the way of that claim being made. If they had looked at some of the religious arguments for calligraphy they would have discovered that Islam is based on a book, so the words of that book have a vastly significant status in the Islamic world. Hence the care taken in their reproduction. But these claims have nothing to do with the aesthetic qualities of what are in front of us; these explanations are all on the level of causal hypotheses about how the work came about in the way it did. These are interesting and important questions, but they are not aesthetic questions. Nor do they help us understand the works as works of art. I hope that the argument of this book will manage to convince readers of this point. I have argued this point at a more theoretical level in the last chapter.

There is a great tendency for discussions of Islam and its products to degenerate into an analysis which leaves the precise object of the discussion out of the discussion altogether. To take a different example, there is a subject called Islamic philosophy, and one might think that would be interpreted as philosophy as carried out in the Islamic world, and so be treated as philosophy. In fact it is often treated very differently, not as philosophy but as a kind of convoluted literature. It is as though Islam is not capable on its own of philosophical thought, and so where this thought does exist it must be attributed to somewhere else, for example Greece. Because it is *Islamic* philosophy it is assumed that it must really be a division of religion or theology, or so it has been argued. What is interesting about this approach is that it treats Islamic philosophy not as philosophy but as something else. The defenders of such hermeneutic techniques are not necessarily hostile to Islam or to philosophy, they are hostile to the idea that Islamic philosophy can be philosophy as such. Consequently, they do not treat it as philosophy but as something else.

I have argued that this approach is wrong, and misleading about the nature of philosophy in Islam. In this book the target is different but curiously related to the earlier target. Many commentators on Islamic art do not regard it as really art. They certainly regard it as fascinating, as intriguing, and in some cases they have devoted their professional lives to it, but they do not regard it as art. This claim seems shocking, since they write about it as art and in books which have 'Islamic art' in the title or subtitle. We will come to see that this claim, although indeed shocking, is justified, for they explain Islamic art in terms which are not aesthetic, not primarily terms to do with art. Sometimes they eschew aesthetic language altogether, and sometimes they use it but explain it in non-aesthetic terms, often religious or social. It is the purpose of this book to question their approach, illuminating though it can be on occasion in bringing out the causal processes behind examples of art. I have learnt a great deal from their writings (certainly not enough) and yet I shall argue that they are wrong. Islamic art is art, and wonderful art at that, and we need to develop a range of aesthetic attitudes to it. This book is an attempt at making a start on this process.

1

Eleven common mistakes about Islamic art

Islam can be defined: the issue of essentialism

Many writers on Islamic art start off by talking about Islam, entirely appropriately, one might think. They suggest that once we can isolate the essence of Islam, we shall be in a better position to identify that essence in Islamic art, and use that essence as the criterion of what counts as Islamic art. This seems very reasonable. If we talk about Islam then we are talking about a religion which is distinct from other religions. If we talk about Islamic art then we are talking about art which is distinct from other forms of art. Once we can identify these distinctive features we shall know precisely what Islamic art is.

Is there an essence to Islam? This of course is an enormous question in itself, and one would think that there are principles of religion without which the religion is not the religion it says it is. Let us take an example of the essentialist view. One of the most distinguished Islamic thinkers is Seyyed Hossein Nasr, and he argues that at the centre of Islam is the Ka'ba, and this plays a vital part in what distinguishes Islam, and Islamic art, from other religions. As he puts it, 'The symbol of Islamic civilization is not a flowing river, but the cube of the Kaaba, the stability of which symbolizes the permanent and immutable character of Islam.'[1] The Ka'ba, which literally means 'cube' in Arabic, is the large granite rock in Mecca that is the focal point of so much ritual in Islam. The Ka'ba edifice was built at God's express command by Abraham and Ishmael, according to Islam. Nearby and of significance are also the Zamzam spring and the holy hills of Safa and Marwa. The Ka'ba became the most important ritual site of the nomadic tribes that inhabited Arabia.

As time went on, the original Abrahamic observances at the Ka'ba were progressively diluted by the influence of pagan features (perhaps arriving through the caravan routes that led to Mecca). The pilgrims of pre-Islamic times visited not only the house of Abraham and the sacred stone of Gabriel but also the display of stone idols (representing different deities) housed in and around the Ka'ba. There were said to be 360 different deities including Awf, the great bird, Hubal the Nabatean god, the three celestial goddesses Manat, al-Uzza and al-

Lat, and statues of Mary and Jesus. The most important of all these deities was called Allah ('god'). This deity was worshipped throughout southern Syria and northern Arabia, and was the only deity not represented by an idol in the Ka'ba.

In AH 8/630 CE Muhammad took control of Mecca and destroyed the 360 pagan idols, with the notable exception of the statues of Mary and Jesus. The idol of Hubal, the largest in Mecca, was a giant stone situated on top of the Ka'ba. We are told that following the command of the Prophet, 'Ali (the cousin of Muhammad) stood on Muhammad's shoulders, climbed to the top of the Ka'ba and pushed the idol to the ground. Following his destruction of the pagan idols, Muhammad joined certain of the ancient Meccan rituals with the Hajj pilgrimage to Mount Arafat (another pre-Islamic tradition), establised the city as a centre of Islamic pilgrimage and dedicated it to the worship of Allah alone. Muhammad did not, as one might have thought he would, destroy the Ka'ba and the sacred stone it housed. Rather, he made them central to the Muslim religion based on the principle that he was a prophetic reformer who had been sent by God to restore the rites first established by Abraham to their original purity. Thus, by gaining both religious and political control over Mecca, Muhammad was able to redefine the sacred territory and restore Abrahamic order to it.

According to the basic tenets of Islam, the Hajj pilgrimage is the fifth of the fundamental Muslim practices. The Hajj is an obligation to be performed at least once by all male and female adults whose can undertake it. The pilgrimage takes place each year between the eighth and thirteenth days of Dhu al-Hijjah, the twelfth month of the Islamic lunar calendar. Before setting out, a pilgrim should redress all wrongs, pay all debts, and arrange to have enough money for their journey and the support of their family while away.

When the pilgrim is about ten kilometres from Mecca he enters the state of holiness and purity known as *ihram*, and puts on special garments consisting of two white seamless sheets that are wrapped around the body. The pilgrim walks seven times around the Ka'ba shrine in an anticlockwise direction; this ritual is called turning, or *tawaf*. Next, entering into the shrine, the pilgrim kisses the sacred stone, if he can get near enough. The stone is mounted in a silver frame in the wall, four feet above the ground, in the south-east corner of the shrine. It is of an oval shape about twelve inches in diameter, composed of seven small stones (possibly basalt) of different sizes and shapes joined together with cement. It is said that the stone was originally white but became gradually darkened by the kisses of sinful mortals. During the next few days the pilgrim walks a ritualized route to other sacred places in the vicinity of Mecca (Mina, Muzdalifah, Arafat, the Mount of Mercy and Mount Namira) and returns to the Ka'ba on the final day (the word Hajj may come from an old Semitic root meaning 'to go around, to go in a circle'). In different countries returning

pilgrims will use a variety of signs to indicate that they have made the Hajj; these include painting pictures of the Ka'ba, and sometimes the pilgrim's means of transportation to the shrine, upon the walls of their homes, painting the entrance doorway of the house bright green, and wearing green hats or scarves. Green is said to have been the Prophet's favourite colour.

The Ka'ba today stands in the middle of an open courtyard known as the al-masjid al-haram, the 'sanctuary'. The cubical flat-roofed building rises fifty feet from a narrow marble base on mortared bases of a local blue-grey stone. Its dimensions are not exactly cubical: the north-eastern and south-western walls are forty feet long, while the other two walls are five feet shorter.

It is worth outlining in some detail the role of the Ka'ba in Islam in order to see whether it is really as central as it is said to be. It is undoubtedly of great significance, but is its *shape* of significance? Its name is its shape, which gives the impression that it is important that it has that shape, but there are plenty of important rituals connected with the Hajj which emphasize different shapes, like the circle, the mountain, the water of the spring and so on. In fact these have become important Islamic symbols in one way or another, especially in Sufism, and as symbols they can represent Islam just as well as the Ka'ba. Something that moves and changes can represent the activity and infinity of the divine, and we shall come to see that many argue for such a meaning lying behind much Islamic decoration. When Hajjis paint the image of the Ka'ba on the walls of their houses are they declaring their belief in the unchanging nature of Islam, or is it their way of referring to a successful trip having been undertaken? Are they asserting that Islam is as constant and immutable as the sides of the Ka'ba itself? Perhaps some of them are, but then there are also some Muslims who have throughout the history of the religion contemplated change and opened the door to radical thought about their faith. Are they not able to see in the Ka'ba a symbol of their religion, but a symbol which allows for change, and indeed encourages it? The Ka'ba could be seen as the symbol of the return to an originally pure form of worship as instituted by Abraham and Ishmael, or it could be seen as the successful transformation of a popular traditional practice into a new and more meaningful form of life. There have been criticisms of some of the practices associated with the Ka'ba, for these have been compared with idolatry or *shirk*, in that the edifice is taken by some perhaps to have special powers, and this means that it is not only God who has divine power. The Ka'ba can then be quite an ambiguous symbol, as can any religious symbol, of course, and we cannot derive from the fact that it is a cube that it has any fixed meaning at all. Recounting some of the history and present use of the Ka'ba brings out to a degree how central it is to Islam, but it is not central as a cube. It is a Cube which is central, but it is not central because it is a cube.

It has to be said that when one examines the vast variety of what passes for

Islam both today and in the past, it is not easy to see its permanent and immutable character. On the other hand, surely Nasr is right in looking for the essence of the religion of Islam, since if a religion is to be distinct from other religions there must be something about it which characterizes it as distinct, and this feature should be something that does not change. Yet when we examine the variety of behaviours which are classified as Islamic, it is difficult to be confident that one such characterization of the faith will cover all interpretations of it. We think there must be an essence to Islam, something central and general which holds it together, but in the words of Wittgenstein 'sondern schau' (only look), and if we look we do not find what we expect to find (*Philosophical Investigations* §66).

Islamic aesthetics does not exist

An alternative point of view is provided by Oleg Grabar, the doyen of writers on Islamic art.

> But there is another side to any interpretation of a specific tradition. It is whether the 'universal' attributes given to its artifacts are justified within the internal, diachronic or historical, constrictions of the culture itself ... One should be satisfied that the classical culture of medieval or pre-modern Muslim societies considered the same issues and drew comparable conclusions.[2]

He is commenting here on the way in which some thinkers like Escher and Owen Jones are fascinated by the sensual geometry of the Alhambra and find an esoteric meaning in it, but one, according to Grabar, which was not necessarily shared by 'the Muslim builders and users of the Granada palace' (ibid.). This is not a particularly relevant comment, since the thought processes of those concerned with putting the building together are not the immediate issue. It could be argued that whatever they were actually thinking about, some very general Islamic principles lay at the base of what they did.

One of the very impressive aspects of Grabar's work on Islamic art is his cautiousness, his disinclination to generalize and a fiercely empirical atttitude to the facts themselves. He tends to limit himself to describing the artifacts, linking them with their historical context and methods of production, and rejects any broader aim. This is an excellent corrective to what he so acutely labels 'the orientalist sin of easy generalization'[3] in which so many others in the field unashamably indulge. In his book *Mostly Miniatures*, he takes this to extraordinary lengths, refusing to speculate at all on any wider presuppositions which might be implicit in the Persian miniatures which he analyses. He is so right to be cautious, it is very easy to speculate on the existence of particular ideas which might be being played out in the paintings, and very tempting to use those ideas as ways into the paintings. Yet as he says we have not a shred of evidence that

those ideas are actually important for either the artist or the audience, at least as far as those paintings are concerned. We do not even have any reason to think that those ideas are of any significance to them at all. They were clearly important to some people in Persian culture, but it is a far cry moving from that to the conclusion that such ideas are part and parcel of all Persian painting. Far too many people argue that Islamic art must have been created with specifically Islamic ideas in mind, and Grabar's caution is highly appropriate.

But isn't he being too cautious? He not only refuses to construct an aesthetics but suggests that one cannot be constructed. This is because we just do not know enough about the people concerned, what precisely they were thinking when they painted or viewed these pictures, or even sometimes who they were. Certainly from an art-historical perspective these are all important questions, but they are not decisive. We have come a long way from thinking that in order to understand a work of art we have to understand the mental processes of the artist. It would make the life of the author of this book so much easier if it were possible to distil the essence of Islam, recognize it in what passes for Islamic art, and then one could trawl through Islamic culture and point to those features which are so common throughout it. That is, Muslims would be taken to share some common principles, those would be embodied in their art, and then one could work back from the art to identify the thought processes, and ultimately the religious principles. This idea seems so obviously true, and like so many obviously true ideas it is false. The evidence does not accord with this idea, and we shall have to reject this strategy for a messier, but ultimately more productive approach.

Islamic art is essentially Sufi

Many of the most interesting writers on Islamic art argue that Islamic art changes the representation of physical reality due to the belief in the impermanence of the visible (see Burkhardt, Nasr, Massignon and Bakhtiar). This often is argued by way of suggesting that Sufism represents the heart of Islam. With Sufism goes a concern for the spiritual at the expense of the material, for the esoteric as against the exoteric, and a certain tendency to value asceticism as compared with the pleasures of this world. In some ways this is well expressed from a different perspective by Miskawayh (d. 421 AH/1030 CE) who argues that aesthetic appreciation leads to pleasure, and so is prima facie a source of evil capable of both misleading its viewers and leading them astray.[4] This desire to avoid treating the natural world seriously could be taken to generate 'the Islamic capacity to geometricize forms',[5] although as we shall see later there are arguments that Sufism does lead to the realistic representation of the world, not to its transformation into a system of shapes and repetitive patterns.

This quotation by Hillenbrand should not be taken to indicate that he is in the esoteric school of Islamic aesthetics. Hillenbrand's ground-breaking work on Islamic architecture is marked by solid good sense. He points to some themes in the ways in which that architecture was construed, and resists the danger of easy generalization. To see in those themes some deep level of commitment to a particular form of thinking about the nature of the world and the deeper level of existence behind this world is far too ambitious. No doubt there were architects and the accompanying craftsmen who did feel a commitment to Sufism and so perhaps looked for some parallelism between the nature of the design of buildings and the ways in which those inside them could be helped to contemplate the design of reality itself. So, for example, a tendency to use certain principles of mathematics could be a reflection of what one thought was sacred mathematics, the mathematical structure that lies behind the world of generation and corruption. Some of the wilder advocates of the ideas of a sacred architecture suggest that there are common mathematical principles behind all sacred aesthetic design, regardless of the particular cultural or religious background of the designers themselves. It is as though the individual designer, of whatever provenance, managed to key or align himself into how things really are and brought that out in their work. It is worth pointing here to the universalist and syncretist nature of some versions of Sufism, one of the factors of course which has made it so successful in attracting support from a range of religious perspectives.

There is a feature of this that we should note, and that is that the more plausible the case is for universal criteria of beauty to reflect the sacred, the less plausible is the idea that those criteria are specifically Islamic. Unless, that is, one argues that really Islam encompasses all the other faiths and worldviews. Some have made this claim, but it is a difficult case to make, especially since so much religion obviously entails *shirk*, idolatry, the very feature which Islamic art so often tries to avoid. One could argue that the *shirk* was only superficial, and that behind all the carvings of gods and people lay a belief in the one God, the same sort of belief we see in Islam, and there are Islamic views which could be construed in that way. How plausible such an argument is is an interesting issue, and not one we shall be considering here. What we are interested in here is the idea that the commonalities of Islamic design are more important than the fact that certain ways of doing things which became traditional continued to have force over a long period of time. This notion that there is a basic Islamic understanding of design is possible, but surely not plausible.

Why not? To answer this question we really have to ask what it is to be a religious person. One thing this involves is possibly incorporating one's faith into the other activities of life. If religion is to be more than surface deep, one might think that it should really dominate one's whole life, because what could be more important than our relationship with God? What is it to be religious?

This is a much more complicated issue than one might think. Just talking about God is not sufficient, since that may only be a way of talking. It might be claimed also that regular participation in religious practices may not be sufficient either, since religion may be carried out as a matter of course without any real feeling. On the other hand, rejecting this kind of participant might be setting the standard too high. After all, who does not sometimes allow their thoughts to stray when they pray or perform some other religious duties? How much straying is acceptable in a religious life? Then there is the issue of how far one's religion should fit in with the rest of one's life. It is often said that Islam is unique in being not just a religion but also a way of life. But that is true of all religions, they are all about practice as well as belief. What would we say about an individual who is conscientious about carrying out the religious tasks but does not apply the principles of her religion to her life? The point is that the issue of whether someone is religious, or committed to a particular religion, is complex. So is the issue of how the attitude to religion affected the art. An artist may think that his religious views affected his art, and may be wrong. That is, the motivation for the work and the structure of the work may be explicable through some other source, and the religion only apparently the cause. It would work the other way round as well, in that someone might not think that their work was informed by religious principles, but it could be. This is not a general scepticism about the explanation of our activity; clearly in some cases it is quite obvious what ideas and theoretical commitments the artist has that are subsequently embodied in his work. The point still stands, though, that the connection between our ideas and beliefs and their physical expression is complex and not necessarily of the one-one correspondence variety. One might well think that the connection between our ideas and the art we produce is even more difficult to account for in terms of simple causation, since the art product is itself such a rich and at the same time problematic object to link up with mental states and a whole range of explanatory concepts. Obviously there is some connection between who we are and what our opinions and aspirations are and the art we produce, but the connection is not a simple one and it is difficult to perceive in very many cases.

But what is of enormous importance here is not the empirical question whether we can tell what was going on in the mind of the artist, but the aesthetic question of how far the psychology of the artist enters into the evaluation of the work he or she produces. Here we are thinking of that vast variety of carpets, paintings, buildings, poems and so on which were created in what we call the Islamic form of art. How far does what went on in the heads of the creators of this art affect our account of the nature of the art? I think the answer has to be not at all. After all, a natural object can be assessed aesthetically, and one may assess it while at the same time having no views at all about its origins.

One might not think that it is a creation of God. One might not think that it is the creation of anyone, and yet we can discuss its design, the structure that it displays.

It might be said that this argument could work for natural objects, but that does not show that it works for artificial objects. If we come across a natural object, and we do not believe that it has been deliberately designed by a mind in some way, then we can assess it aesthetically without any consideration of the workings of any mind, but if we are dealing with what is obviously an artificial object, then the question of the thought processes of the creator does arise. But why? One of the few points on which most writers of aesthetics agree is that natural objects can be beautiful, and so the object in itself has some features which enable us to assess it in that way. Of course, some writers on this topic do insist that the aesthetic criteria we apply are ultimately religious, and so considerations of author are always crucial. We need to deal with this argument, since it is a persistent strain in the various attempts to show that aesthetics has to have a religious reference.

This sort of issue is like the issue of whether the world has to be seen from a religious point of view, which again some would argue it does. They would suggest that it is a mistake to interpret the world as a secular place, since that ignores its spiritual dimension. Here we have a real difficulty and it cannot be resolved unless the issue of whether the world can be seen as a secular environment is resolved. One of the key concepts in aesthetics is the concept of seeing one thing as something else, and that is perhaps the most significant link between aesthetics and religion, since religion also involves seeing one thing as something else. To insist that the world has to be seen from a religious point of view is just wrong, because it does not. Perhaps it should be seen from that point of view, but we must allow for the fact that other points of view are feasible. Once we accept that there is not only one way in which the world can be seen, the whole basis to the argument that aesthetics must be based on religion collapses. What we should also notice is that it should be strange to identify Sufism with such a dogmatic view. Sufism celebrates diversity, and acknowledges the openness of the world. To insist on a particular definition of Islam, of the meaning of artefacts, even of religious artefacts, is to betray these wider principles of Sufism itself. In particular, to demand that art has to be interpreted from a Sufi perspective is not a move that Sufis themselves should find acceptable.

There are specifically Islamic artistic forms

The discussion so far should not lead us to think that religion has nothing to do with aesthetics. In the recent *Routledge Companion to Aesthetics*, a substantial volume of 46 chapters, there is no chapter on religion, which is obviously

regarded as of so little significance for aesthetics that it hardly requires discussion. This is surprising, since religion has played a huge role in setting criteria for beauty and creating art objects. And ideas about aesthetics, in particular what is appropriate as an art object, are not unrelated to religion. What is even more worth stressing is the way in which religious and aesthetic methodologies are in places so similar. They both value personal experience, and they both give a significant role to seeing aspects, what philosophers sometimes call 'seeing as'. We can see the world from a religious point of view, but we need not, and the suggestion that we cannot recognize beauty without such a committed attitude leads to seeing religious themes everywhere, even where it is quite ridiculous.

For example, Laleh Bakhtiar[6] talks sensibly about the various techniques of symbolization in Islamic art. But then her enthusiasm for the topic rather runs away with her. 'The mole, the dot under the Arabic letter ba, symbolizes Divine Essence Itself, the Mystery, the abysmal darkness … Like the face, the hair is veiled because of the sacred power it holds within itself'. Yet in the picture which accompanies the text, an Iranian nineteenth-century picture of a girl playing a drum, we see a young lady with a winsome smile and hooded eyes, with no veil on her face and an elaborate head ornament largely consisting of jewelry. We might think that this explanation is far-fetched. She continues in this vein when she discusses the mandala as a design object.

> The mandala, as a reflection of the cosmos and cosmic processes within all things, works through numbers and geometry, beginning with Unity, moving through its theophany and back to Unity. It recapitulates at one and the same time, the permanence of Paradise as an idea and its impermanence as a temporal reality.[7]

Again, this might be thought of as an over-enthusiastic application of symbolism. One may make this sort of remark about any sort of pattern at all, that it is based on numbers and geometry, it begins with unity (in the sense that there is a pattern, which could be seen as representing one), or because there is a notion of simplicity lying at the base of the complex pattern. Does such a pattern represent Paradise, and the fact that it is changing the fact that Paradise is not available to us within the world of generation and corruption? Accepting for the moment that we could read this into the pattern, we should also note that there is no necessity to read it into the pattern, and it should be said that most observers of such patterns probably do not.

We are told that 'The polarization which is expressed in geometry through static and dynamic forms corresponds exactly to the inseparable pairs of complementary spiritual stations between which the seeker constantly moves'.[8] One wonders, if they are inseparable, how one can move between them. Of course, the language here replicates much of the language of Sufism, but is it really helpful? A pattern is a pattern is a pattern, one wants to say, and these elevated interpretations do not throw light on what is going on in these patterns.

But perhaps this only seems to be a problem if one fails to appreciate how Islamic aesthetic devices reflect a much deeper metaphysical reality. According to Keith Critchlow:

> Islamic art is predominantly a balance between pure geometric form and what can be called fundamental biomorphic form: a polarization that has associative values with the four philosophical and experiential qualities of cold and dry – representing the crystallization of geometric form – and hot and moist – representing the formative forces behind vegetative and vascular form ... In Arabic calligraphy ... this polariza- tion ... can be seen between the verticality of the upright aleph and the rhythmic flow in the horizontal direction of the other characters, starting with bey[9]

and also:

> there is in the Islamic perspective a fundamental symmetry of existence revolving around the four-fold axes of heat and cold, moist and dry. This polar symmetry can be seen as underlying the most fundamental aspects of Islamic pattern; there are thus crystalline, 'frozen', shapes, or conversely 'warm', fluid, outlines (arabesques) ... 'frozen' and 'moving' shapes are complementary, reflecting the concept that time is a flowing image of eternity.[10]

The book is full of speculations about the magical properties of numbers, the ways in which they represent the spheres of the planets, the archetypes behind the Zodiac, and so on. We are told that three is important because it represents God, Rahman and Rahim, the introductory phrase before each sura. Three doubles as six, the number of days in which God created the world, 6 doubles as 12, the number of imams in Shi'ism, and these all can be represented geometric- ally, of course, in terms of developments of circles, triangles and other shapes.

Critchlow does an excellent job in displaying the principles behind the technical production of many of the basic, and extraordinarily complex, combinations of shapes and projects in geometrical decoration. As to whether this has anything deeper behind it, there is no argument. Let us examine the argument on which this sort of approach rests. According to the Ikhwan al- Safa', a group of thinkers who lived in the tenth/eleventh century CE in Basra, practical geometry is vital for ability in the practical arts, and theoretical geometry is important for entry into the intellectual skills. This is sometimes seen as a basic Pythagorean view, which stands in opposition to the Aristotelian understanding of mathematics, and establishes an esoteric meaning by which pattern and mathematical arrangement represents the inner nature of reality. It is this sort of approach, basically Pythagorean, on which the search for symbolism rests, and the trouble with it is that it requires a leap of faith which many might not wish to undertake. And why should they? Can they not admire a piece of carpet, a mosque frieze, a poem or an example of calligraphy without having to buy into some theory about the symbolism of what they are seeing? If they cannot then it is difficult to explain what is going on when they admire those

works of art, since they do not possess the theory which explains why that art is the way it is. It is sometimes argued that they sense the theory, without really understanding it, but this is a very patronizing comment to make about people who do not share the same interpretation of what lies at the basis of reality.

These comments are not at all limited to Islam, or even religion in general, and its supposed influence on art. We might want to be sceptical about many of the references we find to the ideological background to art. For example, in the National Gallery of Art in Washington DC there is kept the Index of American Design, a large project in the 1930s to record what was taken to be specifically American creative style. The aim was to distinguish between American art and European art, to represent the collective and creative spirit of a new nation, in particular through its work carried out in a vernacular and egalitarian manner. In the collection we find watercolour paintings of such objects, and it is a very detailed picture of many of the things that were made in the United States up to the 1930s; there are in fact 18,000 images. Yet do we get an impression of a unique form of design among the pictures of quilts, weather vanes, toys, drums, cooking utensils, and so on? The answer is a resounding no. The collection is very helpful in giving an impression of the vast variety of things which were made in the country during this period, but nothing distinctive or unique comes out of the collection, and why should it? These pictures represent on the whole people who quite recently moved to the country from Europe and so reflects their past in their original countries. It is a tempting idea that there is such a thing as American design in the 1930s and it can be perceived by looking at the products of American designers, but there is no common theme running through all these 18,000 images, and it would be amazing were there to be. If we are going to talk about American design, and clearly there are cases where we can, we should restrict this language to examples of objects which are homogenous in some way and do display some common features apart from all coming from the same national entity.

As both Wittgenstein and Grabar argue, we ought to be very careful about generalizations. Yet for writers on art and religion generalization is meat and drink, it is what often distinguishes them from the average member of the public. Anyone can look at an object, or listen to some music, and come to some comment about what it is like and how good it is. Only the specialist, though, can say precisely what the object is, how it relates to other such similar and distinct objects, what ideas are behind its construction and what the artist had in mind when constructing it, where it comes in the wider scheme of things, how it reflects much broader theoretical and personal commitments, and so on. The specialist is like a magician who produces rabbits from a hat, we all look at the hat and see just a hat, but the magician manages to confound our naive understanding of what we see by demonstrating that there is much more there

than we suspected. The more she can produce, the better the magician, and the less she has to work with, the more impressive the performance. But when we watch magic we know that we are watching illusions, and we should display the same caution when assessing the performance of those who write on art and religion. This is not an argument for nominalism, for the thesis that no generalizations are valid, but it is an argument for being careful when being presented by generalizations about art and religion. As we shall see throughout this book, the wildest generalizations are constantly made about Islamic art, and there is often not a shred of evidence for them. In fact, they are commonly made and accompanied by images that directly contradict them. Good examples of how being wedded to a general idea makes it impossible to see the world correctly are to be found in almost every book on Islamic art.

Islamic art is essentially religious

There is a well-known story about ibn 'Abbas, the Prophet's uncle: 'Ibn 'Abbas advising a painter: "You must decapitate animals so that they do not seem to be alive and try to make them look like flowers."'[11] It is true that there were iconoclastic tendencies in Islamic art, but there are also many instances of animals being very realistically portrayed. One thinks in particular of some of the Mughal artists who seemed to take delight in the precise replication of the animal as it is. The Mughal empire in India did after all extend from 1526 to 1858 so there was plenty of room for stylistic variation. Ibn 'Abbas had a view, but it is not the only view. We are told by Grube that:

> The experience of the infinite on the one hand, with the worthlessness of the transient earthly existence of man on the other is known to *all* Muslims and forms part of *all* Muslim art. It finds different but basically related expression. The most fundamental is the creation of the infinite pattern that appears in a fully developed form very early on and a major element of Islamic art at *all* periods. The infinite continuation of a given pattern ... is ... the expression of a profound belief in the eternity of *all* true being and ... a disregard for temporary existence. In making visible only part of a pattern that exists in its complete form only in infinity, the Islamic artist relates the static, limited, seemingly definite object to infinity itselfOne of the most fundamental principles of the Islamic style is the dissolution of matter ... The ornamentation of surfaces of any kind in any medium with the infinite pattern serves the same purpose – to disguise and 'dissolve' the matter, whether it be monumental architecture or a small metal box ... This idea is emphasised by the way in which architectural decoration is used. Solid walls are disguised behind plaster and tile decoration ... (my emphasis).[12]

Yet in my American suburban house solid walls are disguised behind plaster, and in the bathroom they are hidden behind tiles, yet without any particular attitude on my part to the solidity or otherwise of the world. It is often said that

one must beware of houses which appear on the exterior to be over-decorated, since that decoration can be used to hide imperfections in the structure. One might hope that the builders were not putting the plaster up inside the house, or the render on the exterior, to disguise their lack of belief in the solidity of the material world! Why cannot decoration just be decoration, there to make the surface more beautiful? The answer is of course that for those who seek meaning everywhere meaning is everywhere, even if in reality it is not. It is worth noting all the uses of 'all', which I have emphasized, to bring out the uncompromising view that Grube has of his ability to define exactly what goes on throughout the immense artistic production which took place in the Islamic world, wherever it took place.

Islamic artists often produce very modest comments on what they do. The Persian poet Sa'adi (d. 690/1291) has a phrase which actually is popular in the Islamic world, and often repeated, in one form or another[13]

> How well the brocader's apprentice said when he portrayed the anka, the elephant and the giraffe, 'From my hand there came not one form (surat) the pattern (naksh) of which the Teacher from above had not first depicted!'

Yet we should not necessarily take this modesty at face value. Even if we do, we should not assume that it means anything more than a general desire to link what artists do with what God does, in just the same way that we might link human action in general with the possibilities that God has created for us in the world he gave us to look after. Any more specific religious reference to art is often thoroughly misplaced. Did he really think that he was without talent in poetry, and that the only way in which he could write was to reflect what came to him from heaven? Perhaps he did, but he did not think that what heaven wanted one to do was just sit there and wait for divine inspiration to arrive. He expected to have to work at his profession, and to acknowledge his ultimate debt to God. This will be discussed in more detail in the next chapter, but we need at this stage to be careful about accepting these formulations of humility literally.

If one is determined to find a religious meaning to some artistic feature one will always be able to do so. For example:

> Another use of light which is 'traditional' and yet not a reproduction of the past is the device by which direct daylight is softened and diffused into the prayer-hall through curtains and lattice-work, through a patterned calligraphy-perforated wall, which veils the 'real' structural wall. The screen thus serves as a sort of membrane between the outside and the inside ... It reminds me of the Hadith which says that man and all creation would be annihilated by direct exposure to the Divine Light; and so God in His mercy veils it with the 70,000 veils of Creation.[14]

So using an architectural device to soften and diffuse light apparently has a religious function. Obviously it could, but it does not need to, and the idea that

this is what the device means is difficult to accept. We often construct devices to vary the strength, colour and direction of light yet without any particular religious or metaphysical significance to what we do. When it is sunny in summer I may lower the blinds on the windows of my house, but it is not necessarily something I do while thinking of this hadith about the power of divine light. The argument here is not that this could not be what the designer had in mind nor that we could not have it in mind when we look at the feature. The argument is that this religious theory is not able to define the meaning of the feature. This is even the case when we examine design within a specifically religious building. How much more true, then, is the separation of art from religion when thinking about predominantly secular objects?

Islamic painting is very different from other forms of painting

We are told that

> painting in Islam differs completely from painting in other civilizations ... In the Islamic tradition, the Arabic language is sufficient for spiritual and physical expression and fully replaces imagery with its illustrative vocabulary ... Islamic aesthetics seek to represent the spiritual, intangible qualities of a subject; to free art from the confines of its period; and to render it timeless by leaving aside natural imitation ... The Muslims used arabesque designs to decorate an empty space by filling it in a continuous, repetitive manner that has an obvious aesthetic value, as well as a spiritual connotation signifying the infinity of God'.[15]

So why paint at all, if the Arabic language is sufficient for all the aesthetic purposes of the Islamic world?

The ban on images in Islam does not exist, despite what ibn 'Abbas said. The Qur'an says nothing directly on this issue. There are *ahadith* which are critical of images, in particular images which can be seen as frivolous, but this could be taken as a critique of the frivolous as such, not necessarily all images. Certainly images which can be taken to be aspects of *shirk* or idolatry, the idea of praying to images or through images, is entirely forbidden. This presumably is the reason for the lack of images in mosques and places of worship. By contrast with many churches or Hindu temples, for instance, mosques tend to be bare and empty, often very beautiful structures but with a concentration on space rather than on what that space has within it. Or is this just a very Christian perspective, a wonder at the relative purity and simplicity of the Islamic use of space in mosques? One of the exotic aspects of the Middle East celebrated by Orientalist art was the relative plainness of the mosques and the simplicity of prayer in Islam.

The destruction of images is often the attempt to replace one culture with another, or to signal that there will be no return to the previous culture. The

destruction of Buddhas in Afghanistan, bulldozing of Jewish and Christian sites in Saudi Arabia and the building of mosques over the religious sites of other religions represent a long tradition in interreligious struggle. In the past the Mughal rulers, Aurangzib and Nadir Shah, used their artillery to bombard the great rock-carved Buddhas of Bamian. A sign, one might think, of a basic Islamic hostility to the representation of the figure. Yet much Persian painting is of figures, represented quite naturalistically, and some Mughal painters are highly accurate in their representative skill. In many paintings we see princes and other notables in a state of inebriation. Bihzad (d. 941/1535), probably the best Persian painter, often paints such scenes. Individuals collapse drunk, are carried out or have difficulty staying in one position. We see more wine being brought in, and even wine being distilled. Of course, the wine is often interpreted as not really representing wine, but as having a spiritual significance, and if one wants to believe this there is no reason why one should not. On the other hand, we do know from accounts of the Persian court that drunkenness was by no means unusual, and so these scenes of alcohol-induced levity are probably rather accurate representations of what actually happened. Not only did this commonly take place, but apparently the rulers who commissioned the paintings had no objection to being displayed in their cups. If they did, the painters would surely not have portrayed them in this way. It could of course be that they are really being represented as in a state of *fana'* or ecstasy, since remembering God has deprived them of their senses in just the same way that alcohol can. These are not religious paintings, of course, but they are paintings by Muslims, in the most part, for Muslims, and they reveal no embarrassment at representations of the human figure or even at forbidden activities from an Islamic point of view. We cannot assume then that there was a general suspicion of images in Islam. Although the destruction of images may have been given a religious rationale, that does not establish that they in fact had a religious rationale.

This has much wider scope, the destroying of libraries and houses of worship in the former Yugoslavia, for example, was not necessarily based on any parti-cular theological doctrine. Orthodox Christians destroyed mosques, Catholic churches and other public institutions, and so did the other religious (one uses the term loosely) communities. It is sadly a policy by many political movements to do all one can to destroy the cultural heritage of the enemy. The Wahhabi regime in Saudi Arabia has not banned photographs of the Wahhabis them-selves, for example, nor of most of what is in the Kingdom. The ideology of Wahhabism is hostile to all forms of what can be taken to be idolatry, and we shall come to examine the views of the founder of the movement later on in the book. They are sensitive to unauthorized photographs, but again not for religious reasons, surely for political and security motives. Although their regime is often called puritanical, one does not see much evidence of puritanism in the private

life of the Saudis. There is then nothing specifically Islamic about a hostility to images.

But is it not the case that Islam is well-known to be opposed to the use of realistic portrayals of physical objects? Allen argues:

> Is there iconographic content to the arabesque …? From a modern standpoint it is tempting to wonder if the arabesque, firmly identified with the vine scroll, somehow refers to the vegetal world, and geometric designs allude somehow to the laws of nature that govern the cosmos, or the rules of construction by which man constructs such things as buildings. But these are anachronistic ideas when applied to the tenth and eleventh centuries, and there is no contemporary evidence to justify projecting them backward in time.[16]

He also argues that:

> Islamic civilization was a supraethnic one: its religion, law, and science transcended the ethnic and linguistic groups that became Muslim. On this level its art was aniconic and was lacking precisely in narrative.[17]

Allen distinguishes between texts which are part of the princely tradition, and so represent rulers and their subjects, and texts which are local and require illustration. But these are not religious texts. The former maintain an entirely abstract and general character, in order to further the mission of Islam as a faith sent both to the Red and the Black (in the words of the famous hadith reported by Jabir b. 'Abdullah in *Muslim* Bk. 4 no. 1058). So although mosque design is local and often follows the local style and building materials (but quite often also does not, depending on where those who brought Islam originally came from – Syrians in Andalus), it avoids decoration in order not to obviate the universal message. This is a poor sort of argument. Why could not visual figures be used to define a universal message, as other religions have done? Christianity has hardly been unsuccessful in this respect, yet exactly the same sort of argument explaining why there are few religious images in Islam could be used to argue that there should be few such images in Christianity. The role of the image in religion really needs to be interrogated before we can work out why it was not much used in Islam and was used a great deal by Christianity. It is worth pointing out that both religions follow Judaism, with its tendency to hostility to the image originating in the fierce rejection of idolatry.

> It seems to me that in Islamic art abstract elements such as geometry serve the integrative function of representations in classical art: they tie together the whole work of art by belonging to the same conceptual category.[18]

This seems plausible, and as one views more and more examples of complex interwoven patterns, one becomes better able to appreciate the innovation which can take place within the context of a basic theme. But the idea that Islamic art has to take this form because Islam itself has no central narrative at its base is

false. It is true that the Qur'an is a very different sort of work from the Jewish and the Christian bibles, but there are plenty of stories in the Qur'an, and even more stories in the wider category of Islamic literature such as the hadith and the other books, that the different groups in Islam accept as important sources of information and inspiration. One of the interesting differences between Muslims writing about Judaism and Christianity and Jews and Christians writing about Islam is that the former emphasize the similarity between the faiths, while the latter often do the reverse. For Muslims the Qur'an is the culmination of the two bibles, and so there is taken to be an essential continuity between the traditions. For those observing Islam from the outside the newer religion is often seen as an interloper and hostile, or rather as immensely attractive and superior. Many who convert to Islam become strong advocates of their new faith, it is often said of converts that they become much more extreme in their beliefs and practices than those who have grown up securely within the context of a particular religion. Since the expansion of Islam largely meant expansion into the Christian and Greek cultural territories, it was the representational nature of the native art that stood in the way of the new religion, along with the ideas that accompanied that art. The approach of the new Muslim rulers could have been to replace one form of representational art with another form of representational art, but this was not the approach in fact adopted. A non-representational form of expression is even more distinctive in its opposition to the native culture than a competing representational iconography, and this was the strategy actually adopted. The important thing to recognize is that it was not inevitable, no more inevitable than any other link between artistic form and the nature of the society out of which it emerged. There are after all plenty of pictures of the Prophet, and his image even appears on prayer rugs.[19]

The issue of iconoclasm is much more complex than it sometimes seems. It is worth noting that the suspicion of images that we may deduce from the Jewish bible was debated in the early Church. Yet in the end the decision was taken to use icons and they came to have a subtle relationship with the divine reality that they were taken to represent or participate in. Also, the philosophy on which they were based, like the philosophy that came to be so influential in the Islamic world, was profoundly Neoplatonic. This is a theory based on unity and its central problematic was the account of how from unity, multiplicity emerged. One might have expected that Neoplatonic thought would have opposed images and representational art, since it places such emphasis on the One behind everything, as the principle of reality, and on the idea that the world of generation and corruption is a long way away from what is really real, the basic principles of how things are, and these are both ineffable and unitary. Neoplatonism in most of its forms is just as committed to monotheism and *tawhid* (divine unity) as is Islam, although the One from which everything else comes is not necessarily for

Neoplatonists an actual being. It was not difficult for the One that was origin-ally seen as a principle to become identified with God, and in particular the God of Islam. Yet Christian thinkers had no difficulty in identifying the One in Neoplatonism with the Trinitarian conception of divinity, and also with the use of images, icons and so on. So it cannot be anything in the theory of Neoplaton-ism itself or in monotheism that leads to iconoclasm, since similar theoretical ideas result in a very different form of art in Christianity.

Islam was a new product, it sought to emphasize its links with earlier religions, but also its role as the culmination of those religions. It could have used similar art forms to those religions, and in many ways it did. On the other hand, it also had to represent itself differently, to establish a new brand label, as it were, and this suggests the need for something that would help users of the product both to recognize it and also incline them to accept it. Since the cultures of Christianity were representational at this stage in the Middle East, an appropriate strategy was to be non-representational, but to be non-representational in ways that made references to the representational. So for example coins appeared with writing on them instead of the head of the emperor, but they could have had the head of the caliph on them, that would also have been an alternative symbol of power. Sometimes they did: there are coins from both the Umayyad and the 'Abbasid periods which show the caliph on them, sometimes wielding a sword and sometimes on a horse. These are early coins, but even much later on, in the seventh/thirteenth century, the Seljuq leader Ruhn ad-din Sulayman II has a coin struck with him on a galloping horse. In some ways, though, the use of writing as a symbol is useful for a regime that seeks to extend not only its political power (the head of the caliph would have done for that purpose) but also to convert people, to say that here was a different faith to which one was encouraged to convert. We should not exaggerate the significance of the writing, since there is no reason to think that it was more than an image to many of those who saw it. This is particularly the case with much of the writing on buildings, especially on the interior of mosques. When we look at it we might think that the decoration is in fact the words of the Qur'an, thus emphasizing the significance of those words as words. But when we consider that the writing is often in Kufic script with few diacritical points, that it is often obscured by floral and vegetal features, and set within a highly decorated frieze, it is difficult to believe that many could read it. So the writing is indeed a symbol of Islam, the writing and not necessarily the meanings of the words which were used so decoratively.

The Qur'an reports that Ibrahim broke the idols of his father (6.74), and that has often been taken as suggesting that there is a problem with paintings and similar art objects. This is because it might be thought that the object represented really lived in the picture. On the other hand, there is a lot of

evidence that painting was practised by many Muslims and bought by Muslims, as they are today also. Rooms were decorated with painted walls, richly illustrated with just the sort of images which one might think would be against the spirit of Islam, were it to disapprove of images. Jami in his long poem on the passionate relationship between Yusuf and Zulaykha refers to her preparation of the palace with captivating paintings, designed to stimulate Yusuf, and it is not unlikely that this is based on what actually existed in Iran at the time. Jami suggests that the *shari'a* bans painting because it is not possible to represent divine beauty by painting.[20] That would be an argument against trying to paint God, of course, not against secular painting, and there is plenty of the latter. There is even plenty of evidence of painting religious subjects, although today under Wahhabi influence this sort of work is often not acceptable. (In the National Museum in the Saudi capital Riyadh, for example, there is an excellent collection of very early figures from the pre-Islamic period [the *jahiliyya*] but they are invariably confined to the basement and kept under wraps.)

There is certainly much use generally of the images of the Ka'ba, the mausoleum of the Prophet in Medina, the flying horse Buraq, and for the Shi'i objects associated with 'Ali. These objects are often displayed in mosques, especially those outside the Islamic world, and in the homes and offices of Muslims.

Islamic art is 'the Other'

The discovery of Islamic art as part of the orientalist movement in the nineteenth century resulted in a great process of trying to define Islam as 'the Other', in ways which have become very familiar since then. It is important to recognize that 'the Other' may be a very positive as well as negative notion, and that it is equally inaccurate whatever way it goes. When it comes to art it may take the line of seeing Islamic art as vastly inferior, or greatly superior, to other forms of art. Neither attitude is helpful, there is no championship league of art genres, we should seek to examine each type of art by looking at what it is and asking ourselves how we are to understand it. One of the important points that Nelson Goodman makes in his *Languages of Art* is that most of the evaluative language of aesthetics is not about ranking objects as though they were racehorses, and we could extend that point to art genres and traditions also.

We have to be careful even about how we look at what are obviously examples of the work of minor artists, such as some of the nineteenth-century orientalist painters who produced such exact work on local people and costume in the Middle East. Even so acute a commentator as Richard Ettinghausen goes awry here, suggesting that:

> we find a sizable number of paintings of Near Eastern subjects, often done after sketches made during travels in that part of the world. They are by minor academic

painters, mostly from France but also from Germany. Most of their paintings are no longer highly regarded as works of art, although their realism gives their genre scenes or views an ethnographic relevance, as much of this traditional aspect of the Near East has disappeared.[21]

But most of these paintings are often not objective at all, if this means accurately capturing the image before the artist. We know that many of them were carefully arranged to capture a particular look even if that was not really present, and the clothes are portrayed in a way that makes little reference to the actual clothes worn at the time by ordinary people. In particular, many of the women are portrayed salaciously, wearing few clothes and displaying far more of their bodies (to strangers!) than would normally be the case. We know that these paintings are far from accurate just by reading the accounts of the painters themselves, the difficulties they had acquiring models and the ways they used those models. During the heyday of empire the relationship between the Western artist and the 'native' subject was of course highly charged, and the subject of the exotic east was often stylized in the form of the bodies of the women from the Middle East, leaving quite a different message from that of the putative purity of Islamic art and the starkness of Islam itself. But it is all part of the same idea, that of Islam as 'the Other', and this indicates that we need to be very careful about stereotyping a faith and a culture in any way whatsoever. What we ought to do is try to be objective and observe what we see when examining that faith and culture, and avoid the easy generalizations.

A warning about generalizations is highly relevant:

> Much has been written about the art of medieval Near Eastern ceramics, and a number of conclusions may be taken as reflecting a consensus of scholarly opinions and as corresponding to much of the objectively known evidence. At the same time troublesome questions constantly arise as one attempts to understand any one apparent conclusion in depth or as one investigates what may be called the epistemological borders of an accepted statement, the fascinating gray area in which a generalization is true and yet not entirely satisfactory, either because it does not seem quite to account for all available information or because it raises too many additional problems.[22]

In the chapter 'Non-representational painting', David Talbot Rice says 'it is perhaps true to say that [non-figural decoration] ... was the only truly Islamic form of painting, for it was only in this sphere that a universal style was developed which embraced the whole of the Islamic world from Spain to India'.[23] As he goes on to point out, there were certainly local variations in style, but these were less marked than local variations in style of more secular material such as the illustration of legends or poetry. He does not discuss calligraphy, and it is here where local variations really come in, the actual definition of many of the various styles being linked with where they were practised.

Accounts of calligraphy have spent too much time emphasizing that the calligraphy represents a particular text. It does, in the same way that a painting of a figure represents a figure, i.e. imaginatively. The text itself has a beauty and grace which is unrelated to the beauty and grace of what it means, and the way to determine this is to consider someone looking at it who does not understand it. This is like someone viewing a religious representation composition but without any understanding of what it is supposed to be about. It is a well-known fact that as the genre of Persian miniatures became well-established, and many such volumes of pictures started to appear, the link between the text and the visual material became more tenuous. At first the text and the pictures were closely connected, but as the painters came to be more confident in the ability of their work to stand by itself, it came to stand by itself more and more, so the connections with the story itself were gradually reduced. Calligraphy is not dissimilar, since the beauty of the writing in time came to work independently of the text, and in this case the text is the Qur'an itself. This seems like a terrible thing to say, it is as though the great calligraphers themselves are intent on breaking the link between what they are drawing and what those drawings represent, the words of God. There is no reason to think that that is true, but there is reason to think that they came to value their ability to manipulate writing to the extent that they became unconcerned about the basic legibility of the writing. It is rather similar to the way in which the basic vegetative designs became over time fantastic and almost abstract in form, with the shapes they inhabit transforming into increasingly convoluted patterns.

Al-Ghazali killed Islamic painting

Ettinghausen asks why Arab painting died out long before the other Arab-Islamic crafts. He gives a number of explanations, including the influence of al-Ghazali (d. 505 AH/1111 CE) and 'the spirit of formal orthodoxy [which] led inexorably to a suppression of individual initiative, a stifling of intellectual activities and finally to spiritual decadence. In practice this meant in particular the reliance on well-established safe patterns, to the exclusion of the novel and the individual'.[24] Al-Ghazali is one of the most complex thinkers in Islam, a man whose theoretical and personal commitments underwent a lot of changes during his lifetime. He started off as a theologian interested in philosophy, came to see philosophy as a profoundly dangerous and unIslamic activity, and ended up as a Sufi. Al-Ghazali discussed beauty in his *Kimiya-i Sa'adat* (Alchemy of Happiness), a shortened and more popular version of the *Ihya'*. In this book we find the familiar ascetic line defended by al-Ghazali, with the body being regarded as not of much importance. Beauty is significant because it provides us with pleasure, and the essence of beauty is the recognition of perfection. Everything

has its characteristic form of perfection, but the outer appearance is often a misleading guide to the perfection within, where it really lies. The eye can assess the outer, but it is left to the heart to get to the essence of the thing. The problem with appreciating paintings and beautiful objects is then that it encourages us to concentrate on the outer, not the inner, and to regard the superficiality of the external world as representing how things really are.

Al-Ghazali is blamed for many things which go wrong, or apparently wrong, in Islamic culture, of course, and it is a bit harsh to blame him for the relatively early demise of Arab painting. He is blamed for the fairly early disappearance of philosophy from at least the Western part of the Islamic world, although it is difficult to see why he would be successful in destroying it in one part of the world (the part in which he did not live) but does not seem to have affected it in the eastern part, where he did live. It seems harsh to blame him for a growth of spiritual decadence, since it was the whole project of the *Ihya'* to stem spiritual decadence and to revive Islam. Ettinghausen is not really complaining that Arab painting became stereotyped and unoriginal, he is commenting on the fact that it seems to have died out altogether, at least until fairly recently when it has been revived, albeit mainly due to the influence of Western art. The suggestion is that it ran out of ideas and so came to a stop, as is entirely reasonable when one runs out of ideas. On the other hand, it is not necessarily the case that those without anything original to say or represent become silent. Quite the contrary. We should not regard originality and novelty as essential features of great art, although that is often how we see art from the perspective of European and American art.

Islamic art is essentially minor

> The esthetic aspects of Arab painting [involve] a strong sense of composition … in which the various parts are grouped simply and often lack any specific framing device. The colors used are bold, though of a rather small range. The artists were not unaware of space … human figures are rather shapeless, with their body structure hardly felt under the voluminous robes; but the faces are stressed, though they reproduce types, not individual persons … a remoteness from nature is shown in the treatment of vegetation and landscapes, which often are mere stylized symbols.[25]

This appears to be a damning indictment of the genre. We are told that the range of colours used is restricted, human figures are shapeless, faces are stereotyped and not individual, and nature is not realistically portrayed. These are comments which are often made, although not to the fond parents, of children just starting out to paint.

Lisa Golombek in her 'Toward a classification of Islamic painting' points out that the manuscript illustrations in Islamic painting went through some

changes in structure. Initially the pictures and the text were closely connected, and later on the pictures became more independent of the text. In due course appreciating the pictures did not demand a reading of a text, which in some cases did not even exist, 'but on a perception of formal principles'.[26] This led to the form becoming frozen, since in order to be understood it would need to be reproduced in the same way every time. She points out that these Persian miniatures' purpose was to be radiant and exquisite, that the art of miniature painting is a performing art, one in which the artist's ability to perform is of greater importance than his creativity. So 'whereas the works of the masters attempt to communicate a thought or feeling, the purpose of the miniature painting is to appeal to our senses, to entertain' (ibid.).

There are of course differences which we can make about the skill and creativity of different painters, but the intentions of the artist are not crucial to understanding those differences. Nor is the fact that an artist may be using a highly stylized form of expression. If that was a barrier to creativity then very little work would be creative. It is certainly true that some of the Persian miniatures do look almost as though they have been produced by modern printing methods, they are so similar to each other. Others which follow the same general form are quite breathtaking in their beauty and vivacity. Schroeder, whom Golombek quotes, suggests that the greatest painters took on projects in an impersonal way, just as singers accept the notes of a song and this is a good analogy. One would not necessarily call a singer or musician uncreative just because they followed the notes of a composition, and some of the most impressive art follows a highly stereotypical formula. Actually in some ways it might be said that many forms of music in the Islamic world give rise to more creativity than is the case with Western music, since the performers of Arabic and Persian music, for example, are expected to vary the basic form of musical expression from performance to performance more than is customary in say the Western classical tradition, as we shall come to see. It is the modern fascination with creativity, which tends quite falsely to set up a dichotomy between creativity and tradition, that makes a lot of Islamic art look unoriginal and as a result unexciting. But Schroeder is not quite accurate here either, since the painter is not really following a pattern like a singer following music and words. He has a lot of choice to vary size, framing, colour and so on, and if he chose not to do so then it might be concluded that he was happy with the standard way of doing things. And why should he not be happy with it, since most artists at most times are. They work within a tradition, and some of the time their work is designed to be decorative, to amuse an audience and to demonstrate their skill. This is not a matter of intention but rather one of form, and it is questionable to call artists who produce decorative work 'performers' rather than artists. We need not expect all artists to challenge the parameters of their discipline and go off in

a different direction. This is what many artists do today and have done in the last couple of centuries, but for long periods of human history they have not acted like this, and it is not obvious that they should have. In vindication of the work of the artists we can point out that their work is often appreciated by audiences who know nothing of the particular tradition in which they are working, but who nonetheless find the compositions very beautiful. They are not beautiful because they are wonderfully creative, and this would be unnoticed in any case by those who are not aware of the tradition in which this work appears. They do not know what the tradition is and so would not know what it was to work outside or beyond the tradition. Modern audiences may think this form of painting beautiful because of its formal features, and these would have to be features which the work has in itself as an art work, since any more specific understanding of the work as a part of a cultural system may not be available to the audience.

One factor to bear in mind is that most painting within Turkey, Iran and India between the fifteenth and nineteenth centuries was for the illustration of manuscripts. Size is an issue in book illustration, and there is no need to spend the same amount of attention on the accurate portrayal of nature or figures, with perspective and shadow, as in large paintings that are independent both of direct relationship with a text and of size restrictions. The illustration of a manuscript – and we should not overemphasize the significance of the text itself since the pictures are often fairly independent of the text – involves the production of something dazzling and charming, so colour had to be rich and the scenery lush. The representation of nature is formulaic and ideal, with no attention to accuracy, and natural objects such as trees, stones and rivers are often grouped together very unrealistically, and colours used for them that bear no resemblance to natural colours. Internal scenes are no more realistic, they are often either only schematic, with no detail at all, or with too much detail, portraying the rich surroundings of important characters. This is true of secular and religious illustrations, despite the putative ban on images in Islam there is no shortage of representations of people in illustrations of Qur'anic stories. That does not mean that the representation of any of these features is done in a generally poor way. It is not the detail which we now tend to admire, but the whole ensemble, especially the blend of colours, which often reach an amazing height of lustre. Is it minor to base an artistic tradition on colour? David Batchelor argues in *Chromophobia* that the whole of the modern Western art movement is based on a distaste for colour, and one of the motives for this is its association with the East, with the mysterious exotic Orient . We do not have to accept what he says to acknowledge that colour is an important part of art and the fact that it may be emphasized as compared with, say, line in some traditions of Islamic art does not show that it is essentially minor.

An example: Yusuf and Zulaykha

One of the important cultural factors in much painting is the influence of Sufism. When Sufism became an important part of Islamic culture it changed the approach to literature and also to the visual arts, since Sufism produced a symbolic language of considerable complexity and interest. For example, the prophets of Islam are often represented as the 'perfect men' of Sufism, individuals who have ascended the ladder of self-perfection and who have spiritually cleansed themselves sufficiently to be able to act as guides to humanity on behalf of God. So in a lot of paintings we find haloes around the heads of major figures, light shining on them, they wear green clothes (identified with the Prophet Muhammad, and for the Sufis, with life itself), while the palaces in which they may be represent the temptations and pleasures of this world, which both the prophet and the Sufi must renounce in order to achieve access to the world to come. In the very popular story of Yusuf and Zulaykha, the female lover often represents the mystic who has to remove himself from attention to the demands of the body to be united with God, after undergoing many trials and tribulations. Yusuf, like so many of the prophets, has to undergo all sorts of difficulties before finally achieving his goal. Actually, in the symbolism of the story Yusuf represents those forms of extreme beauty and goodness which can only have their source in God, while Zulaykha is the seeker after contact with those forms of perfection. What is interesting in the iconography is that there are many references to Yusuf's beauty, not only in attracting and captivating Zulaykha, but also her female friends in Egypt. They are sitting down to eat fruit and when they see him they are so smitten that they cut their fingers down to the bone! It is also worth pointing to the ways in which dreams figure in the account; it is in dreams that Zulaykha first perceives Yusuf, and he interprets the dreams of Pharaoh, while the courtiers who were imprisoned with him also had dreams. Dreams are of course in Islamic philosophy closely linked both with prophecy and imagination, and we can make the connection with aesthetics also.

It is certainly true that the beauty of Yusuf is said in the Qur'an to stem from his spiritual perfection, and the love which Zulayka feels for him can clearly be interpreted spiritually as the way in which we are attracted to what is fine and pure in the world around us. Yet many of the illustrations that we find in the manuscripts are far from coy about the physicality which enters into human relationships. When Zulaykha is pursuing Yusuf it is quite clear what she has in mind, and when the Egyptian women are looking at him they are far from modest in the expressions on their faces. One of the attractive aspects of these compositions is often that away from the central activity there are other things going on unconnected to the main theme. Merchants are haggling over prices, horses are fed and watered, domestic tasks are completed and so on. In some

illustrations a number of events which occurred at different times are presented on the same page or carpet, sometimes in lozenges or small boxes, and the viewer then has a birds eye view of a whole sequence of events. In *My Name is Red*, the modern Turkish novelist Pamuk has one of his characters call this sort of view of events the view that God has, where everything which we see in sequence and as happening in different places occurs all at once and in just one place for God.

These pictures are complex from an iconographic point of view. They involve a variety of artistic techniques which relate specifically to book illustration. They often use colours that have a particular significance, and of course they are based upon a particular kind of literature which they are supposed to be illustrating. They may also exhibit a range of further religious themes, Sufi ones, for example, and so the images could be read in a number of different ways. The interesting question arises as to how much do we have to know of all this context for the image to make sense. The answer is nothing at all. For what we have in many of these pictures is a wonderful composition with a theme that can be quite easily recognized. Not perhaps the whole story of which the theme is only a part, and not perhaps the precise details of why the illustration took the form it did, but we can see enough of the picture to appreciate it aesthetically. Some of these illustrations use a combination of colours and organization to produce an atmosphere of great calm, where the main character is perhaps sitting slightly off-centre in a room, but the room is very roughly characterized, so that it almost looks like it is outside a building, although clearly it is meant to be inside. Then there are other characters sitting in quite precise spots looking at him, and there is a harmony in the organization of the people which is very impressive. It may well be that the main figure's head is covered with what looks like fire, but we are not concerned, since it obviously is not fire, and when we come to see more of these pictures we realize that it represents a sort of halo. Of course, the interpretation of this aspect of the painting is familiar to those who understand the genre, but I am assuming now that the viewer is not such a person. Another feature that might be noticed is that the expressions on the faces of the minor characters are all the same, and they may be turning their faces all in the same direction.

The viewer of such paintings familiar with Western art may dislike them. She may think of them as unsophisticated and naive, but without the excuse that they are trying to fit into a naive style. Although the page may be full of colour and images, it seems still to lack something, since the perspective is so poor. Actually, the perspective is not poor at all, in one sense, since it is entirely ignored by the artist. The living figures have no depth, yet the picture is about them, and the story accompanying the picture is certainly about them. This is where we have to take seriously the fact that these are illustrations of a story, a

story which the viewer is expected to read, or at least know. The picture represents a slice of action, a decisive moment in the story, and they are directed to capturing that aspect of the story, they are not interested in doing anything more. Often the text will actually intermingle with the picture, to emphasize this point, that the picture is really just an illustration of a text.

But if it is really only an illustration of a text how could one appreciate it without understanding or reading the text? In particular, even as a picture one does not know whether one should read it from top to bottom, right to left, like Arabic writing, or whether from the bottom up, as seems to be the case with at least some of the Persian miniatures. Sadly, the pictures have sometimes been cut out of the volumes in which they originally appeared and displayed as independent pictures, framed behind glass, and entirely out of context. From a scholarly point of view this is a shame, but does it matter aesthetically? The suggestion here is that it does not matter, the design of the pictures is usually strong enough to survive such treatment. Even out of context we still have the wonderful colours, the careful positioning of the figures and the sense that we are looking at a composition with a meaning that is some way behind what is displayed. Some of the paintings are just there to delight, and there is no reason why they should not delight us even if we do not know what they are about, in just the same way that we can find aesthetic meaning in all kinds of objects while knowing nothing about them. For those which are symbolic we should remind ourselves that many of their viewers who were contemporary with them would not necessarily have grasped the meaning of all the symbols. For some of those meanings are dependent on what the artist would have regarded as a fairly advanced level of spiritual awareness, and there is no reason to think that all such viewers would have achieved that level. It is a principle of much Islamic theory that audiences should be addressed in the language which makes sense to them, and so the charm and balance of pictures are independent of our ability to make further and deeper judgements about them. The conclusion has to be that it is wrong to call these forms of art minor.

That does not mean that no form of art is minor. For example, there is an itinerant painter in the United States called Ammi Phillips who worked in the Massachusetts and New York area in the nineteenth century. He would travel from town to town and paint portraits, largely of the children of the wealthier citizens. Since he had to do these quickly what he did was prepare the setting, the background and the clothes, and just add the head. The girls represented are often in a bell-shaped skirt, with huge sleeves and an animal, usually a cat, on the girl's lap, held by her arms and hands. On the floor at her feet lies the faithful hound. There is nothing natural about the composition, we can tell that it is formulaic and that the individual human being is put into it, as it were, and yet it is rather compelling. When one sees the work of Phillips in an art gallery

it does stand out, and people seem to stand longer in front of it than in front of many other technically superior products. The senior curator at the American Folk Art Museum in New York, Stacy Hollander, commented on this picture, 'The whole thing is a balancing act that is as sophisticated as any contemporary work of abstract art ... It's almost geometric in its precision'.[27] She picks out the cat on the lap as the key component, since it 'perfectly brings your eye right down the canvas, from the lace on the edge of [the girl's] sleeves to the pleated fringe of her pantaloons' (ibid.).

It would be wrong to suggest that just because we know the artist used a prepared structure for his paintings, the latter must be formulaic and so not particularly strong aesthetically. Stacy Hollander calls him a 'great American master [...] of any genre of portraiture' (ibid.) and to support this view she describes him as a wonderful colourist. Of course, anyone who works in a Folk Art museum would be expected to express some enthusiasm for folk art, but we do have a painting here which compares nicely with much Islamic art. It is apparently formulaic, geometric, places a lot of reliance on colour and shape, and much about it is naive. It is like those Persian miniatures where the landscape is highly coloured but unrealistically vivid, where the people are flat and there is no representation of movement. But I think here we begin to see a difference between the Persian paintings and the Phillips paintings. The former are a way of representing the world that applies rules of projection that are unfamiliar to us now but which then were the formula to be applied to such representation. Phillips used a formula because he did not have the time and leisure not to, and it shows. The cat, the dog, and the girl all have the same eyes, for example, except that the dog is looking down, the cat is looking sideways and the girl is looking at us with her eyes, but not with her face. This is not a wonderful painting, but it is certainly an interesting painting. The Persian paintings which are often likened to this sort of work are far more complex, not just in the sense that there is usually more going on in them, but in the sense that the ideas which the artist is developing are more complex and extensive.

We should not think that Persian painting is more complex just because there are lots of things going on in most of the paintings. These paintings are on the whole very busy indeed, and it is this characteristic that leads some to discern a horror vacui in Islamic art, as though there is a repugnance felt about empty space. A lot of these painting are also very formulaic, they were constructed for the court and the patrons of the artists presumably did not wish to be surprised, they knew what they liked and they expected their artists to provide it for them. Yet within these constraints the results are often breathtaking, especially when one examines the colour and when one peers closely at the paintings, as presumably one was supposed to do at the time given that they were to accompany text in books, often not huge books. Clearly the main economic motive of Persian

painting was to delight the patron, and yet a lot of other things are going on also in these paintings, a large number of ideas are explored and developed, as we shall see. In folk art also the main point is to please the customer, but often not a lot more goes on.

Islamic art is atomistic

In his essay on the Bobrinski kettle, Richard Ettinghausen suggests that the composition is atomistic, like Islamic theology and literature. Before we examine this view it is worth pointing out that many of those attracted to Sufi interpretations of Islamic art stress what they take to be the ability of such art to be holistic! But then we have already argued that these interpretations are wrong, so perhaps Ettinghausen is right.

He gives as evidence in literature Hariri's *Maqamat* from the sixth/twelfth century, which indeed consists of scenes from the life of Abu Zayd in no particular order. Then he refers to 'another feature which strikes us as extremely Islamic ... the contrast between shape and decoration. The static quality of the strong shape ... is entirely dissolved by the decoration ... the static quality of the shape conflicting with the movement in inscription and figural friezes'.[28]

The apparent clash between form and decoration is an important feature of much Islamic art. It arises in the features of carving on the walls of buildings like mosques and palaces, where the very elaborate and repetitive decoration makes it difficult to identify a form, in the sense of a subject. We are not sure what is framing the decoration, or whether the decoration is itself what it is about. According to Ibn Khaldun (d. 808 AH/1406 CE), the great classifier and codifier of different kinds of civilization, as civilizations become more complex, they become more sophisticated at decoration, which seems plausible. After all, the techniques which have to be learned for decoration to be successful and complex are not easily acquired, and certainly not quickly acquired. But the playing off of form and content is an even more complex skill, and one imagines that there must have been both discussion, tuition and experimentation before it was brought off so successfully in so many different art forms. It might be argued that the point of dissolving form is to make it inappropriate for the audience to look at the walls, but rather to concentrate on their prayers. There is no point in their looking at the walls because there is nothing there to concentrate on, just a repetitive pattern. This is an implausible argument. For one thing the decoration just cries out to be looked at, its beauty is such that one cannot but concentrate on it, and surely the artist did not spend the length of time he did on it in order for it to be ignored once it was noticed. Secondly, this sort of skill is not only displayed on the walls of religious buildings but also on metalwork and ceramics, which surely can and should be looked at and admired. The

craftsmen who produced these items often left their names on them, they were clearly and rightfully proud of what they had done, and expected their audience to notice it. With a small item the skill of the artist makes the whole object the subject of one's attention, as opposed to one part of it. This is the opposite of atomistic, although Ettinghausen is right that atomism is an important doctrine in Islamic philosophy and theology. The impact of this decorative skill is holistic, and as one turns a plate around in one's hands which has a repetitive floriated design on it, for instance, one concentrates on the plate as a whole, not on some single subject that the plate is 'about'. It might even be said that the rather minimalist design ethos in much Islamic art serves to emphasize what is actually there, since the understatement is effective in precisely that way. The slogan of minimalism 'less is more' is based on this idea, and one might even suggest that the very different forms of artistic representation produced by early Islam were a minimalist reaction to the existing forms of aesthetic production.

It is not necessarily the case that a belief in the ability of calligraphy to carry out all the functions of the aesthetic is a minimalist strategy. For one thing, many modern calligraphers introduce a great deal of complexity into their work, filling the page with shapes and images that betray the calligraphic framework. Of course, there is a long tradition of zoomorphic representation of letters, but this has in the past been an example of the artist's virtuosity, a trick, which like the *tughra* or official seal of the Ottoman sultan represents the control that the calligrapher has over his material. The calligraphy itself is usually excellent, and the calligrapher able to continue practising his art in line with the tradition, but the desire to be modern and up to date overcomes the satisfaction to be felt by working in line with the norms of the art. The argument here is not that there is no point in trying to innovate in calligraphy. Clearly there is a point in such a project, and the various styles which have developed are themselves the results of such innovation. One could not close the door on further innovation and surely artists should try to extend the boundaries of the tradition, although there is no need for them always to be trying to accomplish this. But what we find in much modern calligraphy is a playing about with words and letters in an entirely arbitrary way that really does not advance our understanding of how such symbols can be used. In particular, the slogans themselves are often precisely those of kitsch, ranging widely over the platitudes of world civilization. When a word is the subject then it is generally something like 'peace' or 'war' or 'happiness', and is no doubt designed to induce in the viewer a warm feeling of pride in the ability of Arabic lettering to illustrate a concept in this way and also to recognize the universally valid display of emotions towards the concept in question. Concepts we are supposed to appreciate are given warm and cuddly forms, while the reverse is the case for those we should fear. It must be said yet again that the work is very skilful, in the way in which the painting of Nelson

Rockwell is very skilful, but it does not extend our grasp of the subject of the design. On the contrary, it merely confirms our existing beliefs and has all the intellectual challenge of a soft doughnut.

A lot of discussion takes place on the beauty of Islamic architecture and artefacts, and rightly so. But there is also plenty of kitsch. In particular, the visual arts are mediators of religious ideas, and religious art provides the artists with an established tradition within which they can illustrate a certain topic. This is particularly the case in mosques which are far from the heartlands of Islam, in Europe, say, or North America, and here there is frequent use of photographs and posters of the Ka'ba, the Prophet's mosque in Medina, the Dome of the Rock, the mausoleum of Husayn in Kerbala, the selection of these images obviously depending on the precise doctrinal and national orientation of the community. These pictures are inexpensive, mass-produced and so glossy and perfect that they are rather banal. Actually, the familiarity and monotony of these images enable them to inscribe their message more precisely that this is an Islamic holy space, even though the building itself and the town outside it may seem very foreign to Islam. The photographic image takes the mind of the worshipper away from his immediate surroundings to an idealized Islamic space, idealized because these images are always embellished, glossed and retouched. The objects are presented in perfect condition, untouched by time and use, and even the people in the pictures are only there as part of a group, thus emphasizing the notion of the *umma*, the Islamic community. One thinks of kitsch here because these images are both nostalgic and familiar to the worshippers, a characteristic they have because of their repetitive and conventional nature. They provide a feeling of belonging somewhere, as being part of an authentic and lasting tradition. They reassure because they do not take risks, they link the local with the global and thus reassure again because they relate the individual worshipper to the Islamic community as a whole and probably to his or her original environment, or some imagined environment with which they would like to be associated.

One of the best examples of contemporary Islamic kitsch is calligraphy. The Arabic word for 'peace' forming the structure of a dove, for example, is a particularly popular design on many T-shirts. Technically these examples of calligraphy are quite wonderfully expressive of the virtuosity that the calligrapher can display. It is generally kitsch, though, a playing around with some rather obvious designs and themes in order to illustrate a text, often banal and grandiloquent, so for example we have five versions of a dove for 'peace'. We have lots of 'marching' letters and words for political concepts such as 'liberty', and some very thick and powerful shapes towering over many smaller and thinner words in the work of modern calligraphers such as Hassan Massoudy. These political words which refer to important concepts are then seen to

dominate space in a rather thuggish way. This is kitsch because of its use of obvious associations and its crude use of exoticized design. Like most kitsch it is certainly skilful, but limited in what it can portray.

Calligraphy is the supreme Islamic art

There is another point that needs to be made in criticism of the idea that calligraphy by itself can be enough to satisfy our aesthetic cravings. Perhaps words and language can themselves be enough, but calligraphy is far more than just the reproduction of words and language. It is precisely not the beauty of the meaning of the words which is presented in Islamic calligraphy, nor is it the beauty of the language that the words comprise. It is the beauty of the shapes and style itself, which has nothing to do with the words. Of course, that is not what is generally said, the writing is represented as secondary to the topic of the writing. The proof of the argument that it is the writing and not the meaning of the text which is the chief aesthetic issue is easy, since the writing can be enjoyed by viewers who have no idea what the writing actually means.

A point which Anthony Welch and Schimmel make time and time again is that the letters of Arabic were taken to have a significance far beyond merely being parts of a language. There is supposed to be a resemblance between the form of the Prophet's name and a worshipper bowing in prayer, this was often remarked on, and hardly irrelevant to a religion called *islam*, or surrender. Similarly the name of God and part of the *shahada* – 'There is no god but God' – consists largely of ascending vertical letters. Often letters are compared with people or parts of the world, and are seen as having a significance much wider than just being letters. One might be sceptical of this, it is not difficult to draw resemblances between comparatively simple marks on paper and three dimensional objects. The shape of the letters are sometimes used as an aid to meditation, as the individual worshipper concentrates upon one aspect perhaps of a word or a letter. If both the words have a meaning and the letters themselves have a meaning, presumably the same meaning, does not this result in over-determination? One might wonder why the words were not strong enough in themselves to put over the point they are supposed to communicate. It should be clear that what is being suggested is not that the words can be physically organized in certain ways to emphasize a particular point, but that the letters out of which the words are constituted are themselves aspects of semantic design, they themselves have a meaning and are there to communicate with us just as the words are. Presumably the argument would be that just as we may derive meanings from the words and sentences, we may also derive meanings from the words and even letters as physical objects. This is to take very literally the idea that the parts of the suras are *ayyat Allah*, signs of God, not just as meaningful

words and phrases but also as meaningful letters. Sufis of particular kinds certainly meditate on the form of letters, in just the same way that they might on passages of the Qur'an or indeed on just about anything which they regard as a sign of divine presence.

We should be careful here before we accept this theory as unproblematic. After all, other religions also think that there is something very special about the letters in which their central religious texts are written, and use those letters in meditation and spiritual development. Since all these letters are different from each other, it is difficult to see that any particular letters can be especially appropriate to such a task. Of course, if one sees the world as replete with signs of God, as the Sufi does, then there is no problem in seeing letters as signs of God, but then everything is a sign of God anyway, so this attitude to letters does not really tell us anything about the letters as such. Another reason to be concerned about the letters thesis is that it might be regarded as a form of *shirk* or idolatry. The letters themselves might be seen as having particular power, and then might serve in amulets or as protective lettering, and this might suggest that it is the letters that help us, not God, when things go well.

There is a relevant discussion by Derrida on logocentrism. Derrida argues that the dissociation of words from their meanings is not something we should think is inevitable, although it is a characteristic of what he calls Western culture. There are examples of the shape of words and the combinations of words in poems and slogans having a significance over and above their actual meaning, and of course there is also a tradition of the magical manipulation of words and letters as symbols. It would be wrong to suggest that these were ever very important aspects of Western iconography. On the other hand they might be regarded as more significant features of Islamic aesthetics, in that the writing is often taken to be more than just writing, but the very appearance of it is highly significant. Different calligraphers are rightly regarded as master crafts-men because of the excellence of the work they can accomplish, and it cannot be the meaning of the text which is so impressive, since that is acknowledged as impressive in itself without any embellishment or particular written or oracular performance. To a certain extent the role of Islam as the newest monotheist faith may have led to the search for an alternative approach to representation, and the challenge to logocentrism was gladly picked up and developed in an attempt at drawing a real distinction between Islam and the older competing faiths. What we should be careful about is taking writing at face value as writing. Just because calligraphy is writing, and consists of words and sentences which can be read, it does not follow that the meanings of those words and sentences are what the words and sentences are all about. On the contrary, the meanings have little or nothing to do with the aesthetic meaning of the drawings of the letters themselves, which sometimes indeed are literally (a useful word to use

here) unreadable, and often difficult to read. Some styles of kufic and shikasta writing are deliberately illegible, and perhaps doubly beautiful. In Persian ceramics the slogans are sometimes imposing (e.g. 'devotion fortifies actions') and are matched by the grandeur of the writing, which is sometimes foliated and plaited Kufic, where evenly spaced palmettes span the width of the pot and are connected by a fillet. What is particularly noticeable in much of this work is the clarity of design; some of the slogans on pots are written quite beautifully and yet are in themselves banal. They may well refer to the artist and to the commissioner of the pot, and yet the style in which they are written would make one suspect before one reads them that some weighty sentiment is being expressed. What is going on here is indeed writing, but the content of the writing is of little significance, it is the form which is all important, quite the reverse of logocentrism.

Derrida criticizes the anthropologist Levi-Strauss's claim that the Nambikwara tribe do not write because they only draw on calabashes. This is an excellent example of a thinker (Levi-Strauss) not being able to notice what is in front of him because of the preconceptions which dominate his thought. Levi-Strauss reports that they name writing with a word which means 'drawing lines', and this has an aesthetic interest for them, but only an aesthetic interest. They have no idea what writing means or what the anthropologists are doing when they are writing in their notebooks. Is what they do really writing? Derrida in his commentary on this passage says it is, albeit not writing in the complete sense that we know writing. When they get paper and pencil for the first time they have no idea what to do with it, but after a bit they draw wavy lines, which is what the Europeans seem to be doing, so they copy what they take writing to be. Interestingly, some craftsmen obviously did not understand Arabic because when we see what they wrote on pots and paintings they have obviously copied what was in front of them, and this was not always accurate. For the artists it was just a system of wavy lines, one to be reproduced, but with a meaning very remote from them. Were they really writing Arabic? Yes they were although often without understanding it or realizing what was wrong with what they were doing, when they got it wrong.

Just because calligraphy is writing we stress its relationship to the language in which it operates. But it may not be language which is important to calligraphy, paradoxically it may be that this is the least important aspect of it. Sometimes it is obviously done by artists who do not understand the meaning of what they are drawing, but interestingly in these cases the style is often poor and crude, since these writers are not sure enough of the style which they are using to make a success of what they do. On the other hand, some of the most beautiful calligraphy on pots is banal in its meaning. Many of the slogans are obviously good luck phrases ('Perfect peace, and happiness, and health, and

tranquillity, and generosity, and mercy to its owner') and we sometimes get the name of that owner and the craftsman who made it, and even the date it was made. These are hardly sayings of great spiritual depth, but even where we do find Qur'anic or other religious phrases we may wonder how they were used. For example, a plate with 'God' written on its base is a lovely physical object, and the calligraphy is wonderful also, but one wonders whether the user of the plate is supposed to ponder on the existence of God as he or she cuts an orange on it, or drinks soup, or puts something on his bread. It might be that these religious references are a reflection of the Qur'anic aya 'Everything perishes except His Face' (28.88) or the idea that his face is everywhere (2.115). Many have suggested that the frequency with which religious phrases are used is a sign of the deep religious sensibility of the population. They sought to be constantly reminded of God, even when eating and drinking, bathing and relaxing. Perhaps they did, and some of the sayings are very witty. There is a Persian plate which has the words around the rim 'Knowledge is bitter at the beginning but sweeter at the end'. But many of the sayings are banal, and yet the objects and calligraphy is still very fine. What one admires today, and probably in the past also, is what we see of the artefact and on the artefact. The meaning of the text is not even secondary, it is just irrelevant to it as an aesthetic object.

This cannot be right, one would think, since how could someone use a Qur'anic text and not want it to inspire the user of the artefact? Would it not be wrong to use such a text as mere decoration? The difficulty with accepting this objection is that we are then in the position of having to explain all those artefacts which do not have religious sayings on them, but which mention the artist, or praise the owner, and we have to ask whether those phrases are being used as more than decoration. We might suggest that the religious phrases are used as more than decoration, the secular phrases as mere decoration, but this is implausible. It means that we have to think of someone contemplating two beautiful plates, one with religious and one with secular writing, and take what are physically two equally beautiful pieces of calligraphy differently. This is logocentrism indeed! From an aesthetic point of view the meaning of the words is irrelevant, although from a spiritual point of view the meaning is highly significant. To believe differently would be to suggest that when one finishes off one's bowl of soup and finds the word 'God' at the base one has different aesthetic views of the artefact than when one sees the words 'Made by Salih' on a very similar bowl. Surely the best way of seeing this sort of situation is one where the individual admires the grace and skill of the work, including the calligraphy, and may attribute both linguistic expressions to the power of God. Why should not Salih be proud of his work and sign it? We should respond by admiring what we see before us, if it is admirable, and suspend our assessment of what the letters mean to a different occasion, when that becomes a relevant issue.

But are not the letters a part and parcel of the whole aesthetic object? Are we not supposed to read the words and the image together? Sometimes this is plausible. For example, there are many Persian ceramics which have poems or affectionate greetings written on them and the words clearly relate to the artefact. A plate which shows what was a common theme in Persian visual language, Prince Khusraw watching a bathing Shirin, obviously makes some reference to the poem by Nizami in which this event occurs, and the words and the image fit nicely together. Similarly a Persian jug which bears an amorous verse on it making reference to the lips of the lover has a slogan relevant to the function of the artefact itself. But even in these cases where the words and the object are closely linked they still do not have to be read together. The object can be enjoyed as the object it is without any attention being paid to the words, and the words may be admired for being splendidly composed quite apart from their use on the artefact. Most visitors to museums in which such objects are displayed are unaware of these wider cultural issues since they have no idea what the words or the symbolism means, unless they read the labels. Even reading the labels will not help them unless the labels have a lot of information on them, so perhaps they need to read the guidebook. Do they have to read the guidebook to be able to appreciate the objects aesthetically? In spite of what the museum shops will no doubt say, the answer is no. The beauty of the objects is apparent to any viewer, however much he or she may know or not know about Shirin, about Nizami or about the meaning of the words on the ceramics.

It is important to make this point because many advocates of the 'calligraphy is the supreme Islamic art' point to the ubiquity of writing on artefacts and also to the fact that much painting is accompanied by texts. This suggests that writing is very important for what is taken to be the Islamic aesthetic consciousness, since writing is everywhere. It is worth emphasizing that the artefacts and paintings are predominantly secular objects, whereas writing is clearly highly relevant to the purpose of religious art, in a religion like Islam which is based on a book. If on even ordinary objects like plates we find the name of God, and if there are religious references in a whole range of ordinary objects, then this shows how for the Muslim writing is the supreme art form. It also suggests that the distinction between the secular and the holy which is made by those in many other religions does not apply to Islam. After all, if references to religion are found everywhere, does this not show that religion is the most important factor in the lives of everyone in the Islamic community? This fits in nicely with the Sufi principle that the distinction between the sacred and the secular is basically unreal, and that if we look hard enough at the latter we shall discover that it is really the same as the former.

Impressive though this principle is, there is no need for us to accept it. There are a number of different ways of assessing objects. Scholars obviously

examine them thoroughly, compare them with other similar and dissimilar objects, turn them upside down, measure them and so on. This is not what we normally do when we look at an object. We look at it from a particular perspective and are not that concerned as to whether it might look different from other points of view, or whether we have examined it in detail to ensure that we have not missed anything which is there to be noticed. More importantly here, to see an object aesthetically we just have to see it, we do not need to know anything much about it at all. That is not to say that increasing knowledge of it might not reveal additional aesthetic features, it might, but what is crucial is what we call 'the object'. Provided we can see enough of it to form some sort of judgement, we have done enough to satisfy the basic criteria of aesthetics. We can reject the idea that the writing is vital to our aesthetic understanding of what we observe. It is just another detail of the work. Sometimes it is significant because without it the work would be incomplete. This is particularly the case for some slogans which in themselves are banal, but which are beautifully written and an integral part of the design of the whole object. On the other hand, some religious and poetic formulations which in themselves are beautiful and profound may be inessential to the work visually, and so need not be part of what we take into account when we assess it aesthetically. Calligraphy needs to be put in its place. It is not the supreme Islamic art.

There is a horror of the empty in Islamic art

Abdelkedir Khatibi and Mohammed Sijelmassi, suggest that 'Two prejudices which are commonly held with respect to Islamic art are its aversion to empty space ... and the completely gratuitous nature of its use of geometry'.[29] These are both comments on space and the organization of space, and although they describe these as prejudices they do not appear to disapprove of these views. That is, they seem to accept that Islamic art dislikes empty space and has a very positive attitude to geometrical shapes, perhaps even when the latter are not naturally used within a particular context. The idea that there is an aversion to empty space comes from the fact that much Islamic art is highly decorative and elaborate, and the space which is available to the artist is heavily used. The use of the arabesque and geometric shapes encourages this, since the more they are used in the space the more interesting shapes and combinations of spatial concepts may be displayed.

Richard Ettinghausen[30] argues that the horror vacui in Islamic decoration is due to three factors.

> i. Life in the cities was crowded and this was seen as natural and appropriate to civilization.

So art itself as the prime result of civilization should be similarly crowded. This does not seem to be a very plausible argument. After all, today most people in the West live in crowded cities, and most art is produced in that environment. Yet many people, including many artists, value highly empty and deserted environments. It might be argued that the more crowded one's normal environment, the greater value one places on what contrasts with that, the empty. Certainly today much art does celebrate emptiness, and a recent winner of the Turner Prize (2001) Martin Creed won with an installation called 'The Lights Going On and Off'. One of the wonderful things about this installation, which consisted only of a light going on and off in a room, was that it did not change the environment at all to make whatever point it was making, apart from setting aside a room and having a light going on and off. Apart from the other people coming to see it, the space was fairly empty, and that is the case for much contemporary art. In particular, galleries generally display work in very spare ways, so that there is a lot of space around the work and between works. One of the pleasures of such exhibitions is stepping into them and leaving behind a crowded and busy city, where space is intensively used, and being in an environment where space comes to be felt, as it were, since the subject of the exhibition is often so understated that one looks elsewhere for the context within which it has meaning. That context is often emptiness.

ii. The emptiness of the desert and rural environment was something to be avoided, and in art not using up space looks like the artist has no ideas or insufficient skill.

This is an interesting suggestion. It is certainly true that Arab culture in particular seems to have had a far less favourable attitude to the desert than those coming from outside of it who ended up becoming captivated by the wide open and dangerous spaces of the desert. It is difficult to know how Muslims in the past experienced their environment, but certainly travelling was much more dangerous and difficult than today. The pilgrimage to Mecca, the Hajj, could take years, whereas today pilgrims generally just board aircraft for most of the journey. The experience of spending a long time crossing tedious wild areas would have been a common experience at the time for those who did travel, and of course most people did not travel far at all from where they were born. People did travel extensively, though, and not just for the Hajj and in order to earn a living, but also to escape death at the hands of hostile armies or disease and famine. Those in the cities often had their roots in the countryside, from where they had travelled, and if they were engaged in commerce or learning they would quite possibly need to travel to other cities.

It is difficult to read any particular aesthetic attitude into this sort of life-style, though, since it is not the emptiness of the desert which is so significant, it

is the fact that people had to travel such long and difficult distances. In any case, it is not clear that the desert looked empty to those accustomed to it, since for them the desert is a familiar environment. It only looks empty to those who are coming to it for the first time, once one is accustomed to that environment it becomes quite rich in detail. Again, it is difficult to accept the suggestion that the experience of the desert had any particular effect on attitudes to emptiness.

 iii. The Islamic/Arabic tendency for exaggeration is best displayed aesthetic-
 ally by very busy designs

This is a highly patronizing suggestion, and surely there is no evidence for its truth. There are many examples of sparse decoration in Islamic art, so it is just wrong factually. On the other hand, it is true that there are many instances of arabesque and other forms of ornamentation that cover absolutely the vast majority of the space which is available to them. Pages in books are crammed full of writing and marginal decoration, the inside of buildings is often very elaborate, with immensely detailed fretwork on the wood and complex mosaics, carpet designs and so on. Persian miniatures are often on pages which are crammed with things going on, and where there is empty space this is impinged on by the text which accompanies the pictures. Artefacts are full of decoration, geometric designs vying with writing, and the form of the object is often highly detailed as well. Arabic and Persian poetry is frequently grandiloquent, and is not nervous of using exaggeration in its descriptive mechanisms. One of the best indications of this tendency are the titles given to people. The painter Muhammad Isma'il Isfahani signed his work of 1275/1858 'the work of the humble Isma'il, the Painter Laureate' ('amal-i-kamtarin Isma'il Naqqash-bashi'). The painter Mu'in Musavvir is called 'His Highness the rarity of his time, Aqa Mu'ina'. (It is worth putting these grandiose titles within the context of artists who humbly attributed their skill to God, while allowing themselves to be described as though their talent was very much their own.) If these are the titles given to the humble artists, it is not difficult to imagine the flights of eloquence devoted to the rulers, their patrons! A steel and gold begging bowl made for itinerant Sufis by ibn 'Abbas has his signature and then at the end of a longish poem the words "Abbas is a celebrity in seven regions of earth'.[31] Yet Sufism emphasizes the importance of humility, as does Islam itself. Would it not have been more appropriate to keep the bowl as simple as possible and have nothing written in it? Why is there this apparent urge to fill the space up completely, and make grandiloquent references to the writer? Similarly, there are few empty periods in music, even when most instruments have stopped, one or two often carry on playing until they are joined by the others, and a singer may stop singing for music to continue, and when the music stops the human voice takes over for a bit.

All this is true, but it is far from the whole truth. There are many examples in Islamic art of a very spare attitude to design. For example, the use of calligraphy on plates is often very restrained, with just one word being repeated around the edge, or even just one word at the centre of the plate. It is often noted that the exterior of mosques are often very plain, and actually the interior is also frequently very empty, something that was much commented on by the orientalists in the nineteenth century as contrasting nicely with the interiors of Catholic churches. Some paintings and book illustrations are relatively empty also, consisting of just one person, or an animal, or a plant, and that is all. The shapes of early Islamic pottery are not many, and are simple. Although the colours used were often elaborate, the shapes were not. It has often been pointed out that the decoration of many such artefacts serves to contrast with the line on pots, so emphasizing the simplicity of that line. Finally, it has to be said that in literature there are many examples of spare prose and poetry, and more important perhaps than the actual text is the form of the text. This is often simple and avoids over-elaboration. In music the basic structure of the scale was debated for a long time, and the debate was over which sort of scale would be the most expressive, would allow for the greatest virtuosity and improvisation, not which scale would allow least silence into the period during which music is played.

It is important to rebut the sort of essentialism which looks to a theme or style running right through Islamic art, as though these define that art form. If there were such themes or style then of course we could use them to define the form, but they do not exist. Is there then nothing different about Islamic art as compared with other forms of art? Well, it is a matter of emphasis. There are stylistic features in Islamic art which occur in many other art forms, but not to the same extent, and there are themes which occur far more in other art forms than in Islamic art. It is worth noting these differences, but it is also worth noting that they do not define, they suggest differences. From such differences no very general differences in belief or thinking can be deduced. For our purposes here there is no evidence that there are specific differences between Islamic and other kinds of art, which means that we need to use distinct aesthetic or other conceptual machinery to analyse Islamic art. Ibn Rushd may be correct when he criticizes his peers for their tendency to see things in the most positive light possible – 'Oh Arabs, you have made everything look good, even retreat'[32] – but there is no reason to think that this is anymore charac-teristic of Arabs, or Muslims in general, than among other cultural groups. One of the most potent symbols of poetry and literature in Arabic in the last fifty years has been the Nakba, the catastrophe which resulted in the formation of the State of Israel. This retreat has not been made to look good, on the contrary its implications for the Arab and Islamic world have been endlessly discussed

and explored aesthetically. We shall look at some examples of this later on, and of other techniques in Arabic to deal with disasters. At this stage we need to remind ourselves that when ibn Rushd referred here to the Arabs he meant the Arabs and not necessarily the Muslims. The Arabs of the *jahiliyya* period, the time of ignorance before the advent of Islam, were well known for their love of poetry and grandiloquent language of all kinds. That is why God presented his message within the form of perfect language in order to make it easy for them to accept it, and we shall also come to see how this argument works when spelt out in more detail.

2

God as creator, calligraphy and symbolism

Is God the only creator?

According to Abdelkedir Khatibi and Mohammed Sijelmassi

> a Muslim artist – constrained as he is by a general prohibition preventing any figural treatment of the divine or human countenance – must return to the fundamental theory which asserts that everything must pass through the sacred text, and return to it again ... The Muslim artist constructs the semblance of an object (for only God can create) ... he initiates an esoteric spiritual art which fills the void ... calligraphy of the absolute ... parabolic geometry of the divine. Hence the thrilling example of the arabesque ... This leads to the general conclusion that the significant factor in Islamic art is ... a drive towards absolute sanctification.[33]

Is it really true that only God can create? If it is true, what are the implications this has for Islamic aesthetics? There is a prolonged discussion in Islamic theology about the way in which God's action encompasses every other kind of action. The Ash'arite theologians developed a theory of *kasb*, acquisition, according to which only God really acts, and our actions are in a sense *acquired* from divine action. The precise mechanism here is a matter of debate, but what is important is that there is a strong sense in which everything that happens is a result of what God does, including our our own putative actions. The Qur'an itself frequently refers to the overwhelming power of God, and the fact that what happens will be a result of that power, and so the implication is that really it is God who does the acting, not us. On the other hand, it has to be said that there are parts of the Book which do give scope to human beings to act, we can choose to believe or not, we can accept guidance or reject it, we can decide whether to be good or evil. If it is really God who acts in all these cases, it is difficult to know what to make of the possibility of human choice or the reward and punishment for human actions which results from that choice. Of course, this is hardly a new problem in theology, reconciling the power of God with the power of his creatures is a traditional point of controversy in theology and the philosophy of religion. So Islam is not in essentially a distinct position as compared with any other monotheistic faith.

There are at least three terms for creation. *Khalq* relates to creation in the sense of conceiving of the possibilities of things, and suggests that the creator is aware of a range of possibilities which lie before him as candidates for existence. *Bari'* is all about production and *musawwir* involves the embellishment of forms; it most often relates to artisans and architects,[34] and a word for painter in Arabic is *musawwir*. The range of different names for God which stem from the language of creation and creativity are sometimes taken to imply that the only real actor is God. There are many such statements in the Qur'an and other texts, and they can be used to argue that mimicking the creativity of the deity, albeit on a much lower level, through art is impious. The painter is regarded often as an imposter, someone trying to compete with God as a creator. According to one hadith, owning pictures is like having a dog in the house, and the Prophet and his angels would avoid such a place. But Sa'adi and Rumi argue on the contrary that the artist is actually a valuable member of society in that he represents the creativity of God in his, i.e. the artist's, work, imperfect though the efforts of human beings may be when compared with divine action.

It used also to be argued that one of the reasons for the relative lack of wealth among many Islamic communities is the fatalistic attitude that is fostered by Islam, the idea that all action is really the responsibility of God and all we can hope for is that he will act well on our behalf. There was a time when writers on Islam argued that Shi'i Islam is particularly fatalistic, and so Shi'i Muslims rarely set out to change the nature of the regime under which they live, nor even protest at what they see as injustice. After the Iranian Revolution the line soon changed, and it came to be argued that the Shi'i were especially militant, as compared with Sunni Islam. Both positions are well off course. Many Muslims value greatly the virtues of *sabr* and *tawakkul* without at the same time asserting that political action is vacuous. In situations where it looks likely that political action can bring about a beneficial end, few Muslims would eschew politics. Similarly in the personal sphere, God is not seen as doing everything for us, if he did there would literally be nothing for us to do. God surely expects his creatures to take steps to pursue their own ends, while at the same time acknowledging that it is God who will ultimately determine whether we reach those ends. One of the real difficulties with accepting this position is that it places the individual believer in a bit of an epistemic pickle. If he acts too energetically on his own behalf it looks as though he does not really trust in God to carry out his plans. If he does not act sufficiently energetically, this could be because he expects God to pull his chestnuts out of the fire, as it were, without human effort being important. Many religions have to negotiate a difficult line between these two extremes, and Islam is no exception.

Implications for art

What is the relevance of this to art? The idea that artistic creation is banned in Islam because only God can create is entirely wrong. God's pivotal role as creator does not invalidate human attempts at creation, although no doubt what we mean by creation when it is carried out by human beings is very different from divine creation. This also is a very controversial issue in theology, the link between our use of language to describe an attribute of God and its use of the same term to describe a human attribute. It is often argued that the difference between God and his creatures is not just a difference of degree but rather of kind, so that what it means to say that God creates is entirely different from what it means to say that we create. Indeed, linking those two uses of the term 'creation' can be to run the risk of *shirk* or idolatry, because it is associating God with partners, i.e. human qualities such as what we mean by creation. On the other hand, to deny that by creation we mean something very similar when we compare God with his creatures is to run another risk, that of failing to provide a meaning at all for God and his attributes. Yet again the sign of a successful theologian will be someone who manages to reconcile these two positions and finds some point of convergence. There are several such positions, and perhaps the most plausible is that of ibn Rushd. He argues that when we apply a predicate to God and to his creatures, when it is applied to God it is used paradigmatically. God as creator, then, represents the perfect example of creator, in that he is entirely unconstrained in his creation by the nature of existing matter, for example. His creatures, by contrast, can create but we are very limited, we need something to create out of and our ideas about what to create are limited. Actually, ibn Rushd implies that God is also limited in his creation by his nature, he cannot just create anything at all. He has to create that which is the most perfect and rational. So he had no choice about how the heavens are to operate, according to ibn Rushd, he has to arrange them in the most perfect and beautiful way. But at least he knows immediately what is most perfect and beautiful, whereas we have to cast around both to realize these conceptions and even to understand them.

Implications for Islamic art

The idea that the geometric or the use of letters came to be valued in Islamic art to replace the figure, which could not be represented for religious reasons, is just wrong. There are an enormous number of representations of real physical objects in Islamic art, and even the calligraphy is sometimes used to represent such objects. That is, letters are constructed and grouped together to represent deer, or birds, or some other kind of creature. This is often interpreted as expressing the visual through the literary, as replacing the image with the words,

but there is another plausible interpretation. The beauty of calligraphy often results in the letters on the page looking like something quite other than the letters themselves, and even perhaps other than what the letters mean. We should not get too entranced by this idea of the sanctity of the text and the letters out of which the text is constructed, even where the text is the Qur'an. The beauty of the whole calligraphic composition may draw the mind to something entirely different from the text itself, to a free enjoyment of line and proportion, and its interpretation as the representation of a particular text may have very little to do with its aesthetic appreciation. After all, one may admire the style of calligraphy without knowing anything of the meaning of the text, and it is worth saying that even Arabs often find the text and the words impossible to understand, given the exaggeration of the characters and the arrangement of the letters. The conclusion might well be that the point of the composition is not primarily to display the sentiments expressed by the words, but to play with the possibilities implicit in the graphic qualities of the letters and words themselves.

The theory which has for a long time played a huge role is that calligraphy is so developed because of the absence of a representational tradition in Islamic art, because of theological difficulties in representation and because the Arabic language, and the Qur'an at the heart of it, is so significant in Islam. None of these propositions is true. There is no reason why representation could not be used in Islam from a theological point of view, and indeed it often was used. There are significant traditions of representation in the Islamic world. Finally, and perhaps most important, there is nothing so significant about the language of the Qur'an which makes it the sole repository of aesthetic concentration in Islam. To argue in this way is to ignore the whole tradition of Islamic art, the mosques, paintings, pottery, songs, music, gardens and literature. These are full of representation and creativity, they glory in the virtuosity of the artist and the ability of the artist to produce a sublime object. It is this love of simplification which has brought the understanding of Islamic aesthetics to the sorry state in which it exists today, and it is the purpose of this book to prick holes in this leading paradigm. When it is held up to the light even the notion of a straw man seems too substantial. Where is this drive for 'absolute sanctification'? It exists solely in the imagination. The letters which we see and enjoy in the major works of calligraphy are wonderful works of art because they are in themselves beautiful objects to observe. As it happens, if we understand the text we understand that they make up sentences which are equally beautiful. But this is irrelevant to our enjoyment of them as art objects, they could be laundry lists. (One of the most beautiful examples of calligraphy I have seen is on the base of a plate and says 'Made by Salih'.) A letter first of all is just a line, a line drawn on something, or even drawn in the air, and it has a form regardless of what if anything it 'represents'.

There is no drive for absolute sanctification behind Islamic calligraphy, just a pleasure in the beauty of the shapes and patterns that are produced on the page. Of course one might say that the point of all art ultimately is absolute sanctification, but there is no reason to think that this is true, nor that it should be accepted as true by anyone who did not share one's religious or aesthetic beliefs. The point of writing philosophy is to try to argue for conclusions which do not rely for their validity on the shared traditional understandings of the participants to the discussion. That is what the Islamic philosophers themselves called dialectic or even rhetoric, and which they quite rightly regarded as a lower form of proof and argument compared with the demonstration of deduction itself.

The legibility issue

When discussing a page from a late eleventh-century Iranian Qur'an, Antony Welch says, 'To the unknown scribe, aesthetic criteria were more significant than easy legibility'.[35] In fact, the scribe has added naskh letters to the kufic text in order to identify some of the harder characters, and in this copy he kindly adds vowels and diacritics in red, which contrasts nicely with the black of the kufic letters. Naskh is a much easier style of writing than kufic to read. Kufic on the other hand is easier to carve into stone, since it is much more angular and less fluid than naskh. For this very reason no doubt, much of the calligraphy in stone is naskh, to emphasize the skill of the artist in overcoming the unnaturalness of that form of writing in that medium. In some early Qur'ans there are no diacritics, the marks below letters which indicate precisely what the letter is. Many letters in Arabic are identical in shape to entirely different letters, only the mark below or above it indicates what it is precisely. An additional difficulty in reading is that kufic letters are arranged to emphasize grace not legibility. Some words, for example, are broken up very problematically from a textual point of view, but effectively aesthetically. As Ettinghausen has pointed out, the more incomprehensible because illegible a text, the more sacred it seemed. Schoolboys sometimes work on the same principle by trying to develop a complex and indecipherable signature, seeking in this way to establish a significant and mysterious persona. Actually, kufic is not always that difficult, because some of the words which are very hard to decipher do recur, once one has learned to recognize them once, it is not difficult to recognize them again.

Some calligraphy in ceramics is very beautiful but it consists often merely of stereotypical words of greeting or not really more than a secular proverb. Sometimes they are dedicatory eulogies to delight princes. Often there are serious mistakes in the Arabic of the inscription, which presumably went unnoticed, and this suggests both that the artist did not know Arabic and that his audience

did not examine the writing closely as a piece of writing. Still, the tradition respects purity, delicacy, firmness of brush, and there is no particular desire to display novelty.

The majority of Islamic decoration is abstract and infinite with an emphasis on floral ornament, especially in the form of the arabesque, and in geometric patterns. Figural art is limited to a stereotyped form and is largely limited to scenes of courtly life. Or so we are often told. But when we examine the range of pictorial art we find an enormous range of subjects are considered suitable for artistic treatment, religious topics along with the secular. Even calligraphy is occasionally constructed in such a way as to be representational. There is animated naskhi writing, for example. Letters are presented in such a way that in combination with other letters they produce images of animals. There are many depictions of animals in mosques and mausolea, and calligraphy often displays zoomorphic characteristics, even calligraphy including the name of God.

Central Asian silks

It is worth pointing out that many cultures which are not Islamic, nor even monotheist, have used designs that do not employ directly representational images. For example, the Central Asian silks often called ikats are very beautiful, and have in the last hundred years or so been produced in Bukhara and adjacent areas, extending as far as the Xinjiang province of China, Afghanistan, Uzbekistan and so on. While the production techniques often vary from region to region, the motifs are remarkably constant. Mottled background colours are used, and the patterns are often of concentric circles, flowers, pomegranates, tulips, trees, horns, birds and spiders, but generally abstracted. Sometimes the original image which has been abstracted is recognizable, sometimes it is not, and it is tempting to suggest that this failure to use direct images of nature is based on some religious motive. Yet in the Bronze Age the Altai nomads, who inhabited many of these very same regions, employed motifs remarkably similar to those found in Bukhara in the nineteenth century. And on top of it all we are told that the main manufacturers of such silk products in that century were Jews, not Muslims at all. The only Muslims who were involved in the Bukhara area were apparently Jews who had converted to Islam. Now, of course there is no reason why Jews should not make clothes in accordance with whatever design the majority inhabitants favoured in their clothes, and they did. But the idea that they were following designs that avoided direct representation to fit in with the religious beliefs of their customers is surely correct, and yet the clothes surely followed principles of design which were not Islamic, but rather traditional or national. Muslims wear the clothes which are appropriate for the culture of the country in which they live, and there is no reason why they should not have the

image of an animal, or a fruit or a tree on their clothes. The only reference to dress in the Qur'an instructs Muslims to be modest, and modesty may take many forms. It is not noticeably immodest to wear clothes with recognizable images on them, provided that the images themselves do not offend modesty, of course. One of the things we notice about the ikat weaves is that they often repeat the patterns we see on Uzbek kilims, Turkish carpets, or even of Timurid tilework on buildings. Cultures of all kinds tend to have designs which they associate with themselves, but we should be careful about reading too much into the design. The traditional clothes of Central Asia have features which have characterized the clothes of that region for millennia. There does seem to be a real delight in the abstract in design, and one of the features of this can be found in the Tajik and Uzbek wall hangings. The interiors of houses were often rather bare and they are greatly enlivened by carpets and wall hangings, the latter being used also to create rooms by dividing them, to cover doorways and to be parts of tents on important festive outdoor events. There is no attempt made in these wall hangings to align the pattern, a number of panels is sewn together in such a way as to maximize the clashing of the different patterns on the panels, or so it seems. Perhaps in this way the hanging became something of a focus of attention by contrast with the rest of the surroundings, and this was the intention, to direct the eye away from the general shabbiness of the interior.

We could quite easily construct a religious narrative for this form of interior design. We could say, for example, that the idea was to emphasize simplicity and frugality, not to make a lot of fuss about material possessions, and above all not to display materials with clear images on them since this is contrary to Islam. When we see how homogenous the design is within the culture we could then argue for an organic view of the culture as exhibiting a strong commitment to common religious beliefs and their associated aesthetic values. Well, there are certainly common religious beliefs in much of Central Asia, but the aesthetic values do not seem to have much to do with them. There is clearly a love for the abstract and when one examines the wall hangings this really comes out, since the arrangement of the panels defies any logic of trying to establish a common pattern or motif. That is the motif, i.e. the lack of motif. There appears to be a genuine attempt at putting together panels in entirely arbitrary ways.

Symbolism: Yusuf and Zulaykha again

We should be careful about reading symbolic value into what we see in too crude and simplistic a manner. I live in a town in the United States which is full of references to horses, since one of the local industries of major significance is the horse breeding business. There are pictures of horses in restaurants and shops, streets are named after racehorses, there are horse symbols on the mailboxes

outside houses, and little statues of jockeys in many front gardens. There are statues of horses all over town, and much of the news in the papers is of horses. Were someone to descend on Lexington, Kentucky from Mars and know nothing else about the place it would conclude from the evidence of what it saw that the local god was a horse. The visitor would compile a strong theory, backed up by much evidence, about the local religion, and would analyse the facts accordingly. Yet this theory would be wrong.

One of the ideas that lies behind this sort of theorizing about Islamic culture is the Sufi slogan *al-majaz qantarat al-haqiqa*, the apparent is a bridge to the truth. Sufism does not regard the ordinary world as illusive or imaginary, on the contrary there is nothing unreal about this world. But it should not be taken as the only form of reality which exists, since this world is only an indication of the nature of another and deeper level of reality. In his commentary on Jami's poem about Yusuf and Zulaykha, Pendlebury points out that one definition of idolatry is confusing the relative with the absolute,[36] and this is something that Zulaykha does throughout the story. Not only does she worship idols, but she is obsessed with Yusuf, and not with him as a person but with him as a physical being. She acts as though that (relative) factor about him was absolutely the most important, as though his material beauty did not hide a much more significant spiritual form of beauty. Once she learns that physical beauty is only an idol, and she manages to shatter it, her physical beauty is restored to her and she finally attains the object of her whole life, to live harmoniously with Yusuf. In his commentary Pendlebury suggests that this is a case of her abandoning the self, of coming to the truth and finally attaining peace. But interestingly there is a famous incident towards the end of the story in which Yusuf tears her clothes when he pursues her, clearly designed to contrast with the much earlier period when she tore his clothes in a similar activity. One wonders why he appears to be so passionate at a stage when we are told passion has been transcended for a higher spiritual plane. Perhaps it is a reference to the fact that while we live in this world our physical natures will inevitably involve us in such behaviour, and quite legitimately so if the relationship on which such behaviour is based is sanctioned by religion. Once Zulaykha had abandoned idolatry Yusuf could relate to her physically, and even passionately pursue her, since they were both now aware of the context within which carnal activities take place. They appreciated what these activities symbolize, and as such also appreciate that they are acceptable, at least while we are in physical form and participants in the world of generation and corruption.

How we interpret symbols is important. The Queen of Sheba was confused by the *sarh*, the glass floor in the palace, and she decided that her error there was an indication of a much wider error, and she decided to abandon idolatry and accept the King's religion. Zulaykha also abandons idolatry in the end, recognizing

that the mistake she made earlier, confusing physical with spiritual beauty, had made her life chaotic and meaningless. Like the Queen of Sheba she came to realize that her view of the world was only partial, and she exchanged it for what she took to be a more comprehensive and accurate view. What these stories share is an interpretation of a symbol, a recognition that some feature of the world which both women took to be real is in fact only a symbol of something which is genuinely real. But they also share the idea that discovering the real is a long and difficult process, requiring many different stages and trials. We need to bear this in mind, for without sophistication in linking the symbolic with the real we are likely to carry out the process in far too hamfisted a manner. When Zulaykha hears of Yusuf's death in Jami's poem she is distraught, collapsing, tearing her cheeks and hair, and eventually pulling out her eyes and throwing them on the ground! She has not really managed to abandon her passionate nature, and there is no tranquility in her response to tragedy, despite Yusuf's hope that tranquility would give her strength to bear his loss. The symbol of idolatry abandoned and piety acquired is suddenly turned upside down, and yet Jami does not disapprove of her actions. On the contrary, the plucking out of her eyes is taken to be her determination to be blind to anything except the object of her love, Yusuf, and her death, surely self-inflicted, as a noble determination to join him. She is buried in a shroud of green, the favourite colour of the Prophet, surely an indication of Jami's approval of her actions. She dies with her nose in the earth, just above Yusuf's body, and Jami reflects how lucky the lover is who dies in the aroma of union with the loved one, a bold statement given that shortly before this point Jibril had given Yusuf an apple from the garden of paradise so that he died with the smell of the celestial perfume in his nostrils. As a symbol of passion finally brought to book, as it were, Zulaykha is not an entirely satisfactory character. Similarly, even Yusuf is far from perfect, his response to Zulaykha after she becomes a believer betrays an interest in worldly matters which up to that time he had studiously ignored. It is actually the fact that the main characters in the book are not perfect exemplars that makes the poem such a wonderful work, we are dealing here with people who have personalities and who do not always fit into the stereotyped roles which we might expect.

According to Thomas Arnold, Islam did not develop a symbolic language. Ettinghausen doubts this. On the other hand, he thinks that symbolism is not of great significance within this tradition. In support of his view, he points to the fact that Islamic artists were often referred to as being pure, and the beauty of their works as the effects of this inner purity. This leads to a standardized harmony in the art, so 'It did not matter that arabesques, flowers, geometric configurations, inscriptions, and even the animals and human images suffered from a certain sameness of appearance which made them fall easily into familiar types.'[37]

All cultures have common styles and motifs, of course, but if it is really true that Islamic art has a sameness of appearance which explains its constant reproduction of stereotypes, then that really would be a serious criticism of it as an art form. Where is the virtuosity, we might ask, where the originality and the innovation which we might expect to exist within any respectable aesthetic tradition? The claim that Islamic art is mainly about calligraphy, geometry and a few standardized decorative motifs is a damning indictment of Islamic art as art.

As we have argued throughout, such a simplistic approach to Islamic art does not do justice to the subject matter. Islamic art is just as complex, sophisticated, varied in approach as any other art form, albeit working within the traditional approaches which it, like every other art form, has developed as part of its aesthetic. In his *Yusuf and Zulaykha* Jami at the end provides some advice to his readers, and one of the pieces of advice is not to go for instruction to what he calls 'raw Sufis'. He means by this those teachers who are not really aware of what is involved in spiritual development, and they will not provide the seeker after truth with appropriate training in how to proceed along the Sufi path. Raw Sufism has had a significant and deleterious effect on Islamic aesthetics. The idea that material objects are symbols and that they correlate easily with interior meanings is a symptom of raw Sufism. It means that when we wonder what those symbols are symbols of we need to attain that deeper level of awareness in which the answers repose. Now, sophisticated Sufism would regard this level as consisting of a range of potential explanations, not just one, and would delight in the ambiguity of the object and its aesthetic treatment. Unfortunately many who have written from a Sufi point of view about Islamic art and literature have a fairly narrow understanding of what is involved in aesthetic explanation, and once they have argued that what is before us is a symbol of a deeper reality, the problem is then for them solved. All we need to find out is what the deeper reality is, and then all is clear. But in fact once we know what the deeper reality is, the discussion really starts, for the connection between the object and that reality is both complex and tenuous. As we have seen in the characters of Yusuf and Zulaykha, irony and humour inform our understanding of them and their links with deeper truths. There is no one-to-one correlation between symbol and meaning.

Let us return to the ikats, and the issue of calligraphy. What do these cultural forms symbolize? Are either of them specifically Islamic? The answer has to be negative. That does not mean that they are in any way inconsistent with Islam. Ikats which were replete with Christian or Buddhist symbolism, for example, would hardly be appropriate for a Muslim community, but it does not follow from this that the sort of symbolism on these clothes is specifically Islamic. Even if the symbolism is that of a particular religion, one should not assume that the wearer in wearing it is asserting any particular religious commitment. When one nowadays sees in the West a female popular singer wearing very tight and

revealing clothes, with a crucifix around her neck and positioned deftly over a plunging décolletée, one should not necessarily assume that she is declaring to the public her fervent belief that Jesus Christ is her saviour.

This sort of argument might work for clothes, but surely could not apply to calligraphy. We have been told so often and by so many eminent authorities that this is the key Islamic art form. After all the Qur'an is taken to be the direct word of God, transmitted in Arabic, and eventually written down. Thus the Arabic language itself acquires a unique status in Islam. Hence the development of calligraphy as the supreme aesthetic form in Islamic culture. And as we know there has been a highly sophisticated development of calligraphy in the Islamic world, in marked contrast to the relatively undeveloped status of this art form in the non-Islamic world. Yet other religions also think highly of their leading texts, without necessarily celebrating the language of those texts in the form of calligraphy. Early Christianity sought to distinguish itself from the Judaism out of which it emerged by employing images in ways which Jews found repellent. Islam had to establish its distinctiveness from both Judaism and Christianity, and emphasizing the language of Arabic, and the representation of that language, was a useful marketing tool. It helped bolster considerable brand loyalty and make Islam the very successful religion in comparative terms with its competitors that it so swiftly became. But there was nothing in the decision to emphasize the language which was a necessary part of Islam itself.

It is usually like that when a successful product is launched, the label under which it is represented becomes indivisible with it. Then it becomes difficult to think of the product without the label. The Coca-Cola Corporation apparently spends a lot of time ensuring that the labelling of the name of the company on the sides of their trucks follows a precise model. The miraculous nature of the Qur'an, the theological debates about the status of the Book as either created or uncreated, the significance given to Arabic and to the reciting of the text: all these practices and doctrines make calligraphy plausible as *the* Islamic art form. But it could have been so different, some other aspect of Islam could have been highlighted instead at the expense of calligraphy. Images could have been given a much higher profile, for example. After all, much calligraphy acts like images, in that believers may be unable to read it, understand it, or may believe that the writing has some magical power. It is not the text as a string of meaningful writing which necessarily has power over its admirers, in just the same way that those on the battlefield who fight to save the flag from capture are not necessarily fighting for that particular configuration of shapes and colours. Rather, they fight for a cause or for a country, and that flag just happens to be the flag of the cause or country. There is a historical reason for the flag to represent the country, no doubt, but the country could have had a different flag, and many countries have had different flags over their history at one time or another.

But how could images have had a bigger profile in Islam, given the familiar legal ban on *shirk* or idolatry? Surely, though, in Islam the absence of image became the image. The power often associated with the Book, and verses from the Book, came to represent for many Muslims their faith. Many Jews also, of course, avoid images and hold that the language of the Torah has a divine significance. Synagogues tend to be rather austere places, like many mosques, but then many churches are also very bare and unornamented. It is difficult to call a mosque that contains beautiful calligraphy, elaborate decoration on the minbar and the screens, and massive scale throughout, a structure without any images. The whole building is an image, a material exemplification of a religious doctrine. The calligraphy in the mosque or on the page is often very beautiful, and the meanings they represent are often very beautiful also, but we should not fall into the trap of thinking that the beauty of the former is necessarily linked with the beauty of the latter.

It is worth referring to an historical fact which is highly suggestive here. According to reports, in the pre-Islamic period of the *jahiliyya*, the time of ignorance, the leading poems of the Arab world were hung on the walls of their holiest building, the Ka'ba in Mecca. These *mu'allaqat* (the hung things, a term which came to be important in ishraqi thought as we shall see) are still highly valued today, although they are written in a type of Arabic which is not entirely clear to the modern reader. We always knew that the Arabs valued poetry, and the Prophet is cautious about poetry and poets since they represent alternative visions of reality, visions in opposition to Islam. But what is even more interesting about these prize-winning poems is that even in pre-Islamic times the word and the language was cherished. The display in this holy place was of words, so how can it be argued that the veneration of words came about through Islam? Islam like all religions thinks highly of the leading texts of its faith, yet we may wonder whether the pagan Arab who admired the writing on the *mu'allaqat* really was forming a distinct aesthetic judgement as compared with his Muslim peer who admires the writing to be seen on the walls of a mosque, or in a Qur'an. There seems to have been a fascination with writing and words in Arab culture that preceded Islam, so one can hardly claim that there is anything specifically Islamic about the fascination with writing and words.

3

Religion, style and art

Art and religion

There are many debates in Islamic aesthetics which tend to recur time and time again. The debate between artificiality (*takalluf*) and naturalness (*tab'*) is of course a commonplace within the aesthetics of many cultures. There does not seem to be anything specifically religious or Islamic about it. The way in which the debate tended to be developed was in terms of what is more appealing, what works better with the material, what expectations an audience would be entitled to have of what they see or hear or read. Some poets and writers emphasized the simple and basic, while others developed vast systems of exaggeration. We shall see how this debate was developed in a variety of different areas of art, and it is an interesting debate. When one looks at it initially it looks as though it is not a specifically religious topic, but we shall see that religion does enter into the issue in rather subtle ways.

There are three strong arguments against the use of art in Islamic culture.

1. Creative visual representation will result in reason being overwhelmed.
We need to recall here that Islam as a religion emphasizes the significance of reason, and suggests that it fulfils an important function in religion. How are we to understand the Qur'an itself without a capacity to be rational? The concern about the scope for art to befuddle reason has a long history in Christian aesthetics as well, and perhaps the most famous example of this is Tolstoy. What is very important for Islam is the idea of balanced perception, it is this which makes the Qur'an so acceptable as a religious text, and an aspect of its miraculousness is the way in which it combines orality, writing, sound and behaviour. This emphasis on balance is overthrown by anything which directly affects our senses in a way likely to overwhelm them.

There were some in the Islamic world who argued against such a view. Sa'adi and Rumi were very much in favour of imagery taking a pictorial form. The former saw the inspiration to represent nature as having its source in God, and Rumi went so far as to defend the representation of religious characters and

incidents in paintings. As a poet he obviously valued what could be done with the pen and words, but seemed to regard what the painter could do with a brush as equivalent to what can be done with words.

2. Concentrating on the visual obstructs understanding how things really are.
This is particularly important for aesthetics as interpreted by mysticism. The visual qua physical is immediately suspect in its reliability, since what is important about the world is what is behind the world, not what is on the surface. We get here the distinction so crucial to Sufism and ishraqi thought between the *zahir* and visible and the *batin* and invisible. But we have to be careful about this point, since it does not follow that what is visible is not regarded as real or important. On the contrary, in a good deal of Islamic painting the work is highly realistic and that very realism is interpreted as evidence of its Sufi character! There are Muslim thinkers who take a pretty ascetic attitude to the everyday world, but they are not the norm, and even Sufis who might be expected to read the world in terms of denial of at least some of its ordinary features do not on the whole do so. As mystics the world is seen not as illusionary but as essentially misleading, in that we are liable to regard the world as all that there is. This is misleading since it does not acknowledge the overwhelming presence of God in the world, and of the world in God.

What is crucial to our understanding of the world is that the ways in which we ordinarily see it just do not do justice to its real nature. Ibn al-'Arabi suggests, for example, that we do not appreciate the way in which everything is really just one, and one with God. Treating the world as important might be a way of ignoring this aspect of it, and one way of treating it as important is to celebrate its contents by representing them artistically. This is a criticism which is often made in Islamic philosophy of the faculty of imagination, which is regarded as a very important thinking process, and yet a potentially dangerous one. Imagination may make us think that what is not really real is real, in just the same way that we sometimes wake up when dreaming because we are convinced of the reality of what is apparently threatening us. Something appears to us to be real, and because we take seriously the evidence of our senses, we are seriously affected by it. Art encourages us to take what we see and hear as real, since it encourages us to concentrate on visual and auditory representations, think about them and admire them. King Solomon is referred to several times in the Qur'an as having made things, he got the *jinn* to make things for him. (34.12; 34:13). In order to test the Queen of Sheba, he built a *sarh* covered with glass (27.44), and from the description of it this seems to have been a screen built on the floor and constructed in such a way as to resemble water. Whatever this was precisely, the Queen was supposed to think it was water, different from what it really is. So it could hardly be argued that there is a basic Islamic

prohibition on using human imagination to produce illusory images. After all, the wisest of men delighted in his ability to commission art, and there is no criticism of him in the text for having done so.

It is worth reminding ourselves that the depictions of objects realistically can have a range of meanings, not all of which accord with this attitude to our world. There is a notion of magical realism (see *BLINK*) where the notion of the mundane has been heightened by light, colour and careful staging to something, often kitsch and vulgar, but also extraordinary. The installations of Duane Hanson also raise a lot of issues, their very exact realism makes us wonder what the lives of the people they 'represent' actually mean. In certain periods art becomes highly artificial, very self-conscious and pictorial. Although what is represented is represented as real, it is still problematic to the viewer, since it seems to mock its audience by saying 'here we are, what do you make of us?'. If one stares for long enough at anything, it comes to take on a different status. It becomes very interesting, not perhaps because it is very interesting but because one has spent a lot of time looking at it. This is why realism in Islamic art is sometimes linked with mysticism, in that a concentration on how things are can lead to a sense of transcending those things, at precisely the same time that one concentrates on them. How does this work? One possibility is that a prolonged attention to something does not result in a better awareness of what that thing is so much as a more profound understanding of how it feels to think for a long time about it. This is an experience, and mysticism does stress the significance of experience and the sorts of knowledge which are part and parcel of that experience. So the way in which realism becomes linked with mysticism is in fact through not being so much about the object as about us, while seeming to be all about the object. There is also the fact that in the act of concentration on an object one may well end up concentrating on the knowing subject, which becomes more the object of the act of apprehension than the apparent object, the art object. From a religious point of view this could also be regarded as objectionable since it might be seen as granting too much significance to us as cognitive beings. Again, the aesthetic experience may be criticized for directing the thought of the individual away from specifically religious topics and towards issues which have no direct spiritual relevance. The determined enemy of Sufism from Pakistan, Abu'l A'la Mawdudi, in his *Tajdid-e-Ihya-Din* (Renewal and Revival of Religion) links the unIslamic growth of monarchy, atheism, polytheism and asceticism, and argues that Sufism perverted Islamic thought 'as if by an injection of morphine'. In particular it led to the development of the fine arts, whereas strictly speaking it is forbidden for the Muslim to indulge in such pursuits, according to him. Sufism failed to preserve that sense of balance so significant to Islam, and hence encouraged the growth of political entities quite out of character with Islam, and ways of thinking not at all appropriate to

those who accept the teachings of the Qur'an. In particular we end up with the concentration on the individual and his or her spiritual growth along a path of personal development, together with the gratification of the senses through art.

The debate between artificiality and naturalness comes in directly here. The Sufis might be taken to be enemies of artificiality. For example, they might see the world as operating in accordance with relatively simple principles, and art should respond to and replicate those principles. On the other hand, their enemies might criticize them for favouring artificiality. The whole notion of the path, *tariqa*, which the Sufi sets out to pursue, and the shaykh who guides him or her on this path, together with all the conditions necessary for success with the enterprise, might be regarded as highly artificial. Before the Sufi can initiate the whole process it is necessary to be prepared, find the right place, the right teacher, the appropriate companions if any, and so on, and this is hardly simple and natural. Any artistic expression of this process might be seen as similarly complex, and many of the paintings which have been linked with Sufism, albeit very speculatively, are far from natural. In particular, it is far from obvious that representational art is more or less artificial than any other form of art. An obvious comment would be that representation is natural and abstraction is artificial, but this would be naive. As we have just pointed out, representation may be very puzzling and complex, and the whole point of it may be to raise doubts and questions which otherwise would not be raised at all. By contrast, an arabesque, for example, may be seen as unproblematic, a simple development of a geometrical design to fill a particular space, with no more than decorative meaning. That is why such designs are ubiquitous in mosques and mauselea. They do not distract the mind from the central meaning of the place, which is directed to God, since they are simple and natural. In much Islamic art there is ambiguity as to what is the subject and what the background, and this leads to an equilibrium between the dynamic and the static. That does not mean that they are not examples of very skilful products of wonderful artists, but what makes them so well suited to their role is perhaps the fact that they do not raise the sorts of questions that representational art does. They are unemotional patterns and so do not draw attention to themselves, rather they are understated and as such point elsewhere, surely appropriate in a religious building.

3. The Prophet criticized idolatry.

There is no lack of evidence that the Prophet was critical of idolatry, and the hadith literature refers to this quite often. The question is whether this transfers to art, and in particular representative art. There is the famous hadith comparing owning pictures to having a dog in the house, both of which are said to discourage the visits of angels. It is not clear what the criticism of pictures means, though. It might mean that he advocates simplicity in interior design, and

indeed simplicity in general. Contact with dogs does bring about ritual impurity, and it is difficult to put contact with pictures in the same category, unless we link pictures with idolatry. And the Prophet may well have had in mind the use of pictures by Christians and others for religious purposes, including as that did a representation of the deity and those close to the deity. It is worth pointing out that when he criticizes the use of music in prayer and recital of the Qur'an he is critical of Christian and Jewish melodies being used. He sought to maintain the distinctiveness of Islam. Another object of rebuttal must have been the local beliefs of those living in Arabia, including the belief in many gods, and the Qur'anic verse in al-Ikhlas (Purity of Faith) criticizes the ideas that God could have had a creator and that there are other gods like him.

On the other hand, there is plenty of anthropomorphic language in the Qur'an, and this language is normally interpreted as symbolic and not to be taken as literally true. So there is no need to represent religious figures pictorially, and certainly there is no scope to represent God in a picture, but there were many pictures of major religious characters, the prophets and even the Prophet himself, pictures of what paradise is like and so on. Representations of the Prophet often show him with a veil over his face, especially prevalent in the image of his flight on Buraq from Mecca to Jerusalem and back again (see Hattstein and Delius). In some paintings the Prophet's face is visible on the first stage of the journey, and veiled on the return. The implication is that during this journey he achieved a status which makes his appearance no longer of significance. On the other hand, there are plenty of pictures which show the Prophet's face quite clearly. As in all religious art, an attempt is made to present the main features of the religion, in so far as this is possible. It could be argued that just as the language of the Qur'an itself is frequently representational, so could painting and sculpture. Why should there be a ban on representing even the Prophet in a picture? He was after all a human being and to suggest that he is too holy to be represented visually implies that he shares in God's divine status, which is directly in opposition to the central principles of Islam.

Ibn al-Wahhab's critique of art

One of the most determined enemies of *shirk* or idolatry are the neo-Hanbali thinkers, and in particular ibn 'Abd al-Wahhab, the intellectual and political thinker who did so much to create what is now Saudi Arabia. He argues that there is a close connection between *shirk* and *kufr*, unbelief. Al-Wahhab sees the Christians and Jews, although people of the book, as unbelievers, pointing out quite reasonably that the Prophet did make a clear distinction between them and Muslims. They have minimally accurate views on the nature of God but these do not save them from eventually ending up in hell. Referring to the

Christians, he rejects their claim that in praying to icons or statues they are not really praying to these things, but calling on God through them. He accurately reports that the Prophet did not really make a distinction between different groups of *mushrikun*, as though some were better than others. He also had plenty of scope to criticize those he called modern *mushrikun*, which term he took to describe people who call themselves Muslims but really rely on things other than God to help them and to explain how the world turns out to be the way it is. It is easy to see how this can develop into an attack on science and modernity, but for our purposes here it is important to identify its implications for art. Any approach to reality which regards it as having a single meaning, and a meaning which is very important to our salvation, is going to be critical of any form of activity that does not fit in with that route to salvation. Al-Wahhab argues, and he supports his arguments with considerable textual authority, that idolatry is not just a matter of worshipping statues or rocks, but has a much more insidious and devastating meaning. Having a painting on the wall does not mean that we worship it, but it might mean that we are led to think it is important and acquire inappropriate ideas from it. Even if it is a painting of an Islamic topic it might instil erroneous ideas in us. We might admire the physiology of the people in the painting, or the beauty of the scenery, or the magnificence of the colours. These do not directly lead us to God, and on the contrary they take us away from God, they make us think that things which are not God are significant. But could we not use these pictures to bring us closer to God, as many Christians have argued? Not according to al-Wahhab; it is an essentially dangerous process, like playing with matches. Even if the initial intention of using pictures is acceptable, and based on solid monotheistic principles, the activity itself is likely to corrupt the individual and consequently the community. It is a bit like the relationship which is said by some to hold between 'soft' and 'hard' drugs. Some argue that the former do no harm and do not lead to use of the latter. Others argue that there is no such thing as a safe drug, and that the use of one sort does lead to the use of the more obviously dangerous drugs.

This is the basis of al-Wahhab's attack on idolatry; he argues that it is more dangerous the more subtle it is (more detail on the precise historical and theological setting is provided in Hawting's excellent analysis of the topic). The argument of the religious reformer is on the whole well organized and successful. Art can distract, confuse and lead to the questioning of authority. It is indeed idolatrous in the sense that it may posit for us a set of issues and even images which we then take to be important, and these may have nothing to do with Islam. They are actually more dangerous if they are connected with Islam, since they then suggest that it is appropriate for Muslims to spend time on art in its various forms and so the poison slowly enters the system. Muslims start to interpret their faith through the art, they replace the standard topics on which

they should concentrate with aesthetic issues, and become distracted from their central task, which is to carry out the main obligations of their faith in the correct manner. It is important to make the point that ibn al-Wahhab is critical of art in general, but he would be most critical of Islamic art, since this tries to persuade Muslims that what is forbidden is in fact permissible.

Sufism and wine

One of the targets of ibn al-Wahhab's critique is Sufism. Sufism portrays itself as representing the inner and hidden side of Islam, whereby followers on the path (*tariqat*) to God require the guidance of a shaykh or pir. One of the main symbols in Sufism is wine, as a symbol of intoxication, but not the physical intoxication as a result of drinking real wine. Loving God is like being drunk, one's ordinary senses are in disarray and it is as though one has been transported from the ordinary world to the divine realm. Wine represents the means to moving from one world to the next and the spiritual guide is the cupbearer, the one who presents us with the wine. Music and poetry are important methods for inculcating the right spirit in the seeker after truth.

There is also a lot of emphasis on being in the right place and having the appropriate atmosphere. Quite often groups of Sufis would meet in private homes or tea houses, at saints' tombs or in gardens, and those hostile to such gatherings often claim that they are characterized by drunkenness, drugs and perhaps the illicit meeting of men and women. More importantly, perhaps, is that such gatherings always have the potential for being subversive, for opposing the rules of official Islam and for allowing interpretations of religion which can go in any direction at all. After all, under the influence of poetry and music one may acquire all sorts of emotional ideas that have no relevance at all to the principles of Islam. Poetry and music affect our emotions and may overturn reason, so that we accept a version of how we should act or what we should believe that is at variance with religion.

Can there be secular art for Muslims?

Some have commented that there can be no secular art for Muslims because everything for Muslims is holy: 'An essential difference between Islam and Christianity is that the former does not divide life into the temporal and the spiritual'.[38] This is of course nonsense. Christians also see religion as entering into all aspects of their lives, as do all religious people. Although it is nonsense, it is a slogan often repeated, as though only Muslims were serious about their religion. For everyone else religion is supposed to be a minor part of their lives, mainly there for decoration or as part of tradition, the implication runs, and

religion has a merely ceremonial role. Muslims by contrast really incorporate their faith into every aspect of their lives. This is not an accurate version of non-Islamic faiths and the ways they are experienced by their followers, and it has interesting consequences for the understanding of art. Islamic art is seen as strongly influenced by Islam itself, whereas for other religions art is less connected with their religions, since religion does not have such an overwhelming significance for them anyway. We may question the grasp that the author of the above quotation has of the period in question anyway since lower down on the same page he says 'It is important to note here that in medieval Islamic literature there are no discourses to be found on the relation between art and religion',[39] and yet while I am typing this I see on the shelf in front of me a whole row of such texts. The mashsha'i (Peripatetic) philosophers, those thinkers heavily committed to Greek principles of how to do philosophy, certainly wrote at length on that relationship, if by art we can include literature, poetry and calligraphy, which surely we should. There is in medieval times and much earlier an extensive discussion of what forms of artistic expression if any are theologically acceptable, and we are going to examine some of these discussions in this book. The idea that art had to go in a particular direction in the Islamic world, once the principles of the religion became clear, is entirely wrong. Examining the way in which art did go and suggesting that this was because of Islam is an obvious case of *post hoc ergo propter hoc*. Islamic art could have gone in a whole variety of directions, and still may.

Islam and censorship

But are there not strict religious boundaries within which the Muslim artist must stick? For example, writers and especially Muslim writers who are seen to be attacking Islam or the status of the Prophet Muhammad may be threatened with death by the legal authorities, and quite appropriately given many plausible interpretations of Islamic law. This contrasts with secular law which generally permits the sort of *ijtihad* (independent judgement) that may result in insults to the leading beliefs of the state or community. Secular law in liberal society makes a sharp distinction between offensive literature and images which may offend but are only unlawful if they actually harm. Within the context of Islam offensive claims may be regarded as harmful, and this is often taken to be another indication of the impossibility within Islam of distinguishing between religion and the lifestyle of the inhabitants of the community. We recall the Rushdie affair, for example, when Rushdie was adjudged, quite correctly, to have produced a work of fiction which subverted in a highly offensive way one of the significant features of the Qur'an. The very title of his book *The Satanic Verses* only makes sense if it is taken to refer to the Qur'an, and the way the

story goes seriously attacks the ordinary understanding of some central Qur'anic interpretations. He was condemned to death by a variety of Islamic authorities, and people were killed in riots against the book. Translators and publishers were on occasion assaulted or even murdered. Yet this event caused perplexity to many in liberal society, since the idea that so much rage could be caused by the publication of a book, whatever it said, was thought to be surprising.

To take another example, the Miss World competition due to take place in Nigeria in December 2002 had to be abandoned there because of riots by Muslims objecting to a newspaper article claiming that the Prophet Muhammad would not have objected, and would have wished to take a wife from among the contestants. Many in liberal societies also disapprove of such competitions, but it was not liberals who rioted and brought about the death of over a hundred people. Although many Christians did object to artistic events such as Serrano's 'Piss Christ' and to other aesthetic products held to be blasphemous, these protests were mild and polite affairs, and the greatest worry an artist had was whether his grant would be renewed, not whether his life would be spared. It is this difference of reaction to blasphemy which makes some Muslims doubt whether Christians are really serious about religion. After all, if someone really cares for something, would they allow it to be treated in just any old way at all, or should they stand up for it and defend it against those who attack it? What does it mean to say that one disapproves of an artistic display if that disapproval is merely mild and ineffectual? The implication is that the disapproval is as mild as the ineffective reaction, and so hardly disapproval at all.

It looks as though the rules of appropriate artistic endeavour are so strictly defined in Islam that they had to take the form that they did take. But that is far from the case. Many of the paintings of women in Persian and Mughal books, for example, are highly suggestive. When they embrace with men the feelings displayed are more than fraternal. The rules which have developed over the appropriate clothes to be worn by women in Islam are themselves highly contro-versial. Some feel that the *hijab*, or even more than the *hijab*, are essential aspects of proper clothing for women, while others within the Islamic world do not think they are at all necessary. There is not one view of what women should wear, of how one should react to blasphemy, or even what constitutes blasphemy. Some think that a violent reaction to an attack on Islam is appropriate, others would not approve of such a reaction. Many Muslims would argue that an artist should be free to express himself in whatever way he wished. Of course, there are often powerful political reasons for an intervention in cultural issues by one religious group or another, and no doubt they will describe their intervention as a religious intervention. But there is no reason to accept that the intervention is the only feasible reaction by believers in that religion. Even tiny religions contain a considerable variety of views on what the religion enjoins. A huge religion such

as Islam is no exception to this principle and the religion is practised in many different ways in different parts of the world and different communities.

A problem with defining as obvious the direction in which Islamic art had to go is that it calls on us to accept a crude version of what it is to believe in God for a Muslim. Since the God referred to in Islam is not to be identified with other beings, we are told this inevitably leads to certain forms of aesthetic development, in the direction of an emphasis on ornamentation, taking three forms, namely, calligraphy, the arabesque and geometric forms. All this ornamentation has as its purpose, albeit not perhaps directly, reminding us of the divine Being. One should note the Sufi language of this type of explanation, and one should also note that the Sufi account of Islam is not the only way of viewing the religion, pervasive though it may be among those writing about Islam and aesthetics.

Sufism and Islamic art

To give an example of a Sufi account of calligraphy we could see this form of expression as consisting of constant movement which begins with the ultimate creative act of God and is one of the primary ways of providing evidence of his being in the world. Reading calligraphy is often difficult, requiring adequate preparation and effort, and the consequent pleasure is a reflection of our success in understanding God more profoundly, moving in his direction and forming some conception of the deity. The latter project of endlessly constructing a concept of God is because the appearance of Arabic writing itself is of something without an end, where the letters are linked with many shapes and keep on moving across the page and the manuscript. Thus we acquire experience of dealing with continuity and infinity, and this helps us conceive of God. Similar remarks can be made of the arabesque, the unbroken wavering and curling line that is initially at least derived from the intricate patterns made by the vine tendril. This is taken to refer to the notions of eternal movement and variety of forms, both of which can serve as ideas of the eternal God. Also, the fact that the central motif is a plant, the vine, serves as an indication of the holiness of the everyday, the natural, and the fact that God has given us such objects so that we may enjoy looking at them. Finally, geometric forms come closest to presenting an abstract concept of God, since their shapes suggest the unlimited nature of God, and also the fact that one is presented with a range of symbols that need to be explored and considered for what they conceal before one can really understand them. Finally, it is often said that the reliance of Islamic art on ornamentation brings out the fact that for Muslims there is no contrast between the temporal and the spiritual, that all art has a religious orientation and is designed to help us reflect on the deity.

Two general objections need to be made to this thesis. The first objection is merely to point out that Sufism is just one approach to Islam, and is not the only approach. Of course, Sufis will argue that they represent the way in which Islam ought to be interpreted, but unless we accept this, and why should we since most Muslims do not, we need not adopt the Sufi approach to ornamentation as the correct strategy. Indeed, it is worth adding that even were one to be a Sufi it is not necessary to accept this line, since there are many varieties of Sufism, some of which for example disapprove of music (the Nashqabandiyya) while others argue that music is at the heart of Islam (this phrase, 'the heart of Islam', is popular among Sufi commentators and suggests yet again that there is an essence to the faith). Many Sufis would see these claims for the interpretation of art to be valid, and yet not inevitable. That is, Muslims may see calligraphy as providing a reminder of the eternal power of God, since it has a shape and continuity which seems to be endless, and at the same time accept that not everyone needs to see it in that way. In Sufism there are generally held to be different levels of meaning in images and not everyone needs to follow the meaning all the way down to its most basic level. So if someone takes a drink out of a glass flask which has a religious inscription on it and does not reflect on the Light Verse from the Qur'an while doing so he is not necessarily at fault. Although we are told that Muslims do not distinguish between the secular and the temporal, one wonders how far this is supposed to be taken. Is the believer really expected to think of God every time he or she has a drink of water, or a breath of air, or looks at a building? Theologians often criticize Muslims for repeating formulae such as 'insha'alla', 'bismilla' and so on, since they argue that the frequent use of these expressions does not serve to demonstrate faith in God, but merely in the efficacy of producing particular expressions on certain occasions.

Ornamentation and 'Islamic' space

But the main objection to this account of ornamentation is that it is just wrong. How is writing an indication of the endless, or the arabesque and geometric patterning a symbol of the infinite? Writing does come to an end, as do the arabesque and geometric designs, and the fact that they could all be extended does not mean they are endless. For one thing, unless space is infinite, whatever goes on in that space will have to come to an end at some point. Many have commented on what is taken to be a horror vacui in Islamic ornamentation, a dislike of the empty, and this accounts for the ways in which space is filled up so comprehensively in Islamic art. Yet space cannot be filled up entirely, for if it was the ornamentation would become entirely lost. In arabesques the line is unbroken, but so what? That does not mean it goes on forever, and is a symbol of the infinite. Geometric patterns may be empty of content, and so stimulate

the mind to think of a deity existing without companions and it can get the mind to think of all sorts of things. How are geometric shapes infinite? A triangle is a triangle, a circle is a circle and so on, and any combinations of shapes are just combinations of shapes. I would not for a moment suggest that in Islamic art all these forms of ornamentation are not used effectively to produce beautiful designs, and consequently objects, it is just the further ideas that these designs are supposed to induce in us which appear so implausible. They may induce such ideas in us, of course, but then so may all sorts of images. Christians are frequently said to be inspired by icons, or statues of Jesus, or stained glass windows with pictures of saints, and so on, and what are they inspired to think about? If we believe what they say, they are inspired to think of God, and he is apparently a very similar being to the God of Islam. That is, he is infinite, the source of all being, he directs our lives, and so on. The horror vacui is a function perhaps of the inability of Islamic art when it is decorative to have a main subject or theme and so filling up all the space prevents the viewer from looking for it. But it is a finite space which is filled up, and so the horror at emptiness, if it exists, can be replaced by the satisfaction of having done away with emptiness within the space in question.

One of the attractive features of the sort of geometrical illustration that is so common in Islamic art is its balance. The shapes that are produced seem to be just the right number. Too many shapes would have produced an effect of fragmentation, and too few would have made us concentrate on particular areas of space too much. In some such designs the application of a grid supplies a tight formal structure that gives the impression of being endlessly and infinitely repeatable. Larger areas cohere by colour and shape rather than by subject matter, since the whole notion of subject matter does not really get much of a grip in this sort of design. Repetition within a specific section, or rephrasing of a section within the whole, produces a subtle rhythmic and harmonious pattern of sameness and difference, and this is vital if the work is to escape from both tedious monotony and a gradual loss of aesthetic identity. The work itself defies interpretation, sometimes it seems to be replete with a kind of libidinal exuberance and sometimes to be shot through with pathos. Sometimes it looks as though the flow of time has been arrested, and sometimes as though it has not been constrained at all, since the patterning is so excessive that it makes the attempt to constrain it, or render it coherent, futile. Any attempt at decoding it or synthesizing the vast array of shapes has to be rejected by the viewer, overwhelmed as she is by the *jouissance* of the intricate patterning.

This brings us to another difficulty with the Sufi interpretation of ornamentation. It insists on a single reading of a vast variety of aesthetic material. Here is the entire genre of calligraphy, and of the arabesque, not to mention geometric design, and it has just one meaning, it refers to God. The thesis is both too

broad and too narrow. It is too broad because if everything in the universe reminds us of God, then so does art. But this would work for any form of art, presumably, and also for everything that is not art. There is nothing then specifically about Islamic art which reminds us of God, yet the claim they make is that Islamic art is especially devised to carry out that purpose. It is too narrow because we have to find something in these artistic styles that makes us think of God and unless everything makes us think of God we cannot find anything that performs the task. The argument for a specific reading of these designs just is not compelling. As we have seen, there is nothing infinite about writing or endless about geometric and arabesque design. So there is no obvious route from these designs to thinking about an endless and infinite being. They could stimulate us into thinking about God, but there is nothing about them which has to achieve this result.

We have to get away from the idea that signs are natural, that they only point in one direction and have one meaning. The only account that would support such a view is a naturalism about art that seems most implausible. We would have to accept some variety of Pythagoreanism, as the Ikhwan al-Safa' did, according to which the movements of nature have a direct correlation with aesthetic forms, and vice versa. That would mean that if one did not appreciate the aesthetic features of a particular object, then this is a mistake on the observer's part, since those features are actually there in the object just as much as its size and colour and shape.

Whirling dervishes

Let us take as an example of the dangers of the Sufi argument the ceremonies of the Mevlevi Sufis, the famous dervishes whose main base is Turkey. They spin progressively faster to music, and they form a circle around their spiritual leader, the shaykh. Spinning represents the individual's awareness of the omnipresent deity wherever he turns, and the circle around the shaykh represents the cosmos, at the centre of which is the earth. Their arms are raised, the right hand facing heaven to receive its blessings and the generosity of God, while the left points down to indicate that they are passing on these blessings to successive generations. Now, I do not want to criticize any of these interpretations of what the Sufis do, and once they are explained to us we understand why they do what they do. What is important is that we realize that their actions can be given a whole range of interpretations. Their actions only have the meanings they possess within the context of the dance; when I hold my hand up to the sky it does not generally mean that I am indicating any particular relationship with God, for example. The account of the meanings accorded to ornamentation suggests that there is some 'natural' level of interpretation in accordance with

which one just has to look at these forms of expression and one can understand
what references they have to a higher meaning, to God in fact. That is entirely
wrong, we can certainly interpret ornamentation in that way, but we could also
interpret an entirely different form of art in that way. We could examine the
highly representational Christian painting of the middle ages, for instance, and
say that it makes constant reference to a religious meaning, and here we would
even have the advantage of being able to argue that this meaning is pretty
obvious. We actually see in many of these paintings the son of God, according
to the Christians, and his mother, and assorted saints. Yet even so the images
have to be explained to us; it is not obvious what they mean without explana-
tion, nor does this issue really impinge on their aesthetic value.

It is this latter point which is so crucial here. We may come to admire visual
material without knowing what it is. One does not have to be able to read Arabic
to appreciate the beauty of much Qur'anic calligraphy, nor does one have to be
able to identify the Virgin and Child in paintings of them to discover that such
paintings are often beautiful. Sufis would say that when one admires such
objects without knowing what they are, one is really admiring God's creation
and the ability of human beings to copy that creativity to a limited degree in
what they do. One can tell that here is an object constructed with great skill,
and its composition leads us to call it beautiful. It moves us in some way, it
stimulates the imagination and potentially has an impact on our lives. Whatever
the Sufis say, there is no need to accept such an interpretation. We may
aesthetically appreciate the object just because it is a beautiful object, its struc-
ture consists of parts which are visually pleasing, as is the whole, and it is to this
feature of it that we react when we make aesthetic judgements about it.

This is a very spiritually unenlightened way to see aesthetic experience, of
course, but it seems to be more accurate as a description of much such experi-
ence than a competing religious interpretation. There is nothing wrong with
the latter, it is just not the only interpretation that makes sense. If we can make
aesthetic judgements about religious material without understanding the religious
references, then that suggests that those references are not important aesthe-
tically. They are of course important in a lot of other ways, but not aesthetically.
It follows that we have to be much more careful in the ways in which we
characterize Islamic art than has hitherto often been the case.

There are at least two questions about meaning that we can raise when we
talk about art. One question is about the meaning of the work of art, and the
other is about the meanings it has. The more interesting a work of art, it might
be said, the greater the range of meanings that can be applied to it, not in the
sense that it is designed in such a way as to be purposely complex, but because it
is rich semantically and the range of interpretations which can be made of it are
equally rich. In some ways the more normal a work of art looks, the more

puzzling it is. The hyperrealist figures of Duane Hanson, for example, are very puzzling, consisting as they do of facsimiles of human beings, so realistic that they are frequently mistaken for 'real' people by those unaware of what the artist produces. What do they mean? Here a long line of answers seems plausible, the work is mysterious precisely because it is not mysterious at all, and this makes for a lively discussion about what they mean. Some realistic work is not problematic at all, it is just what we might call kitsch, it skilfully represents the world and the people with whom we are familiarly acquainted and shows us what they look like. But Hanson's figures are not comforting at all, they are disturbing, and one reason they are disturbing is because they always look sad and defeated. Not sad and defeated in a sentimental sort of way, that is the treatment that a kitsch representation would undergo, but sad and defeated as though that is what it is to be a modern American, surrounded by goods yet without the ability to use them in any meaningful way, perhaps because they are incapable of making their owners happy. Now, there is no need to advocate the virtues of this general thesis or Hanson's development of it, but it is worth looking at how a significant artwork is rich in meaning because it calls on us to discuss a range of such meanings. We may interpret Hanson's figures differently, and we may argue that the appearance of defeat is merely a noble attitude to our condition in life, and these are people who are carrying on regardless. Then we could argue that they are not sad at all, that they merely look composed and in fact could be seen as cheerful. For one thing they are continuing with their normal activities, and one might argue that they look very at home in their social role. They wear their clothes as though they wish to identify with the ways in which familiar activities are customarily undertaken, and we can then reflect on what it is to carry out what philosophers of a past age called our station in life. The important point about this discussion, which of course has nothing at all specifically to do with Islamic art, is that it brings out how art raises many questions of meaning. The only form of art which does not, or at least less so, is art which is formulaic, mechanical, limited in scope, and thoroughly minor. Perhaps in insisting on a limited range of meanings for Islamic art the implication is that this form of art is essentially minor, incapable of the sort of aesthetic depth to which we have just alluded here with reference to Duane Hanson's work.

Realism may be seen as subversive. In the days of the Soviet Union realism was not in favour unless it was social realism, unless it put the realistic portrayal of the situation within a certain political context, a context that reveals the part it has to play in the wider scheme of things, as it were. Exactly the same point is made in recent years about the realist films directed by Kiarostami, Panahi and the other modern Iranian directors. They also may imply that all is not as it should be in the Islamic Republic of Iran, and they may not indicate that the reasons for any imperfections lie outside the power of the regime, perhaps in the

previous regime or in the enemies of the present government. Showing life as it really is, presenting the facts in an unvarnished manner, often threatens the ethos of a society which portrays itself in glowing terms. Even in states which are less dominated by Islam realism can be a heady mixture in films and literature. In Egypt the novels of Naguib Mahfuz have often in the past been criticized by religious groups for their realistic portrayal of life in the poorer sections of Egyptian society, the charge being that they are pornographic since they represent quite frankly the sorts of language that ordinary people use and the general lack of interest in basing life on faith that pervades significant sections of Cairene society. Mahfuz collaborated with the director Saleh Abu Seif on nine films, and they present a gritty view of life in modern Egypt, as do his novels. As a result of his condemnation by some religious groups, Mahfuz was eventually attacked and knifed, something that shocked a society that thought that this sort of *fatwa* would never be translated into action.

One can see why fantasy might be thought to be opposed to Islam, but realism seems not to have any specific religious relevance. After all, in Egypt it was not the claim of the Islamist groups who condemned Mahfuz that Egypt was an Islamic society run on Islamic lines with an entirely Muslim population. They accepted that there is a significant non-Muslim group in Egypt, the Copts, that the laws are not yet (unfortunately) entirely Islamic, and as a result perhaps of both these truths Egypt is not really an Islamic society at all. So what is problematic about films and novels that describe the seamier side of life? In particular, the reforms initiated by the Sadat government, the *infitah* (opening) as they were called, were shown to have very dangerous consequences in many of the realist films of the 1980s, leading to corruption, a breakdown of the family structure, gangsterism, drugs and so on. In particular many of these films are critical of the results for poorer people, who are shown to suffer as a result of the reforms, and to become alienated from society. Islam is not challenged in these films; on the contrary it is generally treated with respect and acknowledged to play an important role in everyday life. How could this sort of realism be criticized from an Islamic point of view? Salman Rushdie's *Satanic Verses* is a fantasy directly poking fun at a significant Qur'anic story, and one can see why that might well be criticized from a religious point of view. It clearly raises issues of blasphemy in Islamic law, the very title of the book directs the attention of readers to its critique of Islam and its Book. But a portrayal of life as it really is, however that is interpreted by the artist, would seem on the surface to be a neutral activity from the point of view of religion.

In the Islamic Republic of Iran in the 1990s a realist genre of film arose and was encouraged by the state, a genre which might have been regarded as critical of the government. Not that it was directly, but the fact that it presented society in a very neutral way, and seemed to concentrate on the seamier side of daily

life, did lead some supporters of the regime to wonder whether such films ought
to be allowed to be produced in the country. These films often dealt with the lives
of children, and included a girl buying a goldfish for the Noruz festival (Panahi's
Badkonak-e Sepid), a boy returning a copybook to a friend (Kiarostami's *Khaneh-
ye Doust Kojast?*), a girl lending someone else her red boots (Ali Talebi's
Chakmeh), children trying to replace a broken water jug, (Foruzesh's *Khomreh*).
Some of these films include a mixture of actors and laypeople, thus giving them
an even more realist flavour. Many of these films received a rapturous reception
outside of Iran, and they are often charming, with a strong humanist character
and detailed characterization. On the other hand, they are sometimes so
realistic that they are boring and involve long repetitive scenes of everyday and
seemingly pointless actions. But what is of interest here is that religious groups
in Egypt should seemingly reject realism, while similar groups, indeed groups in
power, in Iran took a different view. This may well have something to do with
the difference between Sunni and Shi'i Islam, and their very different attitudes
towards art. But for our purposes here we are interested in what it might be
about realism in art both to raise the suspicions of the religious (in Egypt), and
also to settle those suspicions (in Iran).

We saw when discussing the realist artwork of Duane Hanson that there are
different approaches that can be taken to his output. They can be seen as defiant
and confident, or as depressing and defeated. This brings out the richness of
realism: it can be seen as a vindication of the way things are going or it can be
seen as an accurate depiction of why they are not going in the right direction at
all. In Egypt those critical of the secular regime can use the obvious faults of
society to criticize that regime. In Iran those attracted to the religious govern-
ment can use social problems as a way of bringing out the human problems and
issues that arise under any sort of administration or social organization. In both
cases it is not the realism itself which is the leading factor, it is the desire to
praise or attack that leads to a particular contextualization of realism. We are
puzzled by realism because we are puzzled by the nature of the world as it
ordinarily is, the very fact that anything exists at all is something that philo-
sophers have traditionally tried to explain. It is hardly surprising that the felt
quality of everyday existence should be experienced as perplexing, even for
those with a strong religious faith. Even the observer who believes that the world
is created by God and infused with the spirit of God is capable of being amazed
by how the world is, perhaps as a stage on the path of coming to understand
more and more about the world. It would be wrong to suggest that realism must
be a part of a Sufi attitude to the world, or of any other kind of attitude to the
world, it can be a part of any attitude to the world we care to adopt. It looks as
though realism makes just as great demands on our imagination as does any
other genre in art.

Orientalist art

To illustrate this point within the context of the Islamic world, we can look at different perspectives on orientalist art. Edward Said can be credited with having really put the concept of orientalism on the map. According to him, it is a construction of the Western imagination, and reveals the uneven power relations which existed and still exist in the relationship between the West and the Islamic world. The thesis has been developed into what are today called 'post-colonial' studies, which has broadened and made more sophisticated his basic arguments to develop a complex theoretical methodology for analysing the links between different cultures. One of the useful contributions which this theory has made is that it helps us understand what takes place when, for instance, people from one culture paint or photograph those of other cultures. The stereotypes which the former has of the latter inform the eventual product. Since the Christian world was seen as 'normal', the Middle East had to be seen as the opposite, and so there was an interest in capturing exotic types and alien clothes in the subjects that were painted and photographed. Often these objects were heavily eroticized, and it is not unusual to have a picture in which there are women heavily veiled (thus representing the exotic) and other women displaying their breasts (representing the erotic). The picturesque nature of the subjects was often favourable, and the noble savage is a familiar type. The significance of colonialism and imperialism meant that the West saw itself as having a civilizing mission, and so the more unlike 'us' the subject of the work, the better able it was to represent alterity, the Other, what is different from us. Not all these stereotypes are negative, although many of them are. Some are very positive, but it is often argued that they represent types who are so different from us that they still serve as images of the Other. Such images help us construct our self-image, of course, and so the noble savage establishes what might be seen as norms of civilized life in industrial society, by contrast with the simpler forms of life of the tribal communities and those not yet part of the industrial nexus.

What is interesting from an aesthetic point of view is what we make of these works. Let us take for the moment some of the photographs and prints of Turkish subjects. In her chapter 'Picturing Alterity' Ayshe Erdogdu argues that many of the photographs which she considers reveal a condescending attitude to the indolence of their subjects. She is certainly correct in reporting that many Europeans were critical of what they took to be Eastern lassitude, and they credited the relative wealth disparities between Europe and the Islamic world as a matter of the social values held within these different regions having very different economic ends. European individualism and hard work resulted in progress and prosperity, Islamic lack of initiative and lethargy resulted in poverty and backwardness. The photographs of men sitting in coffee shops, and the

emphasis on the picturesque, share the style of an oriental spectacle, with exotic clothes, interesting faces and strange customs all portrayed apparently objectively, but obviously in highly studied and artificial tableaux. What Erdogdu says about some of the photographs of sitting men, dervishes and Kurds is interesting. She sees them as representing lack of initiative, indolence, poverty, idleness and even homosexuality, and she finds references in the photographs to Islam, which suggests, subtly, that it is religion and a particular religion which has brought them to these straits. She even criticizes the photograph of the stationary dervishes for not giving any idea of what they look like when they whirl! This seems rather unfair, it is always difficult to represent movement in photography and one can see why the photographer would want to record the clothes and characteristic gestures of the dervishes, and not necessarily to poke fun at them for being exotic.

What is wrong with recording the exotic? It might be argued that it is wrong if it involves constructing a notion of the Other, the irretrievably alien, and if it robs the object of its shared humanity. But there are a variety of ways of reading these images, and the orientalist perspective is not the only one. The facial expressions which might be regarded as vacant and passive could also be seen as relaxed and pensive. The representations of exotic types which look picturesque are also visible as noble, interesting and genuine. The references in the pictures to Islam could be seen as commendatory, as though here we see images of people who live a truly religious lifestyle, or attempt to live such a life. Many of the orientalist painters were impressed by the evident piety of those in the Middle East and painted many mosque interiors in highly romantic style, with very dramatic settings of individuals and groups, and an obvious admiration of the elegance of the surroundings and the simplicity of the interior design. One aspect of orientalist art that is very clear is the fascination with colour, the idea perhaps being that the east represents very rich colours, a brightness and lushness not to be seen in Europe. It certainly is the case that many Europeans visiting the Middle East became enamoured of the lifestyle and culture, and this is also seen as a reflection of orientalism, in that they came to have an unduly positive attitude to the Middle East, just as unbalanced as the negative view which others had. In fact, the positive view might be regarded as more condescending than the negative view, in that it sees the local inhabitants, and also their religion, as totally different from and far superior to anything available in Europe.

So we must accept that the images of the orientalists can distort both positively and negatively, and neither form of distortion is acceptable from a moral point of view. But it is worth acknowledging that these images may be taken in a wide variety of ways. A photograph of a sitting coffee drinker may seem to one viewer to be an image of indolence, to another of deep thought. A

painting of someone praying in a mosque may look as though it is poking fun at Islam, since the individual represented may be carrying out apparently extravagant gestures and be wearing unusual (from the viewer's perspective) clothes, and yet might be seen as either faintly ridiculous or impressive. We can create no common line of interpretation for such images, and the fact that they are not particularly profound art objects does not mean that they are subject to only one reading. If even the rather hackneyed images of the orientalists are subject to a variety of interpretations, none of which are particularly forced and all of which seem reasonable, how much more true is such a demand for a variety of interpretations as lying at the basis of all aesthetic judgement. This is the central problem with the Sufi thesis that religious meanings lie behind everything in Islamic art, in just the same way that such meanings lie behind everything in the world. It insists on a univocity of interpretation which just does not do justice to the richness and complexity of aesthetics.

But surely, it will be said, these writers on Islamic art cannot think that it is minor, they go into such raptures about how wonderful it is, and many of these writers have devoted their lives to writing about it. One would be unlikely to do that if one thought that the art was minor. It has also to be said that even a cursory glance at a catalogue or better an actual exhibition of Islamic art soon establishes that this work cannot be minor at all, for even if there are areas of Islamic art which do not seem very exciting, there are areas which are immensely moving and beautiful, by any standards and for any viewer. How can these advocates of Islamic art be reasonably accused of seeing it as minor? The accusation can be made because of their insistence that only one meaning lies behind it, a clearly religious meaning. If they are right, then Islamic art is minor. A difficulty they have here is really respecting the work. This is because they are so intent in seeing a religious meaning for it that the work itself becomes secondary to the meaning. We are reminded of al-Ghazali's argument that the beauty of art is a reflection of the moral beauty of the artist himself, and clearly here the main focus is on the ethical stature of the artist as a human being, not on the work. The value of art becomes a secondary issue, secondary to the religious acceptability of the artist, and presumably consequently to the ideas represented in the work. As we shall see when looking at music, anything which is *lahw* and *laghw* (31.6; 32.3) may be regarded as unacceptable from a religious point of view. It is the religious meaning of the art which comes first, this represents the criterion of its permissibility, and once this criterion is satisfied we can go on to examine and discuss the object. So the object is indeed secondary to the religious context in which it exists, and the first question about it is not 'What does it mean?' or 'Is it beautiful?' or 'Why is it done like that?'. The first question is what sort of religious context does it satisfy, and once that question is answered successfully we can go on to the aesthetic issues. This is

crucially important, because it results in the work of art having its primary reference not to aesthetics but rather to religion, and further results in the one-dimensional view that Sufi critics often have of Islamic art.

It might seem that this argument really does not do justice to the evidence. For the evidence suggests that Sufism is enthusiastic about many forms of art, and art is often enthusiastic about Sufism, pictures in particular frequently representing them in very favourable light. There is a splendid Mughal painting now in the Freer Gallery of Art (reproduced on the cover of this book) painted between 1615 and 1618 which shows the Emperor Jahangir preferring a Sufi to the Turkish sultan, and to King James I of England. The Emperor gives the Sufi an obviously valuable book, while the potentates look distinctly miffed. The Sufi has by far the best beard also! The artist of this painting clearly had a favourable attitude to Sufism, or maybe his patron did, or both. Some paintings are humorous. Sufis are sometimes not represented as noble sages, for example, but as slightly ridiculous types who are asleep when they should be alert, and unaware of the messages from heaven which are available to them. It would be wrong to see such compositions as critical of Sufism, but they may well accord with the gentle irony that characterizes much Sufi thought, and stand in sharp contrast with the stark dogmatism of the thesis that art has but one meaning.

Many Sufis are committed to music, and see music and dance as significant ways of coming close to God, to recalling him and bringing him back into our lives. That is all true but we should ask why music and dance are said to be important. They are not important because they are beautiful, they are beautiful because they are important, and they are important because they help re-attach us to God. This instrumental interpretation of art results in its being assigned a subsidiary role in our lives, a role in which it is stripped of much of what is delightful about it. This reveals a narrowness about Sufism which is generally concealed. We often think of Sufism as very open to other faiths and forms of religious expression, to rejecting a narrow view of *shari'a* and what constitutes observance of Islam. This is why in many environments Sufism has become a potent factor in encouraging people to embrace Islam, it presents them with a form of the faith that perhaps accords well with their liberalism and tolerance of alternative views. When we look at art, though, Sufism seems to represent another kind of religion, one which is narrow and univocal.

Interestingly, in modern times many Muslims do own pictures, and in particular pictures of Islamic sites and personalities. While in some countries influenced by Wahhabism like Saudi Arabia there is a rather suspicious attitude to pictorial art, the ruler and inhabitants seem to have no problem with photographs being taken of them and indeed put up on display. There are in the Kingdom many portraits of the rulers, and in other countries that call themselves Islamic pictures are ubiquitous. Iran is a case in point. Yet many Muslims

argue that acts of creation that simulate the divine creation of the world are blasphemous, and painting pictures of living creatures might be regarded as similar to creating the things themselves, although the point of resemblance is not that close. There is a lot of difference between a picture of something and the thing itself. Some approaches to the issue of art do mention this issue. The very name of the painter (*musawwir*) implies the ability to manipulate the form (*sura*). What is problematic here, apparently, is that only God can really affect the form of anything, since only God really has the power to create and change matter. This is a strange argument, though, since it implies that it is an error for human beings to do anything at all, or to set out to do anything at all, since only God can really do anything. Islam is certainly not a quietist religion, which advocates doing nothing at all and leaving everything up to God. If Islam advocates human action, then why not artistic human action? There is no problem in recognizing God's role in that action, and many artists do constantly refer to God in their creative work.

One source of antagonism to art is the idea that it is unnecessary, that it is not serious and indeed potentially dangerous. Certainly if one takes a fairly strict interpretation of what is important, art may not seem to be important, since it is not centrally about our relationship with God. If the most important thing about us is our relationship with God then art appears to be superfluous. It is difficult to rule out such an approach, it surely depends on the values of a particular individual and the approach which he or she takes to their lives. There is certainly no need for art to play a part in anyone's life, despite what its advocates tend to say. One may choose a simple life in which there is literally no room for art. Who is to say that such a life is inferior to a life in which art plays an important role?

Is art dangerous? It could be, from a religious point of view, if it induces us to be lacking in gravity in our attitudes to our life and to others. Art does often poke fun, it encourages us to use our imagination, and this may lead us to wonder whether we could adopt a different form of life, one perhaps in which religion has no or little role. Art is fanciful, and once a sense of irony sets in, it is difficult to take the rest of one's beliefs and experiences as seriously as before. This could be regarded as damaging to faith, since faith often rests on unconsidered principles and ideas.

4

Literature

Arabic poetry

It is not inappropriate to discuss the issue of aesthetics by starting with the Qur'an, since the beauty of the text itself is taken to be the proof of the inimitability of the book, and of its divine origin. While the Qur'an criticizes the idea that Arabic poetry is itself a source of instruction, the Qur'an is not critical of beauty as such, and on the contrary presents its message in the most impressive and compelling manner possible. This led quite naturally to the discussion as to what it means for poetic language to work, and what criteria exist to distinguish between effective poetic language, and the ineffective.

The concept of *isti'ara* is identified by al-Jahiz as crucial, since it shows how one thing can be identified by the name of something else, where there is taken to be a similarity between the two terms. This idea was progressively developed by other literary thinkers, in particular ibn Qutayba, Tha'alibi and ibn al-Mu'tazz, all of whom explore the ways in which language can be used figuratively. They produce rules that explain the different techniques which can be applied to language, and grade the different types of expression in terms of their likely success in producing in their audience the appropriate thought processes. For one thing, it is not enough to say that the use of language is figurative for us to understand how it works, only some uses of metaphor and allusion work and even those that work only work to different degrees, so any science of poetry will have to explain the ways in which language can be extended figuratively. In particular, there was an extended debate as to how artificial the use of language ought to be, with some theorists arguing that it is always better for language to remain as natural as possible, while others were in favour of its development in a whole range of unusual and highly artificial ways. The Qur'an as always serves as a paradigm here, since the language of the text manages to be both natural and yet beautiful at the same time. There is a directness of approach in the language and what the language can be taken to mean, and yet the language is often highly allusive. Despite this, the text does not generally give the impression of having been artfully constructed, since the

beauty of the text appears to arise naturally from the context within which the particular point that is being made is expressed. However, literature produced by human beings does not have this perfect structure, and it is therefore appropriate to try to grasp the techniques that we use to construct such writing and assess the success or otherwise of what we do.

The trouble with the philological approach is that it falls into the constant danger of psychologism. That is, developing general rules of what works and what does not means trying to find out what ideas listeners and readers are likely to have produced in their minds when they hear or read particular texts, and of course we then need to distinguish between the average individual and those who are capable of seeing beneath the surface and applying more sophisticated ideas to the text. This is an issue which arises quite readily within an Islamic context, since many argued that the Qur'an addresses different audiences in different ways, presenting the unvarnished truth to an unsophisticated audience, the generality of the Islamic community, and yet at the same time using language that brings out layers of the truth that are only accessible by the more sophisticated. It would be an error for the less sophisticated to feel that they were being presented with only partial access to the truth, so their reading of the text does not make obvious to them this aspect of dual meaning. It is not that they are mislead, merely that they are not encouraged to question a text in a way that will not be likely to take them anywhere that it is in their interests to go. The Qur'an is often praised for having transcended the conflict between artificiality and naturalness since it evinces a style which is so effortless that one thinks of it as natural, and yet on closer examination it is also highly artificial and complex.

Can we analyse texts in ways which do more than just reflect the average psychological constitution of the individual member of the audience? Clearly this is important, the Qur'an is a unique text precisely because it is so successful in making its language understood to so many different people, but other texts may be expected to have different effects on different sorts of people. This led to the project in Islamic philosophy of analysing texts in accordance with the syllogism, so that a poem, for example, is seen to resemble a logical form of reasoning, at least in its basic structure. The philosophers had always attacked the pretensions of the Arabic grammarians to have the last say on how language is to be analysed, arguing as they did that grammar is not capable of exploring the deep structure of language. Only logic can do this, and so only logic can really tell us how poetry works. To rely on grammar is to be guilty of an irretrievable psychologism, it was argued, since there is no necessary connection between the grammatical features of language and what our attitudes to them have to be.

Yet poetry seems to be resistant to logic, given that the basis to poetry and art in general is imagination. Can the imagination be analysed in accordance with logic? Much of what the imagination comprises is after all to do with

illusion and the unreal, so it appears not to have much to do with reason and logic. According to al-Farabi, we can link ordinary language and imaginative language via analogy, so that we can move from two uses of language employing the same term and with justification assume that if both terms share some properties, then they may be taken to share other properties, but only poetically. In reality they do not share all their properties, if they did they would be identical terms. But as far as imagination is concerned what we are dealing with is the association of ideas, and we are justified in linking our ideas if we can link the terms which have the ideas as their properties. There exists a middle premise which brings about this linkage, and the premise is a general claim about how a term may be used in a variety of contexts and can take all its features along with it regardless of the context. According to this important Peripatetic (Greek-orientated) thinker in Islamic philosophy, al-Farabi (d. 339 AH/950 CE), the success of the image or phrase is in direct proportion to the distance between their literal meaning, which is not a bad suggestion. After all, the more far fetched the connection, the more impressive is the achievement in bringing the two sides together.

In the poem by the modern poet Adonis called 'The Tree of the East' the first line goes: 'I have become the mirror'; but he does not really want to claim that he is a mirror. He is referring here to the language of affinities, harmony and unity which links a human being to an object like a mirror. Actually there is another level of meaning here, since he is talking about himself as a poet, and referring to the role of the poet in reflecting reality. Later on in this poem he links himself with water, which of course is reflective. Actually, one of the themes in much of his earlier poetry is the contrast between nature and society, where the former is comforting and healthy while the latter is the source of division and violence. So comparing poetry to water, a natural product, is to operate at yet another semantic level, where he links an aspect of what is natural with an aspect of what is unnatural and cultural, and yet to a degree can also be seen as natural. In the later work nature becomes a bit more like society, divisive and threatening. What is clear from the account provided by al-Farabi is that we have different levels of associations of ideas which are far from arbitrary. I have just given reasons for linking concepts to each other in ways that do not represent ordinary use, yet which rest on those ordinary uses. For example, if we do not know what a mirror is generally used for, the example of the mirror will make little sense. A mirror may be a serious object, it may represent the desire and attempt to report accurately what has passed in front of us. On the other hand, a mirror may distort, and it may be used frivolously to adjust one's makeup or brush one's moustache in just the way that one hopes the object of affection will find attractive. These meanings are linked, although they are also contrary to each other in a way that is familiar in Arabic poetry

within the context of *tibaq*, or antithesis. In early Islamic poetry in Arabic the notion of *tibaq* was important in criticism, since so much poetry of that period quite deliberately created phrases which emphasized the discontinuities and dissimilarities between things. But the word '*mutabaqat*' which was developed from *tibaq* to mean 'antithetical objects', or 'the process of creating such objects', can also mean 'similar objects' or 'the process of matching objects', stemming as these meanings do from *tabaqa*, which has as its basic meaning to bring two things together (Adonis, *K. al-Qasa'id al-khams taliha al-mutabaqat wa'l awa'il* – Book of Five Poems followed by opposites and beginnings).

Adonis is an excellent poet to consider, first of all because he is an excellent poet, and secondly because he writes a lot about the process of poetry. He is representative of much Arabic poetry in his use of sharply contrasting images to make his point. He often blends nature and culture, thus applying to his description of nature the sort of language normally used for human beings, and vice versa. The result is a rich blend of different idioms, and also a linking of the grand level at which the world of nature operates with our very human and petty interests and ideals. For Adonis humanity infuses nature, and he delights in developing more and more recalcitrant combinations of ideas, which due to his poetic skill suddenly seem quite plausible. One of the problems with his work, though, is that it is rather too self-conscious, and so sometimes seems contrived. Because of his adherence to what he takes, not always accurately, to be the poetic principles of a thousand years earlier (Abu Tammam from the third/ninth century is a good example, as is al-Mutanabbi from the fourth/tenth, two poets frequently held up as ideal stylists in Arabic classical poetry) his metaphors sometimes do not quite work, they become formulaic and repetitive. Once he takes on board the principle that poetry involves combining both similar and disparate ideas, there seems to be an attempt to produce the most extreme and natural exercise of metaphorical imagination which as a result is not always natural in feeling. Over time his verse has become progressively more artificial, perhaps to a degree just because he thinks more about the poetic process as such and as a result concentrates too much on the form of what he does and too little on the matter.[40]

There is another interpretation of what has often been taken to be the relative decline in the quality of his work, and that lies in the tragic events through which he lived. Perhaps he could no longer react to those events in the ways of the past, when he was possibly more optimistic of the ways in which history is working itself out through his lifetime. One of the factors in contemporary life which seems to have particularly discouraged him is the growing uniformity of life in the Arab world, the return to religion and its homogeneity, and the whole *salafi* (traditionalist) movement, which sees its future not in unleashing the creativity and imagination of Arab culture but in returning to

the original practices and beliefs of the traditional creators of the religion as a system of practice and belief. Throughout his work on poetry Adonis champions the idea of Arabism as open, strong, dynamic, confident and diverse, and yet in his day this principle is threatened both from within (local authoritarian and cynical regimes, and an increasingly powerful religious establishment) and from without (Zionism and imperialism).

It is an interesting question whether the times can be so out of kilter that poetry no longer makes sense. This was faced in the twentieth century by Adorno, who is often reported as saying that there can be no poetry after Auschwitz. It is not clear what this claim means or even if its various possible meanings are true, but it is an interesting question to raise. Can life be so marked with disaster and retreat that the poet no longer has the confidence to proceed with his or her work? Clearly this is partially an empirical question, and we can see that plenty of poets are at work today in the Arab world, and indeed plenty of Jewish poets were active during the Holocaust. What Adorno's thesis means, it could be argued, is that when the times are completely incomprehensible, then the facts which our language rests upon are radically changed, and as a result we no longer have at our disposal the range of meanings that previously existed. This is where Adonis' more recent poetry falls down; it no longer seems to be confident enough of the world it is describing for the metaphors that used to work to succeed any more. That association of ideas which al-Farabi says is so fundamental to poetry is no longer as smooth as it was, and that affects the aesthetic value of the poem itself. When al-Farabi says that the poem ends in pleasure he does not mean in the pleasure of the reader where pleasure is understood simplistically. He means that the reader feels pleasure in recognizing the unity of the work, the way in which everything fits together tightly and moves on to transcend that poem because new metaphorical expressions have been explored and created, and accepted and developed. So the early comparison of the poet with water was successful, but the later comparisons are tired and ritualistic, and it is surely not by chance that in his *al-Waqt* (Time), one of his later poems, the references to water and ponds seem distinctly stagnant. We may admire the way in which his work has become progressively more self-critical and experimental, although the height of experimentation for him recently seems to be trying to return to much older styles, but it is difficult to admire the lack of cohesiveness in the recent work. It is almost as though he hopes that importing the rhythm of classical Arabic poetry will prevent the audience from appreciating that the aesthetic value of what he does with the language is no longer capable of doing what it did in the past. This may be what Adorno meant when he referred to the impossibility of poetry after Auschwitz, not that there would not be any more poetry, but that what looks like poetry is not really poetry in the earlier sense. It no longer embodies that stable set of meanings and ideas on which poetry rests,

because those meanings and ideas have been turned upside down by the tragic events that have occurred.

Of course, Adonis thinks that his later poems are even better than his earlier ones, that they are deeper and build on the achievements of the earlier work. He also feels that the later poems reflect better the cultural environment of the Middle East and the lack of harmony which seems to have become a fixed feature of the landscape. Many of his readers would argue that tragic times do not imply the need for a different kind of poetry. Poets have managed to perform well in all sorts of situations, and some of the best verse has appeared in very difficult circumstances. Those readers would also criticize his later poems for occasionally rambling, being too long and generally not being successful aesthetic products. They are unsuccessful because they do not move the mind of the reader to link the ideas which Adonis wants us to link. He regards his work as characterized by strong principles of traditional rhythm and structural cohesion, yet the building blocks of the poems often do not work in creating working metaphors and similes. Some critics have responded to Adonis' later work as lacking in *tarab*, in that feeling of appropriateness and purposiveness which a successful poem is often expected to provide in its audience. The earlier poems had it, many have suggested that the later poems do not.

What this discussion is supposed to do is not to show that Adonis' latest work is worse than his earlier work, or vice versa. Certainly hardly any detail has been supplied here of any of his work, and not enough for readers to judge either way. But our purpose is not to comment on the actual poems so much as on the assessment of poetry as such. We want to see how useful the sort of approach developed by al-Farabi, and extended by his successors within the Peripatetic tradition, is. One of the points to be made against his theory is that Arabic poetry is often taken to have more significance than just the aesthetic. The early Islamic suspicion of poetry stems perhaps from its association with the *jinn*, who were supposed to be its creators. The idea that poetry comes from spirits is hardly limited to Arabic culture, nor is the idea that poetry can be dangerous. In particular the love of poetry in the time of the *jahiliyya* was a love of the secular, and Islam was to replace that with what it saw as a more appropriate concentration on spiritual issues based on the truth of religion. In any case there is some evidence that early poetry glorified the tribal community, whereas Islam was intent on celebrating the Islamic community, regardless of its tribal, racial or national origins. It is said that during the *jahiliyya* the rival poets hung the verses of their leading poets on the Ka'ba itself! However, a great deal of secular poetry did arise in the Islamic world, and it has to be said that in fact very little poetry of the past or even today is religious. Perhaps religious thinkers find a different medium for their ideas than poetry, regarding it as of questionable acceptability, as many *ahadith* agree.

A tradition of religious poetry which is genuinely successful in Islamic culture is Sufi verse, and this continues to be written and developed with very variable degrees of success. In modern times the Arab poet has very much seen himself or herself as the representative of society. Poetry in the twentieth century changed radically, often rejecting its classical antecedents and applying new symbols, often non-Islamic ones drawn from mythology, the *jahiliyya* and European poetry. The poet often found himself in a difficult political position as an intellectual in a society which he opposed, and the creation of the State of Israel became a very potent symbol of the humiliation of the Arab nation and its inability to stand up to foreign occupation. Nizar Qabbani, one of the most lyrical modern poets, transformed his content after the 1967 defeat, referring to himself as 'a poet writing with a knife', possibly a reference to the celebrated Abu Tamman poem of a thousand years earlier which describes the sword as providing a much more accurate message than the pen. One of the interesting features of modern poetry in Arabic is that it does not blame only Israel and its supporters, but is equally if not more critical of the regimes and rulers in the Arab world. Sometimes this becomes a descent into a criticism of everything material and spiritual, and this has sometimes led to a search for new ideals and personages to become symbols for renewal. A good example of this is Ahmad 'Ali Sa'id's pen name of Adonis (Tammuz), to represent resurrection after death, and the use in his verse of the myth of the phoenix as a frequent theme is probably not fortuitous. The phoenix is linked with Tammuz, whose blood, according to legend, fertilizes a whole country. Other poets use figures like Ishtar, Baal and so on, and ancient Greek and Arab mythological and historical figures appear often also. Jesus is a particularly popular symbol, representing apparent defeat which leads to eventual victory, and also the propensity of the Jews to kill their prophets.

One theme of particular interest is that cities are corrupt places, whereas nature and the countryside is the repository of traditional values. This is some-times identified with the horror vacui that is said to prevail in Islamic, or at least Arab culture. Arab cities are places controlled by governments and have thoroughly corrupted the values and ideals of Arabic culture. The worst of all cities is New York, which plays a huge role in the Arab urban demonology. A famous poem by Adonis with the title 'A Grave for New York' expresses well the fascination of the Arab world with this metropolis that seems to dominate the world with its intellectual and financial powers, and yet which seems at the same time to be so fragile and accessible. He compares it to a woman both lifting in one hand a rag called liberty while with the other suffocating a child called the earth. Money is the only motivating factor in the city, nothing else holds people together there except the desire to enrich oneself, and it does this at the expense of the rest of the world. The modern Arabic poet, 'Abd al-Wahhab al-

Bayyati, describes New York as 'a ferocious animal' in his 'Funeral Mass for the City of New York', as intent on devouring the flesh and spirit of all who come under its control, and this includes the whole world. A frequent complaint against the city is that those who start out as nationalists and freedom fighters are entranced by its delights and sell their souls to and in it. New York is a particularly acute symbol of this process, being seen by al-Bayyati as sucking people in and transforming them into slaves before spitting them out again.

Poets in the Arab world represent themselves very much as the souls of their nation, and they find it impossible to ignore leading social and political issues. For this reason they have often got into trouble with the rulers of their countries, and many have fled into exile or been murdered by the local political authorities. It would be wrong to give the impression that most modern Arabic poetry is political in nature, because it is not. Most such poetry deals with the sorts of issues that poetry everywhere talks about – personal relationships, love, nature, satire, elegy and so on. But restricting oneself to these topics is not usually an option for the Arab poet. A good example here is possibly the most popular poet in Arabic towards the end of the twentieth century, Nizar Qabbani, previously an Iraqi diplomat, and superb lyricist, who in his earlier work concentrated on romantic themes. Disagreements with the regime in Iraq led him into exile in Syria and then London, and also into his verse not changing but incorporating much more political themes, including his popular 'I'm with terrorism' of 1997, in which he accuses those intent on defeating the Arabs in the Middle East of labelling all resistance as terrorism. In an earlier poem critical of the Iraqi invasion of Kuwait, 'Marginal Notes on the Book of Defeat 1967–1991', he repeats a frequent theme in recent poetry that madness rules, there is one defeat after another, those who die die meaningless deaths, but he adds in an interesting phrase that 'we have lost our voices'. Again this is not an unfamiliar phrase, and it may seem to be obviously false, since is not he as a poet making his opinions known, expressing himself through his poetic voice? He is perhaps making the Adorno point, though, that a culture which is undergoing crisis may lack a voice to express itself, since the facts on which the meanings of the language rest provide no basis for stable semantic connections. Hence the frequent references to madness and defeats being called victories, the led being called leaders and the resistance being called terrorism. It is this sort of situation that brought about the changes in Adonis' approach to poetry also, with his much more fragmented verse, and no apparent attempt at defining a notion of unity within which the oppositions and contradictions in his text can be resolved. Perhaps the incapacity of the individual to believe in a rational structure to history and to the world itself has the implication that the self does not really exist, so there is no point in trying to unify our experience, and our descriptions of that experience.

It is as though the events of the contemporary Middle East have forced its poets into a premature postmodernist stance. This certainly comes out in the work of Adonis, not only in his poetry but also in his many discussions of the aesthetics of poetry. On the other hand the description of this approach as 'postmodernist' should alert us to the fact that it is not restricted to the Arab world, but has quite general application to far more peaceful areas of cultural production. Many approaches to art tend to question the role of the objects of art as signs. Thinking of art objects as signs implies belief in the existence of a stable category of meanings, and further in the idea of a stable world, a world whose basis is logic and is readily comprehensible by our concepts. Concepts and conceptualization (*tasawwur*) seek to enable us to understand the world by shaping our sensations in ways which make sense to us, since unless they are subject to some organization they will be literally meaningless (blind, as Kant puts it). Yet it could be that those sensations are so chaotic that no system of organization will manage to encompass them. It might be that we apply our concepts and they seem to work but as we continue to use them they seem to fail to make sense of the world around us.

What this means is that the ways we link ideas to each other in poetry and other forms of art would no longer occur in the same way, or perhaps in any way. When Abu Tammam plays around with the concepts of distance and nearness –

> Dreams bring her near
> Distances take her far
> She is the near far one

– he produces a poem which works by being able to link two quite opposite ideas, that of being near and that of being far away. Someone may appear to be very close to us when we dream of her, but in reality she is far away, and yet this reality is not the reality of our psychology. We might regard her as much closer to us because we think of her constantly, her physical presence is not that relevant to determining how we think of her. Hence in the last line she is described as both near and far, but in a highly interesting idiom Abu Tamman describes her not as near and far, but as near far, as both near and far at the same time. How can someone be near and far at the same time? Easily, we have just described how, they can be near in thought but far physically, but this is not precisely what he means. He is trying to invent a new expression or concept whereby someone can be not just in one place physically and a different place mentally, but where these ideas are linked semantically, even though they appear to be opposite to each other.

There is a well-known modern Urdu poem by Parveen Shakir which compares a lover to perfume. It starts:

He is a fragrance, and will be dissipated in the air
The question for the flower is, where will it go?
I thought that it is only a wound, and will heal
How could I have known that it will become part of me?
Like the air he keeps wandering from house to house
He is a breath [of wind] that will come and go ...

The last word of each couplet is *jayeega* where this means go, pass, flow away, and this produces a very effective aural quality in the verse, which is so important a feature of Urdu poetry and its main form the *ghazal*. The image is of a person as a fragrance, and yet having power, since it can end up anywhere. The speaker regards the fragrance as having become an essential part of her, as having got into her veins, as it were, and yet also as not being as committed to her as she would like. The idea of a lover as like smoke or fragrance or a gust of wind is interesting, it works well in capturing the changeable nature of love and the fact that one is often much more attracted to someone than the object of attraction is in return. The idea of love as like a wound is interesting, not unfamiliar of course, but when connected with the concept of the lover as like something in the air it leads to ideas of corruption and infection that make the poem slightly more serious. The general theme is the contrast between the solidity of the speaker, who like a flower is just there waiting for the lover to come to her, while he is like something entirely insubstantial and may or may not come. The word repeated at the end of each couplet is as we have said a word which means go or pass away, and establishes an atmosphere of insecurity, change and instability.

How does this operate? According to al-Farabi, we link the terms in imagination, and that means there is a middle premise somewhere which makes this possible. Yet the middle premise does not make the exercise of imagination inevitable, that is the interesting feature of imagination: when it comes into play nothing becomes inevitable. Yet the more successful an artist, the more inevitable he or she can make an exercise of imagination appear. In the poem by Abu Tammam we are encouraged by the spare style of the poem and its combination of lyricism and brevity to weld together the ideas of something being far from us with the idea of something being near, or the idea of a person being like a fragrance, in themselves quite incompatible ideas. The middle premise would be in terms of the concept of distance, and how distance can be seen in a variety of different ways, and of the concept of the lover, and how he could be seen as like something insubstantial. Of course, anything can be seen in any way, but it is not easy for us to carry out this sort of seeing, we need to be helped to make the imaginative leap by being persuaded that it is not only possible, not only plausible but in a sense inevitable. The power of poetry is revealed when we not only think of the subject in the way the poet suggests but

we can no longer think of the subject in any different way at all. At least within the context of the poem we become part of a world of meanings in which the new semantic relationships established by the poet take us over, at least temporarily, and enable the whole train of thought the poet establishes to get going. The idea of persuasion is highly relevant here, since the mashsha'i thinkers tended to see poetry as the weakest logical form, one step down from rhetoric. Rhetoric is about persuasion, and its result is a proposition which we are encouraged to accept, but we are encouraged to accept it not only for logical reasons. The proposition is again not inevitable, it would be possible to reject it if, for example, we do not accept the propositions that make up the premises of the reasoning process, and it is not inevitable that we accept them. This is different from poetry since the result of poetry is a feeling, based on propositions certainly, but it cannot be a proposition only. Yet it can go on to create other propositions, as when a new imaginative connection creates a new concept which then goes on to create other connections.

The falasifa on poetry

Does al-Farabi's theory really avoid being guilty of psychologism? The linchpin of the theory is the way in which one image can generate another, and that definitely seems psychological. Although the process is described syllogistically, it does not seem to be a real syllogism, since the conclusion is only effective if it is connected in a particular individual's mind with the premises, and this is hardly what a syllogism generally means. One would expect the conclusion of a syllogism to compel assent, since it is the only conclusion that one can derive given the premises, yet this is far from the case where poetry is concerned. Readers may make all sorts of semantic links, and do not need to use the range of connections that are listed in the syllogism.

 These objections did not lead to a rejection of the general theory, but to its subsequent refinement by ibn Sina (d. 429 AH/1037 CE) and ibn Rushd (d. 595 AH/1198 CE), two thinkers who continued the Peripatetic tradition so firmly established by al-Farabi. The former defends the use of the syllogism as explaining the structure of poetry, but with premises consisting of emotions and conclusions of pleasure. Yet this seems not likely to succeed since it is impossible to confine the range of associations of even one line of poetry to a narrow set of emotions and images. Ibn Sina accepts this, but suggests that we can escape this vast indeterminacy by concentrating on just one aspect of poetry, and that is the pleasurable associations which it evinces. Pleasure only emerges when there is a particular harmonious interrelationship of parts, and so the range of what a line of verse may be taken to mean can be severely reduced to encompass only those meanings which are capable of leading to pleasure in the reader or listener. He

borrows from the hermeneutics of the grammarians to suggest also that a particular poem generally falls into a specific category of verse, and this further restricts the range of meanings we need to consider. A tragic verse does not lead to the same sort of interpretation as does comedy, for example, although they both require interpretation. Genre restricts what is acceptable, and so forms the context within which the aesthetic syllogism works.

How objective are such syllogisms? They are supposed to be as objective as any other syllogism, since the pleasure which serves as the conclusion emerges out of the entirely objective characterization of different forms of harmony between the constituents of the work of art. Not just anything can lead to pleasure in a poem, say, since not just anything can produce harmony. This is a strong thesis, since it follows that only noble works of art can produce the syllogistic conclusion including pleasure, since only such works are capable of producing harmony. After all, harmony is a state of agreement and balance which is not attainable if what is in question involves conflict and corruption.

In his development of this theory ibn Rushd places emphasis on the ability of poetry to be true. Harmony is a reflection of a connection with truth, in that it represents a plausible linking of diverse ideas, and if the links are weak and tenuous, then the harmony that results is likely to be similarly weak and tenuous. Of course, poetry is not obviously linked with truth at all, since it makes various claims which literally are false and not only false but also obviously false. But if looked at in the right way the verse may hide beneath the surface a route to the truth which is valuable and makes the line work, and the poem as an entirety work. It then results in the pleasure that the audience feels when reading it or listening to it. And they are justified in feeling that pleasure, since the harmony produced by the artist brings out some interesting feature of the real world, and ultimately of our relationship with God (since this world is a God-given world). So although the conclusion is in terms of the pleasure felt by a subject, it is not subjective because the subject is entitled to feel that pleasure and indeed must feel that pleasure given what he read or heard.

It is worth saying how poetry fits into the organon, the arrangement of different kinds of argument, in the system of ibn Rushd, and indeed also of his predecessors. Each type of discourse has an argument form corresponding to it, and each argument form is deductive and can securely move us from premises to conclusion. But the strength of the conclusion is irretrievably affected by the nature of the initial premises. The best form of argument, demonstration, uses as its premises propositions which are themselves both true and necessary, so the conclusions one derives from them are universally valid. The next best form is dialectic, the sort of reasoning which goes on in theology and law, and is based on a particular text or system of jurisprudence, and the eventual conclusion is only valid for those who accept the premises, for those in fact who accept the

religion and the system of law. Poetry calls for a particular exercise of imagination, and derives conclusions about what one ought to be able to feel pleasure in as a consequence, but will only work if that imaginative effort is plausible. And that depends very much on a particular education within a culture and a language. For people who do not share that culture and language the conclusion has no strength, since it applies to premises which are of no relevance to those people. Poetry comes at the bottom of the forms of reasoning in the organon, according to ibn Rushd, since it rests on the weakest deductive premises, those linked with the ability to make certain imaginative leaps, which themselves rest on participation within a particular form of life. For some people, though, this type of argument, and it is an argument according to ibn Rushd, will be very effective, since there are some people who find it easy to use their imagination, and an important source of information is thereby available to them through this method. Indeed, the Qur'an itself uses poetry for this purpose, to help those for whom poetry is important to understand the truths that lie within the message of Islam.

This connection of poetry with religion is perhaps the weakest aspect of the mashsha'i notion of the truth in aesthetics. Since poetry is used in the Qur'an, although this is far from claiming that the Qur'an is actually poetic, it cannot be false and entirely fantastic in its content, for that would imply a questionable attitude to what we find in the Qur'an. At least that is the case for scriptural poetry, and such verse has as its point getting over information, ultimately information that will play a part in the salvation of the reader and hearer. But even in secular verse the connection with truth is important, for ibn Rushd a metaphor only works if it connects things which actually do share something in common. Unsuccessful images are those which are not true, which try to relate things that cannot really be related, since so little of what is true of the one is also true of the other. The metaphor then breaks down, and any reasoning built on it would be similarly unsuccessful, since it would not work and so could not produce the pleasure and harmony that it sets out to construct. The concept of imagination is very different from the notion that exists today, as the ability to think in any way whatsoever. For the mashsha'i thinker imagination is quite simply a source of information, and any other understanding of it represents a descent into the subjectivism and psychologism of the literary thinkers, a descent which they were very keen to avoid. For once one accepts that imagination is up to the individual, there is no longer any scope for deriving objective criteria towards anything that it produces.

Interestingly, the ishraqi or illuminationist school of philosophy also tried to establish an objective basis to imagination, albeit from a very different theoretical framework as compared with the Peripatetic thinkers. Illuminationist philosophy seeks to replace Aristotelian ways of analysing the world by using

light and related concepts instead of subjects and their properties. Things are more and less real depending on the amount of light in them, and the realm of imagination ('alam al-khayal) lies between this world and the entirely theoretical and intelligible world from which the light ultimately comes. Many commentators resist calling the 'alam al-khayal the imaginary world because they feel that this implies that it is unreal, and they are right to have this worry, although as I have argued elsewhere we should still call it the world of imagination. What happens in this world is that concepts become adapted so that they can apply themselves to matter, but this does not happen until they are applied to the lower world, and so these concepts are sometimes referred to in ishraqi thought as hanging forms (al-suwar al-mu'allaqa). They are hanging because they are waiting for matter to inform, as it were, and they do thus represent the imagination, since this is precisely the realm where ideas exist and relate to matter in rather indirect ways. The ideas can reflect what happens in the material world, as when we dream about what happened to us yesterday. They can predict what is going to happen, and they may just represent a playing around with notions of what might exist, what could happen, what things would be like if they were very different from our experience, what we would be like if we were very different, what it would be like to be in an entirely different environment and so on. Although these images are not real in the sense that they are not actually accurate representations of what is happening then and there, they are real in that they relate to the real world, and indeed they might be taken as even more real than what happens in the real world of our experience since the imagination also makes reference to what lies behind and beyond our experience. Our fantasies, for example, are certainly an important part of us, even though we may never bring them into actuality, and phantasia is precisely the Greek word for imagination.

The world of imagination is the source of the forms which are used in art. They cannot come from the world of matter, since art is far more than just matter, it is a playing around with matter. Nor can it come from the world of pure ideas, since art is meaningless unless it has some material form, and even the most abstract art has to be embodied in some way. The advocates of abstract art in the twentieth century sometimes argued that an art object was much purer, more abstract, if it was not actually created, but there would have to be some physical representation of it, a drawing perhaps, or some words.

Imagination mediates between these two worlds, rather in the way that the barzakh in the Qur'an comes between our world and the afterlife in which we may enjoy the rewards and suffer the punishments consequent on our behaviour while we lived in our world. The barzakh participates in both worlds, like the porch on a house which is both part of the house and also part of what is outside the house. Now, this could be taken in two different ways. Some argue that the

world of imagination is objective and connected to higher levels of reality, and so art is only of significance if it is sacred art, if it participates in these higher levels of being and purifies itself, as it were, by looking up to the world of ideas as opposed to down on the world of generation and corruption. This is very much the thesis of Seyyed Hossein Nasr[41] and supports the view that Islamic art is a kind of alchemy that transforms the corporeal into the spiritual and vice versa. He is quite right that there is a constant theme in Islamic philosophy which represents art in this way, as having salvific significance, and if one sees the language of the Qur'an as just attractive literature, then one has missed a great deal of what the text is all about.

Yusuf and Zulaykha again

This thesis is given a delightful twist in al-Suhrawardi's (d. 587 AH/1191 CE) story about Joseph and Zulaykha. This story (*Risala fi haqiqat al-'ishq*) starts off with a long involved discussion about the creation of love and beauty, initially connected ontologically and later on in the person of Adam, the perfect being created by God. Nasr tells us that the angels bow to him not because of the clay from which he was made but because of his beauty (ibid). Yet it is worth pointing out that when the angels complain to God about being instructed to bow to Adam (this is not something they want to do, God orders them to do it), God does accept that they are more perfect than Adam, and that with their free will human beings will bring great sorrow on themselves. Yet God will guide them and give them the opportunity to live well and behave themselves, and we have the task, unlike angels, of representing God on earth. As we became contaminated with earthly life, so beauty packed up its bags and left us alone. We became difficult to love, until, that is, we get to Joseph. He suffers through the treachery of his brothers, the blindness and despair of his father, the love of Zulaykha, his rejection of her, subsequent imprisonment, his ability to under-stand dreams and predict the future, his eventual success and forgiveness of his brothers, and his final ability to heal his father Jacob. His actions are so exem-plary that beauty becomes part of him, and the implication is that throughout human history particular extraordinary human beings will be characterized in this way, by attracting the light of beauty and love through the strength and veracity of their actions. Their actions, in other words, connect them with the objective moral standards that God wishes us to employ, and their steadfastness in following these standards leads to their literally becoming 'lit up' by the light of grace stemming from heaven.

All this serves to show, Nasr argues, that in Islamic art what is going on is the creation of a link with a higher reality in which the stable standards of beauty and truth exist and reveal something of themselves in our world through

both our ethical and our aesthetic activity. This thesis is developed in some detail in what might be called Sufi aesthetics, the idea that the beauty of art is reflected both in the beauty of the artist's soul and in a higher level of reality, where it brings out something of the glory of the divine being himself. So the artist has to be himself a morally and spiritually advanced sort of person, and his work is the progressive revelation of the inner in the outer, as it were. He brings out in his work the nature of how things really are, and how misleading the objects in our world are if they are what we think is really important, or if they are all that we can discuss in our work. Two Sufi notions are important here, the notion of *kashf* or unveiling, and the notion of *dhikr* or remembering, and through both of these processes we come back to the state of affairs that we experienced far earlier in our career as human beings, spiritually speaking. As Abu Hamid al-Ghazali suggests, there is a danger that in looking for beauty we will be satisfied with the superficial and physical. As his brother Ahmad points out, when compared with the beauty of inner reality, the 'beauty' of what conceals it is really nothing but ugliness. A fine balance has to be maintained, between using the images of this world to help us delve deeper behind this world, and yet still delighting in those images, since they are provided for us precisely for that purpose, to delight us and also to provide us with the opportunity to see beyond them. The angels can presumably know what the real nature of beauty is since they are independent of our world, in just the same way that they always know how to behave. But is this so desirable? Is it not better to be in the position of having to work, to find out where beauty lies and to use our senses to pursue beauty both in this world and in the next? It might be thought that because it is better, the angels were instructed to bow down before Adam. They do not need to cope with the difficulties of materiality, but they do not then have the ability to appreciate beauty in the way that we can.

In the *Mathnawi* Rumi tells us of a competition between the Chinese and the Greeks over the most beautiful screen that could be painted (I, 3465–85). The Chinese take over the side of a room and get to work on it, using the King's 'hundred colours' and working on it steadily. But the Greeks concealed what they did, although they seemed to be polishing away at an equal rate as the Chinese were painting. When the Chinese were finished they displayed an extraordinarily beautiful painting, but the Greeks produced a burnished mirror, which then magnified the beauty of the Chinese painting. They were said to have won, and they won because they stuck to essentials. Colour is linked by Rumi to the clouds, it conceals and confuses, while colourlessness is related to the moon, and we are told that whatever illumination arrives in the clouds comes originally from the moon and higher celestial bodies. So colour is a physical property of which we should remain cautious; what is significant is our ability to get in touch with what is higher than us, with what is real, and this the

Greeks manage to do. On the other hand, when we examine the story more closely it is not so clear that this is what happens. They manage to reproduce the Chinese picture and make it even more radiant than it is originally. Anyone who has ever seen Persian miniatures will appreciate the Persian ability to incorporate an enormous amount of light into their pictures, even on what are after all the pages of books. But what the Greeks do is to make what the Chinese do a bit brighter, that is all, and if Rumi is a bit critical of the colours that the Chinese use, then he should be even more critical of the Greeks, since they make the colours brighter.

On the other hand, the meaning of the story might be something very different. It may not be critical of colour at all, but rather of the idea that we can do anything significant in so far as art is concerned. The Chinese thought they could, and what they accomplished was impressive, but not as impressive as the impact of nothing more than light and reflection on their work. The Greeks could be seen as modest, only working to increase the ability of light to illuminate what already exists, while the Chinese presumptuously seek to outdo the glories of nature. Of course, it is ironic that an attack on art should appear in a very skilfully organized poem, but then so many attacks on art do use art to make their point.

In his analysis of this passage Nasr definitely tends to the Platonic inter-pretation. Islamic art is a matter of dissolving the straitjacket of external form in favour of the indefinite rhythms of form, space or sound, which opens the soul to the reception of the presence of the One who is both absolute and infinite. The source of this art is the truth which resides in the Qur'an, and we seek to use it to make more beautiful our everyday existence. This involves remembering God and the beauty of the world above, which we tend to forget, but not entirely, while in this world. However far we travel away from God, his face still remains (2.115) and through Islamic art we can recognize aspects of that face in the world. I am not sure that this story really emerges in the Rumi passage, although it certainly does in other aspects of his work. After all, the Greeks were entirely dependent in what they did on the Chinese artists doing a good job, since whatever they had created would have been copied, and surely to copy a poor work would have been to make it even worse, since its impact would have been magnified by the polishing of the surface. In one version of the story the Greeks are said to have won the competition and their reward is a pile of money, which is given to the Chinese artists. All the Greeks get is the reflection of the money!

The Greeks won because they produced the most staggering picture. They produced the most staggering picture (when the King saw the Chinese picture, Rumi said it was as though he had lost his mind; when he saw the reflection his eyes almost dropped out of their sockets) through indirect action. They trusted in God to supply them with an adequate image to reflect, and they doubted

their ability to produce the image directly. In a sense, of course, it is God who produces everything, and so the artist is only successful if he follows God and works with God in his creative endeavours. But what does this mean? We do not know what the Chinese drew, apart from the fact that it was very colourful, but we can assume from the structure of the competition itself that they were confident of their ability to create, and we may worry about the acceptability of that from a religious point of view. The Greeks seemed only confident of their ability to copy, a far milder form of action, and one which respects the notion of significant action as stemming from elsewhere. Yet it has to be said that as artists the Chinese were superior, since they actually had the skill and energy to make something new, all the Greeks could do was copy it, and plagiarism is hardly an aesthetic virtue. Perhaps Rumi is hinting here at the way in which the creativity of the artist to a degree mimics the creativity of God, and may seem to go too far when it is proud of its accomplishments. What we need is a sense of balance, that sense of balance which is often taken to repose in Islamic art, and which serves as the theme of so much of Rumi's work.

Before we examine how he develops this point, it is worth thinking a bit more about how the idea of the mirror is used in religious thought. The Sufis make much of the verse 'What they were earning was overshadowing their hearts' (83.14), which they interpret as the mirror of the heart being over-whelmed by the rust of evil actions and thoughts. What is required is that the individual polishes his mirror by constant recollection of God so that the heart can reflect the divine light and avoid being contaminated by dust or rusty accretions. Some Sufis go so far as to suggest that even breathing on the mirror of the heart, i.e. speaking, is to interfere with its purity. There is a hadith, 'The believer is the believer's mirror', which suggests that each Muslim is responsible for the evil deeds, and also the good deeds, of everyone else in the *umma*. It also suggests that if one sees a negative characteristic in someone else, then it is probably in the viewer also. This is presumably not true of God, who in another hadith refers to himself as a hidden treasure who wants to be discovered. He created the world as a mirror in order to contemplate his own beauty, and the best way to acknowledge the beauty of something is merely to look at it. Rumi reproduces this idea in the *Mathnawi* when he talks of bringing a gift to Yusuf, the exemplar of perfect beauty, and the only appropriate gift is a mirror so that he can contemplate himself. If something is already perfect, then nothing more can be done for it, and this is one of the chief problems with explaining the creation of the world. Why would a perfect being create something which is not perfect, why would he feel that this is something worth doing? As this is expressed in the language of Neoplatonism, why would something perfectly One lead to the creation of the many? Why would God think about anything other than himself? These issues were problematic for the Islamic philosophers, and the last

issue came strongly into their approach to divine knowledge. Many philosophers such as ibn Sina argued that it is inappropriate to think of God having know-ledge of the individual and changing matters of the world of generation and corruption. There is a good theological reason for denying such knowledge to God, since if he had as objects of his thought items in our world then he would have changing objects in his mind, and this would imply that he changes. Yet he is supposed to be unchanging. There is another reason, this time more aes-thetic, and this stems from Aristotle's suggestion that there are some things which it is better for God not to know. Why should he concern himself directly with anything which is not himself, since everything which is not himself is impure? If God feels any emotions, *nostalgie de la boue* is certainly not among them.

Zulaykha wanted to unite with the object of her love, Yusuf, just as the person in love wants to unite with the object of her love. She is attracted to that object, while the object is itself unmoved by those that are in love with it. One of the nice aspects of the story of Yusuf is that he never appears to change during all the things which happen to him on the Qur'anic account. Even when he is in prison and he has the opportunity to leave it, at the command of the ruler, he remains where he is until he is entirely satisfied that the ruler is certain about the innocence of the prisoner. He just tries to preserve his integrity, and the rest of the world revolves around him, like the planets around Aristotle's unmoved mover. Aristotle characterizes that relationship as one where those who are in love with the mover do things in response to that love while the mover remains unmoved, everything else just moves around him in response to his being, not to anything he does. Some of the Persian illustrations of the story of Yusuf show him pursuing Zulaykha, and yet the Qur'anic story does not have this in it. Towards the end of the account he marries her, but this is at the stage where she has rejected idolatry, become reconciled to her fate as lying in the hands of God and where she engages in prayer. In the narrative, she is now old, and has white hair, but once he acknowledges the sincerity of her feelings, and prays on her behalf, her beauty is returned to her. That is, she can participate in his beauty, since she has become his mirror, she has accepted in her heart what has always existed in his heart, belief in God. So when he looks at her he for the first time sees a reflection of himself, albeit a partial reflection, and this is the appropriate time for them to be united in marriage. After all, they have now become the same sort of person, for a mirror to be able to reflect it must be appropriately structured to carry out that function. The world can represent the beauty of God, to a degree, since it consists of objects that are very beautiful. Similarly, Zulaykha can represent the beauty of Yusuf, the paradigm of beauty, once she becomes spiritually purer. When her thoughts of Yusuf were material and sexual he could find nothing of himself reflected in her, and so he turned away from her and tried to evade her. Once she became more like him, she became attrac-

tive to him and it is worth pointing out how unlike ordinary human attraction this intellectual and moral form of attraction might seem to be. We are notoriously attracted to that which rejects us. The more Yusuf rejects Zulaykha, the more she wants him, and it is a theme of romances that nothing puts off a fervent lover so much as a fervent positive response. The language of love is often structured in the form of a hunter and the hunter, a pursuer and the pursued, a man and a woman, and certainly was in much of the literature of the Islamic world, and still is. In the illustrations of the story of Yusuf, lust is rarely far from the surface, the lust of Zulaykha for Yusuf, of her friends for him, and so on. When Zulaykha dreams of him, for instance, she often adopts a very unmaidenly posture, it is clear that what she has in mind is something very physical. His rejection of her merely makes her want him even more. That is because the relationship which she is trying to establish is built on a misunderstanding, she is after a physical relationship while he is interested in a spiritual relationship, one in which physicality would enter but not as its prime motive. When he looks at her he does not find a reflection of his inner beauty, since her heart is not acting as a mirror. When she looks at him his heart does not act as a mirror to her feelings, since he is not interested in a largely carnal relationship with her. This makes her more excited, but does not stimulate him at all. Both hearts are like mirrors covered in dust, since they are unable to find anything in what they are asked to reflect which accords with their wishes. Zulaykha is not interested in his real feelings, she is overcome with lust, and so her heart really is clouded over by her emotions. When she becomes old the dust is blown off, since for the first time she can appreciate her relationships with others in a calm and collected manner, and then, paradoxically, she reaches a state where she can really get a response from Yusuf that is passionate. So this form of love is not so different from the notions of love and attraction with which we are normally acquainted. Harmony is finally attained when both people come to share the same views, but their route to this end was not smooth, and despite the sufferings which they both had to endure, they might conclude that it was better to suffer in that way than to reach that end automatically, as it were. That is perhaps why the angels were instructed to bow to Adam, not because Adam was more perfect than them but because he and his successors had the opportunity, denied to the angels, of trying to work out how to live and establish relationships with others in the world of generation and corruption.

One of the attractive features of the story is that it is open to a range of interpretations. This comes out so well in Jami's long poem which elaborates on the Qur'anic account, a work written in the ninth/fifteenth century. It is not precisely the same as that account, it is a poem. So it is not difficult to accept that there are a variety of interpretations of the poem. But of course there are also a variety of interpretations of the sura in the Qur'an itself; if there were not

differences of interpretation there would not be the need for the vast traditions of *tafsir* or commentary on the text. The story of Yusuf and Zulaykha is presented time and time again pictorially, and with its heady mixture of passion, desire, violence and ultimate redemption it is clearly the stuff of popular entertainment and spiritual instruction. Quite a few of the illustrations are very humorous; we should not assume that just because this is a religious story it has to be treated with great solemnity throughout. As in all stories, we require a balance between the different aspects of the narrative, and if some are deadly serious and spiritually uplifting (not that these necessarily go together, of course) others can be amusing and quite subversive. What is important is the balance of the whole story, and that balance is crucial to its aesthetic success as a work of art, so when we look at each individual illustration we should bear in mind that these are really parts of a much larger sequence, meant to be read in sequence. Or are they? One imagines that the stories were familiar, and that readers would not necessarily read them from start to finish, but would return to those pictures which they find most impressive, or sexy or in accord with whatever interests them. That is what we do if we are looking at these pictures from the point of view of someone for whom the story on which they are based is not well known, or not known at all, and certainly not part of our culture. We may still find a good deal to interest us and even excite us aesthetically in the illustrations, for each illustration represents an individual exercise in graphic balance while the whole series represents narrative balance. We do not even need to know what the story is about, who the participants are, when they were painted or indeed anything about the whole genre. We can still admire the composition and in particular be completely bowled over by the exuberance of the colours and textures. So these pictures work at a number of different levels, and we should not insist that they are only acceptable aesthetically if they accord with just one understanding of what they mean.

Persian poetry

The thinker Muhammad Iqbal (d. 1357/1938) was very influenced in his work by the poetry of Rumi (seventh/thirteenth century) and Hafiz (eighth/fourteenth century). As well as writing philosophy, he was an exceptional poet, and the style of his work in both Urdu and Persian, is impressive. Yet we do not normally make that much of a distinction between Rumi and Hafiz, in so far as their ideas go. That is not to say that they are indistinguishable, obviously they are not, but they both seem to be committed to the same sorts of theories and even similar ways of expressing those theories. In particular, they are both advocates of a particular form of Sufism, and their poetry expresses their commitment in a direct way to that way of thinking.

Is there any important distinction between the ways in which they express their characteristic views on our relationship to God, and the nature of love? It is difficult to think of one. They both emphasize the importance of the distinction between reason and the emotions, and the lack of reason in the phenomenon of love. I think it is this which interested Iqbal, the danger, as he saw it, in an overemphasis on the emotions when considering religion, and the consequent lack of an appropriately rational attitude to what is involved in being a believer. This hits at the nub of the issue, although religion clearly involves the emotions as well as reason, an emphasis on the former can lead to too little attention to the latter, and it is important for us to realize that there are things which religion instructs us to do which have a rational basis and explanation. The opposition which took place for a long time within Islam to forms of Sufism was based on the apparent antinomianism of that form of thought and practice, the idea that Sufis would think that once they had established a primary relationship with God they were not any longer under any obligation to carry out the laws and obligations of ordinary Muslims.

It is the particular emphasis on love which helps to give this impression of the essentially emotional side of our relationship with God. As is well known, the grounds of love can be quite arbitrary. Although later on one can see why one might have fallen in love with someone, at the time it can be quite mysterious, and even after the event it may be inexplicable. So one of the worries which Iqbal had in the sort of imagery which Hafiz uses, by contrast with Rumi, is that the relationship of love between human beings and God may be given an emotional description which identifies it as irrational, inexplicable and also to a degree outside of our control. This seemed to him to be inappropriate as the relationship between the creator and his creatures.

Following on from this idea, there is the notion that the sort of love which exists between us and the deity is not that easy to distinguish from ordinary love, the sort of love which exists between human beings. The trouble with this form of love is that it is physical and so characterized by all the frailties of human relationships. For example, it is famously difficult to distinguish between physical love and lust, where the attraction between two people is entirely based on physical attraction, and this is hardly appropriate as a description of our relationship with God. Yet one of the ways of describing love in general, which both Hafiz and Rumi use, is precisely physical love, and one might think that in doing that they are going beyond the bounds of acceptability for Muslims. After all, God does not have a body and so one should not relate to him as to someone with a body. On the other hand, for the Sufis it is important to relate to God in more than just an intellectual sense. The whole concept of *dhawq*, or taste, which represents an aspect of the desirable character of our relationship with the divine is expressed in physical terms, to get over the point that our relation-

ship needs to be based to a degree at least on our physicality, on our nature as material creatures who experience through the senses.

The emphasis on the physical may lead to a lack of emphasis on the spiritual. What is significant about the difference between God and his creatures is precisely that he is not material, and treating him as material is a well-known form of *shirk* in Islam. But for the Sufis, treating God as an immaterial being is also problematic, in that it implies that we can separate ourselves from him and clearly distinguish who we are from what the divine is. The work of ibn al-'Arabi is interesting here, in that he emphasizes the significance of not distinguishing between ourselves and God. He argues that in a sense everything is in God and is a part of God, and we ourselves are no exception here. The comfortable distinctions made by religion between the divine and the secular, between the lower and the higher, are undermined by him with his insistence that this isolates our world from God, and in a very real sense drives God out of the world.

This is a point we need to bear in mind when we consider the criticisms of writers like Rumi for their apparent confusion of secular and religious forms of love. The attempt by religion to make a strong distinction between different kinds of love should not, Rumi would argue, obscure the fact that when we talk about loving God, or God loving us, we really mean the very same sort of love as we find in our lives. This might seem terribly irreligious, as though Rumi is claiming that God is very much like us, a charge which many also brought against al-Ghazali when he insisted that we should understand language when applied to God as the same sort of language as we use to describe ourselves. But the point here is that if our language about God is to be really meaningful and vivid, if it is to represent what we really think is important in our lives, then it must use the terms which we normally use and also use them in the same sort of way. Does this mean that when we talk of loving God we mean it is just like loving a fellow human being? Well, in a sense it does mean this, in that since physical love is often the most important part of our lives (during a particular period at least), then loving God must be understood similarly if it is to have an even greater significance than our ordinary form of love.

Why does Rumi stress the non-rational aspects of love? One point which he makes time and time again in his verse is that love is itself a source of considered action, it creates reasons for having feelings. This puts the relationship between love and reason within what might be called a rational context, and for the first time we can see the major contrast between Rumi and Hafiz. For Hafiz there is something basically irrational about love, it is not that love is itself the source of reasons but love stands in the way of reason, it directly sets out to oppose reason. Now, we are familiar with the fact that love can often induce us to act in ways that are unreasonable, in that the reasons which love creates turn out to be on a broader conspectus not reasons at all, but merely

causes of action. This is the contrast on which Iqbal comments; Hafiz goes too far in distinguishing between love and reason, and as a result the notion of love becomes inappropriate as the attitude of the individual to God. In Nietzschean terms, it is Dionysian rather than Apollonian, it has too much frenzy in it and not enough deliberation. We need to recall here something very important about religion in general, and Islam in particular, and that is the very marked role which reason plays. The Qur'an repeats many times that the truth of what it reports can and should be assessed by reason, and it has been argued that if religions were to be classified in terms of degree of respect for reason, then Islam would surely rank as the leading faith. But what is positively dangerous about the approach of Hafiz is that an emphasis on the passions can so easily lead to a form of religious expression that goes against the main principles of the faith itself. Rumi's verse provides much more of a balance between the carnal and the spiritual, between the secular and the divine, between the immanent and the transcendental, while Hafiz by contrast often gets the balance out of kilter, he tends to represent these dichotomies as standing in opposition to each other. By contrast, Rumi's verse is so successful because he emphasizes their harmony, and it is in this that his great popularity in countries which are unable to read him in the original and which do not on the whole share his religious ideas rests. Commentators often rather sneer at his great popularity in the English-speaking world as though his readers are missing a great deal of his thought and only assimilate what they seek to find in the text. To a degree this is always true, of course, but in an important sense it is false. What American readers, for example, find in Rumi is a perfect expression of the unity of being, and the illustration of this unity through the medium of love. The smooth move from the ordinary to the extraordinary, from the physical to the spiritual, and back again, this *wahdat al-wujud* type of balance, is what his American audience quite rightly gets from his work.

Some commentators criticize the translations of his work – and there is always scope for this – in particular attacking the way in which Rumi is presented as someone without a commitment to a particular faith. There is often emphasis on those of his verses in which he appears to present a universalist message, and where the specificities of Islam are absent. Now, there is no doubt that Rumi is a strong and passionate Muslim, but that is no reason why he should not also be a universalist, in the sense of praising and accepting other, in particular *kitabi*, faiths. For Islam there is nothing wrong with Judaism or Christianity, and sometimes the class of people with a book is extended to cover other important religions also. For Sufis the whole world worships God, even the flowers and trees acknowledge the divine being, in a sense, and there is no particular religious commitment in operation here, merely the idea that the world as a being is infused with the love of God and tries to reflect that love.

Rumi was writing for a Muslim audience, there was no need for him continually to bring in specifically Islamic themes, but in any case there is no reason for this since he saw all the forms of expression that he used to describe the world as Islamic, albeit often shared with those of other faiths.

Let us consider briefly Rumi's characteristic form of expression, the *ghazal*. Hafiz of course used the same form, and was obviously influenced in that use by his predecessor, but they used it in different ways. Rumi took very seriously the facility which the *ghazal* provides of balancing and contrasting ideas and emotions, in particular using brief forms of expression to produce crisp, contrasting and highly focused points. Hafiz tends to use the *ghazal* to get somewhere rather different from where he started, and there can be no doubt that he does this wonderfully on every occasion. But one could say about Hafiz that the ideas and expressions he is producing are not always apparently under his complete control, as though he was transported by his emotions and what lies behind these emotions to write as he does. This can, and does, make for very effective poetry, but from a theological point of view, as Iqbal suggests, it is rather dangerous. Who knows where the extravagant use of language and feeling will end? This is not an aesthetic criticism, of course, but rather religious in nature, suggesting that a form of aesthetic production is at its highest when it is capable of capturing religious truth as well as poetic beauty.

One important source of inspiration for Rumi was undoubtedly the *Nahj al-balagha*, which tends to be critical throughout of what it regards as worldliness, i.e. treating the events of this world as being of great significance. But although the *Nahj al-balagha* is highly critical of an over-enthusiastic attitude to the everyday world, it is by no means ascetic either, emphasizing the significance of a balanced spirituality. This could be taken as the leitmotiv of his approach in the *ghazal*, to criticize rejection of the world but at the same time to criticize seeing the world as the only important arena for human action. It is this balance which Hafiz rather puts behind him, with his characteristic imagery of love and wine, we start with the ordinary and end up somewhere quite different, with a heightened understanding of how far one can transcend the everyday and be transported to somewhere quite different. Yet Rumi plays on the numinosity of the ordinary world, the fact that one can see so much higher meaning in it and yet (pace Hafiz) that it is in the end exactly the same place it always was. The spiritual is not something to add onto the world, it is there all the time in the warp and woof of the world, the ordinary and the transcendent being part of the one accurate description of reality.

One of the problems with Sufism is its treatment of love. The distinction between *eros* and *agape* in Christian thought is also quite often referred to in Islam, where the notion of secular love and the form of love appropriate towards the deity and from the deity are sharply distinguished from each other. The

advantage of this is that it places our attitude to God in a context that it is relatively easy to describe, that we relate to God not as a person like other people, but as someone so unlike everything else of which we have experience that our love for him has also to be utterly different from every form of love with which we are familiar. Since love describes a relationship it is appropriate here to think of the ways in which we have a relationship with God, and how close that relationship can be. There are two notions of relationship which are relevant here, *ittihad* or unity with the other, and *ittisal* or contact. When al-Hallaj was executed and said 'Ana al-haqq' he was using the first form of relationship, where he claimed to be the same as God, albeit by this he probably meant that he was a part of God and that the human participates in the divine through having been created by it. It is characteristic of love that the lover feels as one with the beloved, and for the Sufis the sort of disinterested abstract form of love that we might have for a disembodied and distant deity is not at all appropriate for the passionate attitude which we can have for God. The sort of contact characterized by *ittisal* is both polite and formal, but not close enough for the Sufis. But is *ittihad* too close? After all, the secular lover may claim to be one with the object of his love, but he is not literally one, there is a distinction between them, as swiftly becomes apparent once the initial honeymoon period is over. But the Sufis would say, and Rumi repeats on many occasions, that the link between us and the divine is characterized by a much purer and more constant form of relationship than is possible between human beings. It takes the ordinary human notion of love and extends it to encompass the divine, and paradoxically it is only if this extension is firmly grounded in the ordinary that it will be able to be used in this way. This is because it is only the ordinary notion of love which is strong enough to describe our relationship with God, albeit obviously that relationship has to be described in rather different terms to reflect the greatness of its object. We return inevitably to the point that al-Ghazali made, that if our language about God is entirely different from our ordinary language, then it is inauthentic. That is, there is a tendency of the mashsha'i philosophers to talk about God but to give him no role to play, because they insist that he is described in such etiolated language that it fails to make any connection with our language and our world.

5

Music

Music in Islamic aesthetics

Music became an important issue in Islamic thought right from the start of Islam. The Prophet made several references to it in his conversations with others, and quite soon a controversy arose as to the role, if any, of music within the religion. Before we examine some details of that controversy, let us look at the main theories of music which arose within Islamic philosophy.

There are two main theories of music, on one side are al-Farabi and ibn Sina, and on the other the Brethren of Purity (Ikhwan al-Safa') and al-Kindi (third/ninth century). The former group of thinkers lived around the tenth and eleventh centuries CE (fourth and fifth AH), but very little is known of exactly who they were, and they shared with al-Kindi a strong commitment to Neoplatonism. It is worth examining this conflict, because it is very revealing of similar conflicts which lie at the heart of Islamic aesthetics itself. Ibn Sina and al-Farabi did not take the Neoplatonic line on music, unlike al-Kindi and the Ikhwan. For the latter, music is linked with arithmetical and celestial facts, in a very Pythagorean sort of way, so that music has an affinity to something real and objective, from which it derives its power. For the Ikhwan music is a mirror of the music of the spheres, and represents a route to the spiritual advancement to that higher realm of existence. For al-Kindi, more prosaically, music as a system of harmony connects with physical and emotional balance, and can be used therapeutically in that way. But this also is to suggest that music is linked with something that is really there in the external world, and it can be assessed in terms of accuracy or otherwise.

By contrast, both al-Farabi and ibn Sina treat music as independent of anything else, in terms of sound itself and the ways in which the organization of that sound can produce pleasure in the hearer. What is important about music is the way in which it can lead to our enjoyment of sound, and that is all. The contrast between these two views cannot be exaggerated. For al-Kindi and the Ikhwan, what is important about music is what it reflects, for al-Farabi and ibn Sina what is important about music is what it does for us. Al-Farabi is actually a

very significant musical theorist, not to mention composer, and there is music said to be by him still played today in the Middle East. What is even more interesting is that he is largely responsible for what is known as the Arabian tone system, which divides the octave into twenty-four equivalent intervals. This is still the basis of traditional Arabian music, while a slightly different system based on the Pythagorean analysis of music had produced the Turkish and Persian tone systems. From the number of books written on music in the first few centuries of Islam, we can tell that this was an area of great theoretical interest, and much music was obviously played. The Pythagorean theory became the reasoning behind Sufi music, which sees itself as doing far more than just producing pleasure in its listeners. The notes and movements in Sufi dance and music are designed to replicate the basis of reality and to worship God by using our body in ways that are not customarily parts of prayer. Our concern here is not with issues of musicology but aesthetics, and it is worth looking at some of the issues that arise within the Islamic world related to music.

Following the line established by al-Farabi, Arabic music puts a lot of stress on *tarab*, or the enjoyment one derives from listening to music. There is a saying, '*al-fann ihsas*' (art is feeling). One of the words in Arabic for music, *sama'*, means both listening and hearing, presenting music as a holistic experience, and placing it within a spiritual category. The *tarab* player must play the neutral Arab intervals properly and accurately, and feel their musical effect, in particular by responding to the cadential formulae at the end of each melodic phrase, especially in modal improvisations. He must have *ihsas* or feeling, i.e. correct intonation, rhythmic accuracy, good judgement about modal progressions and tonal emphases. These are assumed to be more than merely technical skills. He also should have an intuitive ability to find the right delicate musical balance between renditions which are too static and too repetitive to be emotionally engaging, and those which are too excessive and wild to generate and maintain a true sense of musical achievement. The *tarab* culture attributes creativity to the interactive circle of communication between the performer and the audience. In ideal circumstances there should be a dynamic nexus between a talented performer who is ecstatically transformed and a similarly talented and emotionally transformed audience. For this there must by ambience, *jaww*. It often takes a long time to start the performance because the artist is trying to establish the right sort of ambience. This is both a matter of his trying to get himself into the right state of mind, but also of the audience trying to do the same thing, and the performer trying to help the audience achieve this. As one might imagine, this is hardly an easy process. What needs to be stressed is that music is seen as an essentially spiritual activity, although not necessarily a directly religious activity, and this places interesting constraints on what can be allowed to take place from an aesthetic point of view.

Umm Khulthum

One of the greatest singers of Arabic music of all time was Umm Khulthum (1903–75). When Umm Khulthum came to learn a piece, she would first leave it to her qanun player to approve it and then work with the composer on adapting it to her particular approach. She would memorize it and work with the orchestra on it, and then change it all the time to make it fit in better with her feelings and voice. When she sang it in public she again changed it in line with the reactions of her public. One of the unusual features of Arabic music is that the reaction of the audience is important. The singer and musicians know what they are going to sing and play, but they have scope to vary it, and the parameters of that variation lie to a degree in the reaction of the audience. It has to be the right kind of audience, an audience who genuinely understands the music and responds in an intelligent and sensitive way. One should not necessarily think here of a small group of connoisseurs listening to music in refined surroundings. The audience can be an enormous number of people, as often occurred in the concerts of Umm Khulthum, for instance, and she would give them the opportunity to respond to the music and on the basis of that response she would vary not what she sang but how she sang, to a degree at least. Actually, in the case of Umm Khulthum this response was often rather phony, since she was so famous and held in such awe by her audience that she had a tendency to manipulate them into producing the response which fitted how she wanted to sing anyway. This is not an essentially critical comment, it was not after all her fault that she had such a justifiably high reputation, nor was it her fault that as a result she was obliged to sing to very large audiences. There was sometimes criticism of her style as heavy. Such criticisms are unfortunate, since her public performances had to be ponderous to an extent in order for her to be heard. But this is an issue which will be taken up again.

The role of the audience in music

The reactions of the audience are often very noisy, sometimes too noisy. They can interfere with the music itself, and they can sometimes be a performance in themselves, a self-indulgent and uncreative performance. To a degree the audience reacts as it has seen Sufis react, and this is often in a rather wild and free way. Yet in many of the leading writings on the topic the Sufis stressed the significance of remaining quiet and contemplative when listening to music, and if the music and dance throws one into ecstasy then obviously we might act wildly, but when that stage is over we should be quiet and still, physically and mentally. As al-Ghazali puts it, in the *Ihya' 'ulum al-din* it is often the quietist person who achieves the highest degree of ecstasy (*wajd*). Sufi thinkers often point out that

silence is an effective means of relating to God. In some old customs in the Middle East, when a marriage proposal was made, if the answer was silence then this signified acceptance, and one can be thought of silently accepting the presence of God in a far more sincere manner than many loud declarations of faith. Music consists after all of connected silences, and the periods of silence both before, during and after music may form a very potent space for contemplation. That is perhaps one of the criticisms that can be made of the *tarab* culture, it does not give much scope for silence and the reflection which it can encourage.

Really we need to distinguish here between two kinds of response, one of which is active and noisy, and that is what we generally find in much of the Middle Eastern repertoire, and much more widely in the reactions to Sufi music wherever it is performed, and especially in South East Asia, where Sufism is very strong. Then there is the quiet form of response where the feeling of emotion infuses the mind of the hearer, not so much his body, but he is deeply affected by what he has heard. It would of course be entirely wrong to suggest that we can easily distinguish between the mind and the body, and it is one of the aims of Sufism to challenge such a distinction. On the other hand, the sorts of activities that a lot of Sufis practice musically and in dance in pursuit of their attempt at coming close to God may be expected to fall foul of any likelihood of genuine success. They often literally become performances, and this is what happens when genuine improvisation comes to an end. When the performer and the audience are in real harmony and can each reflect on and respond to what the other produces, then we have a form of dialogue which perhaps fruitfully repre-sents the connection that we have with our creator. There is a gradual growth of consciousness, a slow increase in understanding and appreciation, and at the end of the whole process we have developed to a degree, but that does not mean that we have necessarily been shouting and gesticulating in response to the music and singing. It is these sorts of actions which may encourage us to see the performance as a performance, and so once it is over we get on with the rest of our lives as though it never happened, because it never really affected us deeply. The Sufi literature is highly nuanced on what it is that enables a human being to change his character, and warns us not to expect it to be an easy or dramatic process, although parts of it may be easy and even dramatic. On the whole changing takes time, and the instant ecstasy merchants are precisely that, offering a quick and efficient fix when what is needed is a slow and permanent trans-formation. The popularity of Sufism is probably based on the idea that it provides a fairly comfortable route to enlightenment, and when one understands more about the approach the reverse is the truth. Remembering what we knew originally, that we were created by God and are one with God, is a very tough process, and it is no criticism of Sufism itself to suggest that many of its practitioners either do not realize this or do not want to confront it. This is not

specifically an issue for Islam, of course, all religions have rituals and ceremonies and it is not difficult for the ceremony to play a disproportionate role in the life of the believers. Sufism constantly warns against this. When we observe the sorts of activities that go on under the label of Sufi music and dance we may wonder whether these warnings are sufficiently clear and strong.

Is Arabic music 'minor'?

Criticism has been made of Arabic music that it is limited in range, at least by comparison with much 'Western' music. It is difficult to know how to interpret such comments. Certainly a particular range for classical Arabic music is preferred, but it is not clear that a restricted range is any worse than a wider range. It is like saying that a painting that contains more colours is clearly superior to one with less, or that a sculpture with more parts is better than one with fewer. In any case there is nothing Islamic about Arabic music. It was in the past often performed by Jews, for example, in Iraq and is equally popular with all religious communities in those Arab countries which have some ethnic and religious diversity. One of the factors that encourage the belief that Arabic music is minor is its occasional appearance on radio programmes such as National Public Radio in the United States or the BBC in Britain, where it is rarely allowed to speak for itself. In order not to frighten away audiences an attempt is often made to find some artist or group whose music represents some sort of fusion or mixture of Middle Eastern with more familiar kinds of musical expression. So we get some Yemeni musician, say, who left his country when he was eleven and went to live in Germany, who plays on an 'ud (lute) but treats it like a guitar and is in a salsa band. The resulting music is authentic in no tradition at all, it sounds just exotic enough to make some reference back to his original homeland, and yet familiar enough for the radio dial not to be automatically turned either off or to a different programme. Of course, classical Arabic music is a rather different experience from Western music, but a repertoire of the necessary listening skills can be acquired if one is prepared to spend a bit of time listening to it. It is the familiar problem that as interpreters of a musical work we either add something to it to make it comprehensible to an unfamiliar audience, or we do not. If we do, then we distort the music and its cultural context. If we do not then we fail to make it comprehensible.

Religious music

Some forms of music, recitation and song are clearly religious in nature. For example, the call to prayer (adhan) can be a very beautiful sound, it is not purely functional, at least it does not have to be. The adhan is characterized by

contrast, providing an individual musical profile to each repetition of a phrase as well as to different phrases. During the first appearance of a phrase the melodic line generally comes out short and simple, with a limited tonal range, but the repetition may be extended, becoming far more complex and with a tonal range extending over an octave. On special occasions there may be two *mu'adhdhinan* in operation (*mu'adhdhinayn*) to produce an antiphonal *adhan* of considerable charm and complexity. In the main Ummayad mosque in Damascus when I was last there every tower had a *mu'adhdhin* reciting the *adhan* in a slightly different way, producing an extraordinary impression. It might be argued that the point of the *adhan* is merely to call people to prayer, and that an over-elaboration is to turn into an aesthetic event what should be basic and simple. On the other hand, it is worth pointing out that even the minarets themselves from which the *adhan* is produced are nowadays entirely redundant, given the existence of microphones, and yet they are still used. They are used because they are beautiful, and their beauty is surely intended to be an encouragement to prayer, as is the musicality of the caller to prayer himself.

Similarly the imam or leader of prayers will often be respected because of the way in which he pronounces the language of prayer, Arabic, and the recitation of the Qur'an itself (*tajwid*) is rightly often called a science. There are a variety of styles, each popular in particular areas of the Islamic world, which makes the competitions for excellence in this skill difficult to judge when they are international. Some audiences will find a simpler form of expression more compelling, while others favour something more florid. At the competitions frequently very interesting arguments emerge, with some suggesting that the point of reciting the Qur'an is to produce in the simplest and purest manner possible the words themselves, which are after all taken to be the actual words of God. This approach to recitation argues that the words themselves are so radiant with beauty that all one has to do to produce a beautiful rendition of the text is to say it clearly. Some of the leading reciters deny that they have any musical ability or training at all, and that the beauty of their expression comes directly from God. Certainly the idea that the verses are sung would be entirely rejected. The rules about how to read the Book are said to have been laid down since the time of the Prophet himself. They regulate pronunciation, intonation and breaks, but within those rules there is considerable scope for development even into what sounds like a *maqam* or musical performance, though with a great deal less freedom of expression than is involved with secular music. One is limited by the text itself and the necessity to stop at particular places, although it is possible to start at various places, and before coming to the end of the whole sura. In all cases the stress is on each consonant and vowel, so that each word is pronounced clearly and with regard to the syntactic structure of the sentence in which it occurs.

The other school, and there are many variations in between these two extremes, supports the idea that since the words are so beautiful, they have to be pronounced in an especially beautiful way. This follows the principle behind the transformation of the written Qur'an into a very beautiful object through calligraphy and painting, something which we have seen is so important in Islamic culture. The argument could have been that since the text is already so beautiful it does not need further beautification, as it were. Yet much effort went into the celebration of the text in art, and we can understand why. Yet we can also think of equally strong arguments against any decoration of the text at all, returning us to the prolonged arguments which took place in Arabic literature between those who advocated simplicity and naturalness, and those who see literature as essentially artificial anyway, and so ripe for the application of elaborate exaggeration.

Recitation of the Qur'an

There is little instruction in the Qur'an itself as to how the Qur'an ought to be recited, although the very name of the book 'Qur'an' or 'recitation' suggests that this is a question which needs answering. We are told at 73.4 to *'rattil al-Qur'an tartilan'* (repeat the recitation in a collected distinct way). This has been the principle used in Qur'anic recitation ever since, which is produced at a steady rate, is calm, rhythmic but not melodic, with the emphasis throughout on the clarity and distinctness of the diction. The significance of not rushing is that the reader and the listeners can then concentrate on the meaning of each individual word and phrase, as is surely appropriate for such a text. *Tajwid*, or the technique of recitation, is then to a degree assessed in terms of a clear criterion, that of how accessible the recitation is to those intent on concentrating on the words.

The place where there are many comments on recitation is the *ahadith*, but since this is now a written text not much of the information is of direct value in the precise nature of recitation. Clearly the Prophet appreciated the beauty of recitation when performed by some talented individuals, but on the other hand he was critical of those who used the melodies from love poetry and extravagant singing. So clarity is always important, but there are several ways of being clear – seven, in fact. There is a tradition which mentions seven ways of reading (*al-qira'at al-sab'*), and skilled readers will often be expected to know more than one style. It is difficult to overemphasize the significance of the oral nature of the Qur'an, and the consequent significance of how it is pronounced. Reciting the text is more than just reproducing the words, since it is done to evoke an emotional as well as an intellectual response. The *hafiz*, the memorizer of the Qur'an, is more than someone who just remembers how the text goes, and can reproduce it at will. For the superstitious the words themselves have a *baraka*

which is only increased by their oral production. Putting that aside, the oral reading or recitation of the text in a sense reproduces what God did originally when he transmitted the message to the Prophet, and so the reciter is imitating God, in so far as we can.

Although the recitation of the Qur'an is not supposed to be musical, it often does incorporate musical principles. It is not difficult to identify different styles when listening to a variety of reciters. In particular there are large differences in the speed of recitation, but not only in speed. Some recitation can be emotional and display considerable virtuosity, and such reciters are often criticized for making a performance out of something which is too serious for such a form of expression. It is the task of the *muqri'* to produce a correct recitation, not necessarily one which draws the attention on the reciter rather than the recitation. This is perhaps the greatest problem with the incorporation of too much musicality into recitation; it treats the text as just a means to produce aesthetic beauty, whereas the attention should be on the text itself, not on how it is recited. Similar reasoning leads to problems in incorporating Qur'anic passages in secular and political songs. In 1999 the Lebanese singer Marcel Khalife was tried for offending Islam. His alleged crime was to have used a short ayya or verse from the sura Yusuf in the Qur'an in a song. In fact the song was a poem ('Oh my father, I am Yusuf') by the Palestinian poet Mahmud Darwish, which incorporated the line 'I saw eleven planets and the sun and the moon. I saw them kneeling before me.' Darwish was comparing the suffering of Yusuf at his brothers' hands with the suffering of the Palestinians at the hands of the Israelis. Khalife turned this into a song in an attempt to support the Palestinian movement. In vindication he claimed that only the Qur'an could really provide the inspiration for such a creative task as he had performed. By contrast, the court charged him with attacking religion and denigrating Islam. The complaint was not that he had used the quotation inappropriately nor that there was anything objectionable about the rest of the song. The complaint was that he had used a part of the Qur'an in a secular context; he had actually sung that part, set it to musical notes and then presented it as part of a melody. This is far beneath the dignity appropriate to anything that comes from the Qur'an and should be punished, many in the religious authorities argued. Without the intervention of the political authorities it is not clear that Khalife would have emerged from that trial declared innocent. The confrontation offers an interesting perspective on two views of the role of music in the Qur'an. Some would argue that a beautiful text is appropriately complemented by beautiful music, while others would suggest that to use music to illustrate a text implies that it needs supplementation in some way. For the Qur'an this implication is a direct attack on its nature as a religious authority, and so setting it to music is forbidden.

This may seem a narrow and repellent view. After all, if someone with a

genuine love of God in his heart seeks to use his skill at music to portray that love, and wishes to use the central book of his religion with that music in some way, what more appropriate religious activity could one find? In the case of Marcel Khalife, he actually claimed that the Qur'an inspired him to write the song, and this seems an honourable motive, from a religious point of view. We can understand why the Prophet may not have wished the Qur'an to be recited in the sorts of tunes that the people of the Book used, since it was important to distinguish Islam from the two older religions, but today that differentiation has been well established, and there seems no good reason to exclude the Qur'an from artistic expression. After all, the calligraphy that exists for the text is often very beautiful, and sometimes one gets the impression that the style operates in opposition to its readability. It might at least be said that in many of the most beautiful Qur'ans that clarity of expression is not the most significant issue, but the beauty of the script is. If it is acceptable to use writing to illustrate the beauty of the words, why it is not similarly acceptable to use musical notation?

It is not clear why there should be a distinction between writing and music here, but the whole discussion reveals an interesting view of art itself, as having the function of concealing and confusing. That is perhaps why the Qur'an often insists that it is not poetry, although at the same time demanding that we regard it as miraculous in its perfection, and part of that perfection is its aesthetic quality. We can see why there might be an injunction not to produce anything like it, because such an attempt would imply that one thought one could, and that would suggest that one did not think it was unique and miraculous. But that does not show why one should not use art, or in this case music, to bring out the essence of the text in ways that make them easily transmittable to the widest possible public.

Naturalness vs artificiality in music

Ibn al-'Arabi makes an interesting connection between naturalness and spirituality, in opposing *sama' ruhani* and *sama' tabi'i*. The latter is just music in general, however used, while the former reflects the nature of reality, and is a stepping stone to *sama' al-muqayyad* (limited hearing) on the route to *sama' mutlaq* or complete hearing, which as complete receptivity should probably be thought of as silent. One might think that this would mean that the simpler the music, the better it is, but this does not necessarily follow. For example, it might be argued that complex music matches the complexity of the divine organization of the universe. However, although this could be said, on the whole it is not. The view is that there are a few fairly basic principles behind the structure of the universe, and we can replicate these aesthetically in our musical efforts. The Ikhwan al-Safa' argue in a similar way that art has to copy the basic

constitution of the world. The body of the world is spherical, so that is the best shape to use in art, the movements of the planets is circular, so that is the best form of movement, the light of the stars (except for the moon) is essential and basic and the quality of the spheres (except for the earth, the centre of the spheres) is transparency. Hence these are shapes and textures we should use in art.

Despite this orientation towards simplicity in Arabic music, it is often regarded as over-elaborate. In Western music there is a form of composition known as the arabesque. The arabesque is a piece in which the composer aims to achieve a decorative rather than emotional effect. It is clearly taken to replicate musically the aesthetic effect of that familiar form of decoration in Islamic art. Certainly quite a bit of Arabic music seems to be characterized by the arabesque; it is often decorative and the improvisation sometimes seems to be improvisation for improvisation's sake. This phenomenon is known as *maqam* in Arabic. Music is defined in terms of space and time, in terms of tone and rhythm, and in the *maqam* space or tone is fixed, while rhythm is less undefined. In much of the classical Western tradition, the reverse is precisely the case, where the rhythm is completely specified but the tonal dimension is left relatively free. As a result when Westerners hear Arabic music it often seems chaotic and without direction, since it is without a regularly repetitive bar scheme and a constant metre. On top of everything, the *maqam* musician performs without a musical score, thus encouraging the idea that he is making it up as he goes on. There are usually long pauses differentiating the melodic line into smaller melodic passages, and how these are developed will define the product. For example, the musician may emphasize the first tone of the *maqam* row in the second melodic passage, then the fourth tone of the *maqam* may be introduced in the third melodic passage. Whichever tones are regarded as significant may be repeated together in which-ever passage is regarded as especially significant, but the important factor of the genre is that there are no definitive rules for the order in which the tones are emphasized, the number of melodic passages within a *maqam* and the degree of repetition. No two performances of the same *maqam* are ever completely the same, since while the tonal structure is fixed, the rhythmic scheme is subject to improvisation.

The singer or player moves into a certain area of expression to see what comes of it, as it were, to play around with certain ideas and musical expressions in order to explore them in what might seem to be an analytical as opposed to emotional manner. Sometimes the improvisation will collapse, and the musician will start again from a position a bit earlier on, having worked out where he went wrong and being able to get over the problem on a second attempt. Sometimes it takes several attempts to 'get it right', and although it is difficult to describe why this works so well, it does. One suspects on occasion that the artist has possibly deliberately 'got it wrong' in order to be able to display his skill in

eventually getting it right. In this performance he is also of course in a position to encourage the audience to work with him, and to elaborate their ideas as to where he should be going, and this gives the audience greater motivation to remain alert and involved in the performance.

The contrast between the decorative and the emotional is an interesting one, since it does not need to be made. The decorative can be highly emotional, and vice versa. This certainly is true in the case of music, and performers are often obviously highly emotional about what they do. In the case of a singer of Arabic music there is an interesting contrast between the singer and the orchestra. The singer is usually very emotional and the orchestra very straitlaced, dressed in sober clothes (often suits and ties, smartly polished leather shoes), and the contrast is important here. It is as though the orchestra wants to preserve the integrity of the work being played while the singer is prepared to respond to the feelings of the audience, and her own feelings, by varying the work to take account of those feelings. It is not difficult to see how useful a strategy this can be in the appropriate context. The singer is on our side, the side of the audience and the easy expression of emotions, while the orchestra is on the side of authority and convention. Yet the audience knows that without the discipline of the orchestra nothing will be possible.

The easy emotionality of the singer should not be over-emphasized, it is merely a stylistic feature of many of the greatest performers. Others are far more restrained. Kazem al-Sahir, for example, frequently sings love songs in a well-modulated and grainy voice that is often rather analytical and precise in form. He really does dominate his orchestra, the latter often being a rather eclectic mixture of the traditional and the modern, the Arabic and the Western, containing the ney or flute, the hand drum, together with electric guitars and trap drums. Sometimes he sings without music for a bit, and then his song is answered by an accordion or violin, or gradually accompanied by a qanun (zither). What is interesting about his work, apart from its great popularity at the time this book is being written, is the attention he pays to diction. This produces an interesting effect, in that the lyrics of his songs are often romantic or nostalgic in a rather hackneyed way, and yet they are balanced by an almost scholarly and precise recitation of the Arabic words. This recitation effect provides the event with a quasi-religious flavour, albeit the songs themselves and the whole context within which they are produced has nothing at all religious about it, quite the contrary. We cannot get away from the fact that the pronunciation of Arabic in a certain way, and especially the use of some classical expressions, gives to the event a certain formality which otherwise would be lacking, and gives the words themselves a more profound resonance than their actual meaning warrants.

Umm Khulthum revisited

Let us return to the idea of a contrast between decoration and emotion. When we consider the case of Umm Khulthum it just seems wrong, since her singing is redolent with both emotion and decoration. But is it really? Does not the emotion often seem false and forced? The argument is certainly not that the artist must himself or herself feel the emotions that are represented in the performance itself. Indeed, often the opposite is the case, so that the more successful the performance, the less the artist genuinely feels the emotions being conveyed. Thinking that an artist who portrays someone unhappy in love must himself or herself be unhappy in love is like expecting a philosopher who writes on ethics to keep his promises. The trouble with improvisation, as anyone who has seen Mike Leigh's plays will readily understand, is that the attempt to look natural in one's response to others' behaviour or comments is often rather mannered. As a result the emotions which are represented can be flat, and the accompanying performance heavy. The decoration is very accomplished but in some ways too accomplished, taking the attention of the audience away from the emotional aspects of the performance and towards its virtuosity.

Umm Khulthum was a most extraordinary musical figure in the twentieth century, someone whose skill and virtuosity places her in the very first rank of singers in the world. Biographies place a lot of emphasis on the influence of her father, a religious figure, and her participation in recitation of the Qur'an, but we should not take this too seriously. This is an attempt to put her femininity and the sensual nature of much of her music within an acceptable cultural context. The fact that she was born in an obscure village to an equally obscure family is sufficient to establish her *baladi* (popular) credentials, and the stories that she had initially to dress up as a boy to perform are quite probably true, given the problematic status of female singers at that time. A contemporary 'ud player and singer of great skill, Farid al-Atrash, suggested that only he and Umm Khulthum knew how to enunciate Arabic properly since only they among major performers of the time had received a training in *tajwid*. Again, we should not necessarily accept this at face value. He is symbolically linking what they do with Islam, when as he knew there was and continues to be significant religious disquiet about secular music, and indeed about music in general in the Islamic world.

Umm Khulthum was a wonderful improviser, changing the tempo of a song, lengthening and shortening phrases, repeating parts of the text and emphasizing parts of the song by long improvised melodic elaborations. Her spare hand movements were very effective in moving her audience, and when she became very famous her performances were listened to by millions of people in the Middle East with great attention, aware that they were in the presence of a talent whose equal is unlikely to appear for many more centuries. What was

particularly impressive about her was her free improvisation, her ability to disentangle the rhythmic form of a song in order to vary, repeat, paraphrase and obscure particular parts to make the music and words more dramatic. There is no doubt that she was without equal in her ability to manipulate an audience. She was helped by using texts of the form of the *qasida*, a classically constructed poem with a definite metre, and this provided much more of a structure for her really than the rhythm of the composer. In fact, we rarely talk of the composers of her songs, linking the songs much more closely with her than with whoever actually wrote the music. And that is justified, since she was able to transform quite ordinary material into something entirely extraordinary. The words and music themselves were unexceptional until she took them on and infused them with her own ability to improvise and her unique musicality. The Arab public played the appropriate role of her audience in this interactive process of singer and listener, and encouraged her to reach new heights in her creativity. This was an example of the *tarab* form as it ought to operate.

Modern Arabic music

This contrast between decoration and emotion plays a large part in the appreciation of Islamic art, and certainly not only music. There is often the feeling when one looks in particular at some of the repetitive patterns and developing themes in visual art that one is in the presence of tremendous skill, but not much else. What is often taken to be the determinedly anti-iconic nature of those patterns is difficult for those brought up on a form of art which does place such emphasis on the figure. It seems as though the Arabic artist is operating with one hand tied behind his back, and nowhere is this more true perhaps than in music. The range in Arabic music is so much less than in Western music, although we should remind ourselves that Arabic music is not necessarily Islamic, nor is Western music necessarily written and performed by non-Muslims. But when one compares what is available to the contemporary musician within the Arab world musically and what is more generally available, one notes a contrast. Even the modern music written for young people in the Arab world is generally different from the Western canon, although obviously highly influenced by it. Pop videos show singers who are sex symbols surrounded by scantily clad ladies, and female stars are gazed on with wonder by their male admirers, using all the conventions of the Western pop video. The music, though, is different, albeit heavily influenced by modern Western popular music, and of course many in the Middle East today are great admirers and customers for the ordinary Western repertory. In what might be regarded as the local music the emphasis is on the minor tone, and there are references to the classical tradition out of which that music arose.

Music and Islam: the theological discussion

Is music *halal*, permissible, or is it *makruh*, despicable, and so *haram*, forbidden? It depends on which Islamic arguments one regards as stronger. It is difficult to call for a complete ban on music because of a very well-attested hadith in which the Prophet enquired of 'Aisha his wife whether a woman who was married to an Ansari (someone from the tribe that frequented Medinah) had any entertainment, since the Ansar are fond of entertainment. Ibn 'Abbas also reported that when 'Aisha gave one of her female relatives in marriage to an Ansari, the Prophet asked whether a singer had been sent for, and when he heard that this had not been done, he suggested that it should have been done, and even quoted a popular song of the time. Also, Abu Bakr (the first caliph or ruler following the Prophet) wanted to silence two girls from playing the hand drum and singing, and the Prophet stopped him, since it was Eid, a time of celebration. This apparent approval of music was not followed by many of the major legal schools, and even Malik ibn Anas of Medinah (the founder of the Maliki school of jurisprudence) came down hard against most singing. However, it is reported that he approved of simple singing, if it had a beneficial purpose (e.g. placating camels and helping women in childbirth) and if the sole accompaniment was the duf, a simple drum. Many present Islamic musical performers such as Yusuf Islam (Cat Stevens) argue that only a limited amount of instrumentation is acceptable. This point is taken up nicely by ibn al-Jawzi (d. 597/1200) the Hanbali jurisprudent, who in his *Talbis Iblis* (The Deception of the Devil) says that *ghina*, singing, was originally the rhythmical chanting of poems, and its point was to lead people to a religious life. But once this developed into a throbbing and more complex melody it became *bid'a*, an innovation which should be banned. *Al-taghyir* or novelty is *bid'a*, it breaks the rules of simplicity.

Ibn Khaldun produces his familiar line that as civilizations develop their artistic forms become more complex, so that Qur'anic recitation was originally linked with the simplicity of Arabic tribal life, but later on became much more complex, involving degrees of harmony and musicality that would have been thought very extravagant at much earlier times. He then reports that while Malik is said to be opposed to the use of melodies in *tajwid*, al-Shafi'i (the founder of one of the schools of jurisprudence) allowed them (M II, 400). He criticizes the use of music in recitation, arguing that it distracts from the clarity of presentation of the text itself, which is the primary point of the activity. Pleasure distracts also from the text, since the point of the text is not to give pleasure. He then suggests that provided that the recitation is melodious and 'simple', it is acceptable. But he appreciates that at the stage when luxury and extravagance is all the rage, this desire for simplicity is hardly likely to have much resonance with the *umma*.

Is music *laghw* and *lahw* (idle and distracting; 32:3, 31:6)?

According to ibn Taymiyya (d. 728/1328), one should distinguish between the *sama'* of the companions of the Prophet and those who are after amusement.[42] He argues that there are reasons to be concerned at the use of *sama'*. It manipulates our emotions and this is dangerous. It is too subjective. Then he argues that the *ahadith* on this topic are not clear. He suggests that the hadith in which the Prophet heard the singing of the servant girls did not imply that he listened to the singing, and so approved of it. He may have heard it, but this could have been inadvertent, and when he made references to singing and music this might have meant that he was wondering whether what would normally take place was taking place. It does not mean that he thought it ought to take place. According to ibn Taymiyya, if we look at the consequences of *ghina'* we can see what is wrong with it. It overstimulates us and can distract us from the word of God.

Shihab al-Din al-Suhrawardi would allow dance if it is carried out for the right motives, since *inna al-a'mal bi al-niyyat*, acts are (assessed) by their intentions. Al-Ghazali also argues that just because an action resembles an impious action, one should not condemn it if it is carried out in the right sort of way. There is no condemnation in the Qur'an of *lahw* or *batil*, the distracting and the vain, provided that the latter is there for gentle amusement which does not distract us from more important things for too long. On the other hand, the sort of *lahwa al-hadith* that is mentioned in Sura Luqman does suggest that if it is equivalent to 'idle talk' then it will be difficult to justify. From a legal point of view we need to distinguish between two categories of what is *batil* or empty. One objectionable kind is where one becomes so enchanted with what should not be an object of our protracted attention that it takes our attention away from the objects of our appropriate attention. There may be nothing wrong with the empty object in itself, but its evil derives from its role as a distraction, and music can easily fall into this category. On the other hand, the relaxation afforded by entertainments like music may make us better able to concentrate on what is really important, our religious duties.

Sufism and music

Within the Sufi tradition music is generally highly regarded. *Sama'* literally means 'audition' and in the Sufi tradition refers to listening with the heart, as it were, in the sense of a kind of meditation. It is a sort of focusing on the melody in order to get to what the melody represents. There is in the Islamic world a very long tradition of *sama'*, although as we have seen there is also a very long tradition of opposition to music in any form, and also degrees of opposition to music that come out as opposition to kinds of music. For the Sufis, music can

only be effective if it is carried out in the right place, at the right time and in the right company. The right time is when the hearts of the audience are open and ready to appreciate what they hear, so it could actually be any time at all as registered by the clock and calendar. The right place is similarly not necessarily a specific spot, it is where one can put oneself in an appropriate frame of mind. Finally, the right company is very important, one needs to be with the right people, and sometimes this is interpreted as being with people who are on a similarly high spiritual plane as oneself. Some have argued that no such condition is necessary, *sama'* is helpful for anyone, however unsophisticated or unprepared they may be.[43] The state (*hal*) that results from the music is a spiritual state of aesthetic awareness that graduates to metaphysical depth, and the notes represent divine harmony.

Similar points are made by the Sufis about dance and poetry, both of which are also sometimes not welcomed by many in the Islamic community. They can be effective in developing the spiritual awareness of the believer, and as such should be pursued and encouraged. Of course, not just any dance or music or poetry fits into this category, and it is important to remind ourselves yet again that what makes these sorts of activities permissible is nothing about the activities themselves, but what they indicate about the nature of the inner world, or what they do for us in helping us approach that inner world. Just enjoying music is in itself of no value, it only becomes worth doing if it has an ulterior purpose. In this way the main principles of Sufism are entirely in line methodologically with those of the opponents of Sufism in Islam. Both groups believe that the only way to justify an activity like music is in terms of its consequences for religion. The Sufis in the main think that music strengthens religious conviction, and in many environments helps nonbelievers embrace Islam. In modern Europe and the United States, for example, Sufism has become very popular among many non-Muslims and in the case of some at least is the reason why they eventually become Muslims. The country with the largest Muslim population in the world, Indonesia, was converted to Islam by Sufism. The early missionaries did not order the Indonesians to abandon their customs, such as their puppet shows, which might seem rather indecorous from an Islamic point of view, but gradually introduced new Islamic characters into the drama. This is a good example, the Sufis would say, of using music and other artistic devices to bring people closer to Islam, and so to God. Taken by itself there is nothing either desirable or undesirable about music itself, just as there is nothing desirable or undesirable about anything at all. It is only when related to religion that activities take on a moral relevance. The notion of the autonomy of art within Islam finds few supporters among either the supporters of art or its detractors.

6

Home and garden

Islamic gardens

We have already looked at some arguments for the notion of a specifically Islamic concept of space. A claim is often made that there is a category of garden which one should call Islamic. In particular, the idea of gardens as representing paradise is fairly well developed in Islam, and what more natural conclusion is there than to suggest that gardens within Islamic civilization are really there to picture paradise?

It is worth pointing out, as Fairchild Ruggles does, that the linguistic connection between paradise (*firdaus/janna*) and garden should not be taken too far. The Qur'an does describe paradise as a garden (2.25, 47.15), but it does not follow that subsequent gardens in the Islamic world are designed to represent paradise. In many ways this would be theologically suspect, after all God is the ultimate creator of all gardens (6.99, 6.141) and there is no reason to think that earthly gardens represent the afterlife, or could represent the afterlife. Poets like Rumi and Sa'adi do of course often link gardens with a transcendental arche- type, but then so do virtually all poets regardless of their cultural background. You do not have to stem from a culture that originates in the desert to appre- ciate the salvific potentialities of gardens; there is in fact a much more developed culture of gardens as paradise gardens in cultures that are entirely secular. Enthusiasts writing about gardens frequently compare them to paradises, im- porting a cultural reference rather than a religious one. The idea that water is particularly important in the Islamic garden because of its importance in the Middle East is also just wrong. For one thing it is not true that water is a rare commodity in the Middle East in general. There were places in the past short of water, and there are places today short of water, and deserts are of course environments in which water is at a premium. But there are and certainly were many parts of the Middle East with plenty of water – not all the Islamic world consists of parched desert. In fact, one of the difficulties of the environment of Mecca is the propensity of the city to flood, since it is in a valley that often floods when rain does come in large amounts. What makes the suggestion that

water is particularly significant to the Islamic garden doubtful is the observation
by anyone with any knowledge of garden culture that water is important in
virtually every such culture. It is just as popular in countries with lots of water as
it is in drier countries, and the plants also are fairly ubiquitous. For example, the
garden designer in seventeenth-century France, André le Nôtre, was not
content to construct the gardens at Versailles with just plants and buildings. He
also had to include water features, and a large number of them, including
fountains and cascades. Versailles was not connected to a river, although it is in
a part of France which is quite wet, and very complex and expensive pumps and
reservoirs were constructed to operate the water features in the gardens. Perhaps
Louis XIV wanted water in his garden in order to reflect religious ideas about
the significance of water, but there is no evidence that he did. He certainly did
not want water in order to reflect the appropriate passages on paradise in the
Qur'an! In any case, the reference in the Qur'an to four rivers tends to suggest
that the cross-axial garden in the Islamic world comes from this reference, but
in fact it is the result of pre-Islamic ideas, and gardens themselves started off as
fitting in with local conditions and ideas without any explicit reference to
Islam. Later on, Fairchild Ruggles suggests that gardens did sometimes come to
be linked with paradise, especially when they were designed with tombs placed
in them, and when they were part of a mosque complex, but this came quite
late. In al-Andalus, Islamic Spain, gardens reflected the power of the ruler, their
'political meaning reverberated more loudly than the religious'.[44]

Gardens could be used for purposes which were far from religious, of course,
as we see quite often in Persian painting. Neçipoğlu refers to the garden in
Turkey as serving a similar purpose, reflecting political authority and providing
a discreet area for drinking, parties, enjoyment of nature and romantic trysts.
The sultans seemed not to walk much in their gardens, but used them to sit in.

The Mughal emperor Akhbar was critical of the self-indulgent possibilities
of the sorts of gardens which had been constructed.[45] This is worth bearing in
mind, those whose approach to aesthetics is based on a general suspicion of
physical pleasure would quite naturally be worried about gardens. In particular,
gardens present great scope for abandonment of the self in the pleasures of nature,
and in particular the taking seriously of the phenomena of this world, the world
of generation and corruption, the environment which from a religious point of
view might be regarded as superficial. There is no attempt here to suggest that
this is the standard Islamic view, nor even that there is such a creature as a
standard Islamic view, and many Muslims would not accept the idea that one
should be wary of the pleasures of the senses. Islam often does not go in the
direction of asceticism, seeing itself as a religion in the middle, standing between
the indulgence of Judaism and the self-denial of Christianity. On the other
hand, there is no doubt but that there is an important and persistent ascetic

trend in many versions of Islam, and this must be acknowledged, especially for its impact on the appreciation of beauty.

Similarly in Persia, 'the Persians don't walk much in gardens as we do, but content themselves with a bare prospect; and breathing fresh air: For this End, they set themselves down in some part of the Garden, at their first coming into it, and never move from their Seats till they are going out of it'.[46] As in many cultures, Persian gardens of the grand kind were there not so much for energetic exercise as for contemplation and relaxation. But lassitude in the garden is not reserved for that part of the world, nor for that culture. In the modern small garden people may spend a lot of time just sitting and looking at it.

Abdul Rehman states that 'There was a strong relationship between Mughal aesthetics, Sufism, and gardens'.[47] This is because 'the gardens were designed to highlight and to recreate nature. Both the Mughal ruling elite and the Sufis appreciated the various color schemes and designs of flowers and leaves, sounds of water and birds, and other sensory effects at various times of the day and night. By appreciating their qualities they could praise the Creator' (ibid.). So one could interpret the garden in a specifically religious way, and see its parts as representing something deeper and more significant. We have seen this conflict to extend throughout much of the area of Islamic aesthetics, the conflict between regarding physical pleasures as leading acceptably to spiritual growth, as compared with the view that such pleasures essentially make it harder for us to appreciate the real basis of nature. It is an interesting discussion, and raises some profound issues surrounding the role of the aesthetic within religion, issues which we have tried to clarify. Whatever side of the conflict one finds more plausible, they both illustrate the problems and possibilities of a religious aesthetics. Accepting the physicality of the world with some enthusiasm risks limiting our understanding of that world to its exterior features. On the other hand, rejecting that physicality seems at the same time to deny the role that God plays in presenting us with a certain physical environment. It almost looks as though one were critical of the sort of environment which has been so carefully constructed for us by God.

What do 'Islamic' gardens mean?

In the same book D. Fairchild Ruggles claims

> In pre-modern Islamic society the gaze was curtailed by the veiling and clothing of the body; in architecture doors, screens, and walls limited vision to select individuals; and even in urban space, there were few occasions when space was opened up by an avenue or plaza to 'reveal' the city. Therefore, those occasions when views were possible were highly meaningful and warrant investigation.[48]

It is worth examining this claim in some detail, since it is so patently false.

Firstly, there are many examples of cities in the Islamic world where space is opened up to reveal the city. Rulers naturally felt that such designs emphasized their authority, and they existed all over the Islamic world, and continue to exist today. It is worth noticing how the author himself observes this but claims it is the exception which proves the rule. Exceptions of course disprove rules, and the idea that there is some basic Islamic notion of seclusion and privacy is just wrong. The comparison that some make with veiling and the status of women is useful here, since it suggests that at every time in every Islamic society women were treated in much the same sort of way. We know that this is not true of the past, and at present the visitor to an Islamic country will often see girls walking hand in hand, some wearing *hijab* and quite modest clothing while their friends are often happy to reveal far more of their bodies to the public. Some contemporary Muslims feel the veil is appropriate for women, some do not, and during different historical and cultural periods a whole range of attitudes have been adopted to this sort of costume. Of course, the rulers of the Islamic world did not want everyone to see into their gardens, and this is a characteristic of property owners which is fairly universal. They want people to know they have magnificent gardens, but these are not public parks, and along with ownership goes a degree of privacy. There is nothing especially Islamic about this. There is evidence that in some Islamic gardens, pavillions were built for amorous purposes, and indeed there were parts of the garden which were designed for romantic encounters of one type or another, and these would obviously need to be discreetly organized.

One of the interesting questions is why the privacy issue should arise at all. When one looks at pictures of the Mughal gardens in India and Afghanistan one sees very open, extensive gardens which are constructed to relate to the very dramatic environment in which they are often situated. This is particularly the case from what we know of the gardens in Srinagar, Kashmir (e.g. Nishat and Shalimar), where the backdrop of mountains, flowing rivers, forests and the man-made details of roads, bridges and so on is used quite explicitly as a frame for the garden. The garden represents another kind of beauty from the sublimity of nature, quite self-consciously so. The Emperor Babur in the sixteenth century constructed a particularly impressive garden in Kabul and it is clear from what we know of it that its primary purpose was political and indeed amorous. There is certainly nothing specifically religious about it, at least in so far as its original structure and design goes. That does not show that it is not a religious artefact, of course, but we need to think quite carefully before we claim that any sort of garden should be classified as religious.

James Dickie claims:

> The differences in psychology between Muslim and European are accurately reflected in their respective garden traditions. The high walls of the Islamic garden prevented

its owner being seen from outside and insulated him against the glamour and dirt of the antipathetic life of the streets. There, inside his artificial paradise he could enjoy in solitude the voluptuous pleasures produced by different perfumes, colours and shapes in endlessly varied combinations ... the Islamic garden betrays ... an equilibrium of ... the rational and the natural, in a felicitous compenetration where each one supplements the other.[49]

There is too much Jungian speculation on gardens and other aspects of Islamic art, as though there is some general psychological principle which lies behind these forms of cultural expression and which ultimately explains them. This is an attractive idea, and one which would neatly resolve all sorts of confusing problems, but it has not a scrap of evidence in its favour. On the contrary, it is entirely implausible. This description of the Islamic garden can be replicated by any suburban garden which sees itself as an oasis of peace in a world of bustle and commotion.

Artificial vs natural again

The aesthetics of gardens comes in between what we might call the artificial and the natural. They are made up of primarily natural material, of course, but are arranged artificially, albeit often in an attempt at reproducing the natural. Gardens, or at least plants, migrated from the outdoors to visual artefacts also, but it is often not obvious that the representations of plants are really supposed to represent plants and not just shapes. Some of these representations are fantastic in structure, and there is more going on here than the attempt to reproduce a natural object. We could say the same about the gardens themselves, the arrangement of the parts is designed to produce an effect that is far from natural, although it takes place in nature. The theory that Islamic gardens are basically paradise gardens suggests that they hark back, or forward, to the garden which exists in paradise, but even such gardens are hardly descriptive. In his *Gardens of Paradise: The History and Design of the Great Islamic Gardens*, John Brookes provides a very flawed account, the author's enthusiasm runs away with him. He is determined to find the source of all the gardens in the Islamic world in the Persian garden, despite all the evidence that he presents of a wide range of different garden designs. We see here yet again the orientalist obsession with generalization, an obsession that flourishes regardless of the great amount of contradictory evidence which accrues alongside it.

Some of the Mughal miniatures of gardens are certainly not religious, especially those with bathing maidens, who give the observer a very unmaidenly glance. One might say that they are reminiscent of the delights which await the righteous in paradise, and it is certainly true that the description of those delights is very corporeal. This would be far-fetched. Many of these illustrations

are of familiar stories and legends in the Persian or even Indian literary canon and have nothing to do with Islam, let alone paradise. It is certainly the case that Muslims have in the past enjoyed gardens, and continue to do so today, but the attempt at discovering some Islamic essence to such gardens is doomed to failure.

Islamic space

> In opposition to the Western attitude and its concentration on the external look of a building, the traditional Islamic concern is primarily for the feel of space within The result is an internal architecture ... less concerned with buildings in space, more with space itself. Such a concept mirrors the ideal human condition: a lack of concern with outward symbols, but space for the inner soul to breathe and develop ... The extreme example is that of the traditional Muslim woman behind her veil, which externally creates a walled space of infinite privacy.[50]

John Brookes comments correctly on the significance of intermediary spaces in the architecture of hot countries, and goes on to say 'Metaphysically, the *talar* [porch] is viewed as the locus of the soul moving between garden and building, where garden is spirit and building body. It is therefore the transitional space between the spiritual and terrestrial world'.[51] On the other hand, is not the porch just a porch, a common feature of architecture in many countries, and certainly not only Islamic countries? Those committed to *tasawwuf* (mysticism) often comment on the concept of the *barzakh*, a Qur'anic term for the isthmus between this world and the next world, and this concept is often taken to be equivalent to that of the imagination. It seems a bit far-fetched to identify such a commonplace architectural feature as a porch with a grand metaphysical concept like the *barzakh*, but on some approaches this would be appropriate, since the world that we inhabit is seen as a microcosm existing within a macrocosm, and everything in our world is seen as mirroring something even more significant in the universe as a whole.

The argument is that there is something universal about Islamic buildings and gardens.

> The metaphysics of Islamic thought and its application to the concept of traditional architectural elements are the bond linking Isfahan, Granada and Agra ... their common denominator [is] that they were built by Muslims for Muslim usage ... this single factor transcends all other structural differences and it is this which unifies all the regions of Islam.[52]

The space often takes the form of the *chahar bagh* or quartered garden, where the force is outward-directed. Here there is a central pavillion or tomb, positioned at the intersection of four avenues. On the other hand, we have just seen that many gardens are inward-looking, emphasizing privacy and seclusion. Brookes

seems to acknowledge both kinds of design, and says they are both Islamic! They both represent 'a defined space, encompassing within itself a total reflection of the cosmos and, hence, paradise. Within it, this concept fosters order and harmony'.[53] Well, of course most gardens foster order and harmony, even the rather open and apparently wild gardens fashionable in England in the eighteenth century of which Kant so thoroughly disapproved are based on principles of order and harmony, albeit those principles are not that obvious. Brookes cannot argue that Islamic gardens are either inward- or outward-looking, and both forms are typically Islamic, since these forms are contrary to each other. It is not plausible to argue that there is a concentration on space itself rather than on the buildings which circumscribe that space, given what is obviously the extreme care which is given to many of those buildings. Certainly in a mosque the interior may be relatively empty and uncluttered, but the structure itself is hardly irrelevant, it is not just a box to contain space. There is after all no necessity for Muslims to pray in a mosque, often prayers are said at home or when said communally in the street, on an aeroplane or wherever one happens to be. As in so many books on Islamic art, Brookes has principles which he seeks to defend and yet his examples are too accurate for those principles to look plausible. The theory does not lead the perception, it follows it.

There are three sorts of book on this topic. In one the author is so convinced of a particular universal perspective followed by anything which can be called Islamic art that he or she refuses to recognize as Islamic art anything which cannot be read in the appropriately circumscribed manner. Fortunately there are not many examples of this sort of approach any more, although it still persists in the subject. Then there is the more common form of approach, where the theory and the description are seriously disconnected. The author outlines the theory which is said to explain the art, but also is far too learned in the topic to restrict the discussion to what falls within the theory. There is then a wealth of fascinating description which clearly overrides the boundaries of the theory, but the author does not acknowledge this nor even perhaps notices it. Finally there are authors who allow the theory and the description to work together in a fruitful sort of way. The difficulty here is being open enough to the examples for the theory to be accurate and appropriate, while finding something interesting to say that encompasses all the examples. This third category is rather slim since it tends to suggest that there is not a great deal of point in using the term 'Islamic art' as though this told us anything interesting about a category of work.

This sort of vague speculation about gardens is even more common when discussing buildings, and here the emphasis is on the inner. 'The Islamic house ... is an introverted form, conceived from the inside outwards, with emphasis on the decoration of interior elements ... while the street facade is usually a plain wall'.[54] This is because 'Enclosed space, defined by walls, arcades and vaults, is

the most important element of Islamic architecture'.[55] Western and Islamic architecture are very different from each other – 'In modern Western architecture, a house is placed within a space and the space is defined by the contour of the material forms it surrounds. In much of Islamic architecture, space is "cut out" from the material forms around it and is defined by the inner surfaces of these forms'.[56] The reason why Muslims are not interested in the outside of their houses is because they are apparently loathe to make distinctions between poverty and wealth. According to M. S. Amini 'Islamic society was not divided into different classes ... the exterior appearance of all houses was almost the same; humble, closed and unpretentious, without difference, whether they belonged to poor or rich families ... there were no quarters for the rich or the poor'. This is because 'The teaching of Islam condemns all kinds of arrogance and ostentation',[57] which is certainly true but has no perceivable effect on the lifestyles of the inhabitants of Islamic cities.

Architecture

Grabar asks, 'Is there anything in the *forms* of these monuments – as opposed to their use – that makes them Islamic?'[58] and suggests

> One approach I would like to call symbolic; its assumption is that there are features, perceptible visually, which, whatever their origin, possess or have possessed an immediately accepted cultural association ... The second approach is iconographic, meaning that in Islamic architecture certain forms denote or describe a Muslim idea or concept (*ibid.*).

This leads us to posit 'the existence within the evolution of Islamic architecture of an *order of meaning* which is inherent neither to forms nor to functions, nor even to the vocabulary used for forms or functions, but rather to relationship between all three'.[59]

In this article Grabar is sceptical of the idea that there is a clear link between the architecture of the Islamic world and any specific meaning deriving from its form. Minarets, for example, which are often attached to mosques and which call believers to prayer, often seem to have other functions, and as was pointed out earlier in modern cultures with loudspeakers are no longer even necessary. The *muqarnas* (the combination of three-dimensional or curved shapes that can be used on a flat wall forming a frieze or even within a cupula) is sometimes said to be a visual metaphor for a Muslim view of reality, according to which human creation is immaterial and only divine action is real. This is because the *muqarnas* produces an illusion, it creates the illusion that the architectural form of which it is a part is of a different size, usually larger, than it really is. Grabar is sceptical of general claims like this, it may be that these intentions form part of the use of such forms but there is no reason to think that they are

essential aspects of them, and we might say more importantly, there is no reason to view them from such a religious perspective in order to appreciate them.

He is on the right track here, although the intentions of the builders and designers are not really relevant to this issue. It is interesting how many of the exteriors of mosques are bare and lacking in detail, yet how elaborate (over-elaborate, some would say) the interiors are. After all, other sorts of surfaces are highly decorated in Islamic art. The internal walls and pillars, for example, not to mention vessels, ceramics, carpets and so on. Ettinghausen thinks it might be due to 'the restrained, frugal streak in Islam',[60] but this cannot be true, since that restrained frugal streak seems not to affect many other surfaces. This frugal aesthetic streak seems to be decidedly absent from all the rich and heavily per-fumed gardens which were said to prefigure paradise, and also from the decora-tion on surfaces produced as the result of a putative horror vacui identified by Ettinghausen himself. We need to examine some aesthetic features of the issue here to get some idea of what is behind this common architectural feature. Having a structure, in particular a massive structure, with a bare exterior and a decorated interior, is very effective visually. One moves from the secular exterior and its absence of feature to the religious interior and its wealth of detail. This is not just a religious phenomenon, since it serves just as well with ordinary houses. One leaves the public sphere which is characterized by streets of blank walls, often dusty and hot, and enters the comfortable interior, cool and refreshing, where fine wood-panelling and rich carpets establish the sort of space one is in.

This contrast should not be overdone, since there are mosques and houses with highly decorated exteriors, especially in India, and there are certainly parts of the Islamic world where great displays of wealth and power are openly made. In parts of the world where Muslims are in a minority the local architecture of houses is usually no different for Muslims than for anyone else. Mosques will often be in local buildings also, buildings which were perhaps previously churches or synagogues, or which had an entirely secular use. Some new mosques do make reference to other more famous edifices, and obviously help worship-pers locate themselves within the world Islamic community by making a symbolic reference to the origins of Islam, or to places where it is the pre-dominant faith. Sufis will interpret the contrast between the outer and the inner as having a specifically spiritual meaning. The outer is not significant, and it is not appropriate to spend much time or concern on it, but the inner is where the focus of our interest should lie. How does this work aesthetically? Buildings are objects in space and they succeed or otherwise as spatial objects. Such objects often succeed by using understatement. The relative blankness of the exterior of a building is suggestive of what lies within. Our attention is drawn to the interior, our expectations are aroused and the invisibility of the interior is

made more of an issue. The absence of detail on the outside leads to a recon-figuration of the space as a whole, it draws the eye in yet at the same time prevents the eye from going in.

In some ways the outside of a building might be seen as the frame, in the sense that what is important about the building, what it is for, is made possible by the outside but it is not the outside. The outside is a box or wrapper, and it is there to convey the inside of the building to us. This is very much the strategy behind many buildings in the Islamic world. When one wraps up a present for someone the wrapping is important, and can be more expensive than the present itself. One of the things which amuses parents of very young children is that the latter often enjoy the wrapping more than the present itself! Why do we wrap things up? To increase the pleasure we feel at the contents, for example, by delaying our discovery of the contents. To protect the contents, and to preserve them until we wish, or are allowed, to use them. Buildings are not quite like that since they have to be wrapped up in the sense that they have to have outsides, but apart from that difference everything else is the same. Entering a building which is plain on the outside to get to a sumptuous interior is a sensuous experience in itself, and the experience is deepened in proportion to the contrast between the outside and the inside.

Sometimes a wrapping gives a hint as to what is inside, to tantalize and provoke, and the exterior of buildings is often like that. There is often some-thing on them which indicates what is being concealed, it could be a slightly decorated frieze, a playful railing, a small section of tiling. The very massiveness of many buildings suggests at the very least the size of what is within. It is rather like the frame around a painting. Frames are usually designed to complement the painting, and so they are carefully constructed to concentrate the attention of the viewer on the painting itself. A very elaborate frame might distract the viewer, but on the other hand an elaborate frame might be effective in convey-ing a total impression which the central image alone could not do so well by itself. We should not emphasize the contrast between form and decoration in Islamic art and architecture. Although buildings do tend to be plain on the outside, they are not usually entirely plain, and the small amount of decoration provides detail which leads the eye to the interior even before we can approach the interior. This is rather like the Persian manuscripts in which the paintings are framed by text, but sometimes the images actually burst into the text, as though they were so powerful that they could no longer be confined by what surrounds them. This is also the case with some lusterware, where the object portrayed on the dish breaks through the decorated border, thus apparently breaking the rules for that sort of artefact. Borders are supposed to keep things in a particular area, there is no point in having a border unless it is respected. Yet it is a very effective aesthetic device to violate a border, for this suggests that the

vitality of the image can no longer exist within the formality of the design.

It is this violation of borders that we see in the small amounts of decoration of outside buildings, where there is such decoration. It is often applied not to the main area of the buildings, the walls, but to the various domes, minarets, doors and gates – small touches of variety in a great area of uniformity. Or sometimes, as in Iran, there are structures that are fabulously decorated with coloured ceramics on the outside, within cities and towns of staggering plainness, as though those few buildings themselves have the task of implying what is within the whole city, not just within themselves. They are there to contrast with the rest of the city or town, the very elaborate single or a few more buildings representing, as it were, on the outside what lies on the inside of the entire urban area.

We need to say something here on the use of colour. Much of the Islamic world in the Middle East is rather dull in colour, although it is certainly wrong to identify it predominantly with desert. There are mountains and rivers, but not many trees, and the buildings tend to be made of materials such as mud baked bricks, grey or sandstone, or manufactured brick. Sometimes walls are whitewashed, but the predominant look is of a uniformity which is monotonous. Now, we are familiar with the fact that the interiors of many of these buildings stand in marked contrast with the exteriors – tremendous colour inside, very little colour outside. But there often is colour outside, designed exactly to provide a degree of continuity with the inside. No doubt the magnificence and the positioning of, and calligraphy on buildings are all designed to make political and religious statements, not to mention the broadcasting of the authority of the owner of the building or the regime of which the building is a part. The more expensively a building is put together, for instance, the more blatant its declaration of the wealth and power of the owner. But we should also take notice of the aesthetic features of these buildings and how they resonate both with other buildings in the area, perhaps with the rest of the town, village or city, and certainly with the building's interior.

What are these aesthetic principles? For many of the classical buildings in the Islamic world these are balance and harmony. The use of highly dramatic colour in parts of the structure tend to be balanced by areas where there is no colour at all, or a very limited use of colour. Decoration in one part contrasts with lack of decoration elsewhere; restraint in one place is linked to expansiveness elsewhere. There are often architectural features which bridge these opposites, thus bringing them into even closer harmony. It is the interplay of these different features which makes many of the buildings in the Islamic world so satisfying aesthetically. Whether these principles of design should be seen as having any wider religious meaning is moot. Clearly they can be seen in this way, but equally clearly this is not necessary, and so it is dubious how much point there is in importing religion when it seems to be an inessential feature.

The Queen of Sheba and King Sulayman

One of the references to buildings in the Qur'an is in the sura al-Naml (27.15–44). Here the Queen of Sheba, Bilqis (although she is not given this name in the Qur'an), visits King Sulayman (Solomon) in a visit which is full of symbolism. This is the pagan world visiting the world of a prophet and eminently wise authority. The Queen enters the palace and comes across a floor which in fact is made of a reflective material, and so looks like water. She is so convinced it is water that she lifts her skirt, offending against social convention, and then the King tells her that it is only a *sarh*, an area paved with glass. She immediately admits her error and accepts the King's religion. There are lots of stories built around this incident (Lassner is an excellent source of information here), some of which say that the purpose of the *sarh* was to prove to the King that the Queen really did not have hairy ankles! Presumably it would have defied social convention to have asked her. Clearly a central theme of the story is the overcoming of the power and wisdom of the world of *jahiliyya* by Islam, belief in the one God.

On the other hand, it is surprising that as soon as the Queen is tricked by an architectural detail, she submits to the new religion. Sulayman was famous for being able to get the jinn to make things for him, so a floor of reflective glass is not a difficult thing for him to have in his palace. The trick of the floor is only the last of a series of wonders which had impressed the Queen, it is the last straw, as it were, though in itself it is not so amazing a construction, one might have thought. But the glass floor seems to have been a popular device in several palaces in the Islamic world[61] and was certainly a popular image on paintings and pictures. Later rulers found the temptation to emulate King Sulayman difficult to resist, and the very sophisticated glassware that was produced in the Islamic world would have meant that such constructions were quite feasible. In the story the Queen mistakes glass for water, and why should she not, given that they resemble each other, at least when constructed cleverly, as *jinn* tend to do? This is also not the only time that the Queen discovered that what she had taken to be one thing was in fact something else. Her reasoning presumably was that since she often seemed to confuse what appeared to be the case with what really is the case, her religious ideas might similarly be linked not with what is real but with what is only apparently real. This is a good characterization of idolatry from a monotheistic point of view. Physical objects seem much more plausible as deities than does an invisible being, since the former (unlike the latter) can at least be seen. The problem is though that what they look like, i.e. strong, powerful, effective, is only an appearance on which no reality rests. Like the glass floor which resembles water, it is merely a resemblance. In fact the floor is dry; in fact the gods are powerless.

It is worth spending some time looking at the sort of event which features in this story. The Qur'an has no difficulty in contemplating the existence of miracles, as we have seen the Qur'an is itself the result of a miracle, on its own account. But what we have here is not a miracle but a trick. When Musa performed the miracle of turning his rod into a snake Pharaoh reacted by rejecting this as merely magic, but his magicians knew better and understood the miracle to be a clear sign of divine intervention in the course of nature. But this is far from the case of Sulayman – he merely tricks Bilqis, and she swiftly succumbs to the trick by submitting herself to his faith. Was she right to do so? I have in the past seen wonderful magicians perform marvellous tricks, but it does not occur to me to find out what their religious beliefs are and convert to them.

Perhaps it should, but there does not seem to be much in the way of an argument for such a conclusion. What we call a trick is precisely something which does not challenge our understanding of reality, but is rather an event that we cannot understand given our present knowledge, but which we are fairly sure is explicable were we to know how it was done. Once Bilqis established that what she had taken to be water was not water; she knew that she was mistaken in her interpretation of what was before her, but that was all. She did not have to conclude that her understanding of the nature of reality in a deeper sense was awry. She just made a simple error of judgement in a particular case, and once she found out why she had gone wrong she should just have smiled and determined not to be fooled like that again.

What made this architectural feature so effective was that it was constructed so that there was nothing there to tell the viewer where the imitated world ended and her own began. There is no frame around the construction, as it were, to announce that what in fact we have here is a work of art. One is reminded of a short story by Guy de Maupassant in which Bel-Ami, the hero, is at a reception and sees at the end of the room a man standing in an area of water. This strikes him as strange until he realizes that it is in fact a picture of Jesus walking on the water. In talking with other guests, the illusion is credited to the particularly realistic composition of the painting, but in fact Bel-Ami knows that it was because the frame had been obscured by tall plants that he had been taken in. Had he not been a Christian already, would that experience have led him to convert? Strangely enough, it might have. Stranger stories of what has led people to convert, or indeed what has led people to lose their faith, have been told. Often the explanation is aesthetic.

Here we touch on what is plausible about the notion of Bilqis' conversion. The episode with the floor was not the only thing to happen to her which made her re-examine her attitudes towards the one God and Sulayman. A number of things had happened, and indeed her journey to see the King had in itself the flavour of spiritual quest. Sheba is often seen as being a particularly sublime

realm in Islamic thought, and Suhrawardi refers obliquely to the Qur'anic passage in his *Hikmat al-Ishraq*. He talks of a hoopoe bringing us greetings; our arriving at the Valley of the Ants (the sura in which the story is positioned is called The Ant); being told to shake our skirts and then, dramatically, to 'kill your woman'! The hoopoe is a wise bird, who brings a message of revelation, which explains how one may undertake a mystical journey. The Valley of the Ants represents the carnal or physical realm, and shaking skirts and killing the woman mean repressing our physicality in order to extend our spirituality. This is the real problem which Suhrawardi argued that ibn Sina had raised but not settled, namely, how to move from this realm of generation and corruption to the highest level of spiritual knowledge. In his *Hayy ibn Yaqzan*, ibn Sina had correctly identified the problem but did not provide a solution – a gap which Suhrawardi was only too ready to fill. One reason for ibn Sina's reticence, Suhrawardi suggests, is that the former did not appreciate the constitutive power of imagination, in the sense of the imaginal realm. For the mashsha'i thinker, there is the active intellect and there is the acquired intellect, which represents the highest form of reasoning which we can attain when our thought is perfected as much as it can be, but that is it. Imagination itself is a faculty which works predominantly at a much lower level of knowledge, and although it can function to a degree in syllogisms and logical reasoning, on the whole it is most closely related to our sensuality and so should be treated with a degree of suspicion.

For Suhrawardi, though, imagination is far more significant than that, not when it is linked with the world of Platonic ideas (*muthul al-Aflatuni*) but when it is extended by the suspended ideas (*muthul al-mu'allaqa*). These are ideals, and as such they play a role in leading us intellectually to a higher level of knowledge than we can otherwise attain. Now, this is not the place to look at the long-standing argument between the mashsha'i and the ishraqi philosophers on the nature of knowledge (although we shall examine this debate elsewhere in this book as it is clearly very important for a grasp of Islamic aesthetics), but if ibn Sina is correct then aesthetics has to be limited to a fairly peripheral role in our spiritual lives. If Suhrawardi is right then aesthetics is crucially important, and is far from being merely an aspect of decoration. On the contrary, aesthetics represents a decisive route to the truth, and without it the scope for spiritual growth is entirely at risk.

We can see now why the illusion set up by the King really had such a leading role to play in Bilqis' conversion. There is a well-known Buddhist parable which Rumi uses in the *Mathnawi* of the elephant which different people touch in a dark room. They each feel its trunk and all disagree as to what it is. Rumi concludes the passage by pointing out that if everyone were to hold a candle they would all have agreed. That is, if they all had access to the truth then there would be no disagreement. That may be true, but does not seem to be very

relevant. Naturally, if we are in the dark we do not see as clearly as if we are in the light, and in the case of Bilqis, if we are tricked by an architectural feature then we are unaware of the real situation. But so what? This observation does not seem to have much to tell us about what the consequences of the confusion are, although Bilqis does draw dramatic consequences from it. We need here to take up the ishraqi point of imagination leading the intellect. Sometimes when we find that our ideas are misplaced in a single area, our imagination extends this idea and leads us to wonder whether our ideas are misplaced in general. To take an example, suppose we have a particular relationship with someone, or think we do, and he says something which makes us wonder whether we really have that sort of relationship with him. We use our imagination to reinterpret our experience of his actions and to extend it to the past and the future, even though our actual experience is limited. This what Bilqis does, she realizes that she has been wrong in what she believed to be the case about the surface of the floor, and extends that mistake to wonder whether she has been mistaken over a much wider area of her experience, including her religious beliefs. Is it rational to act in this way? It is difficult to answer this question since our general beliefs about the world do not really stand on anything except themselves. It seems perfectly acceptable for different people to have different views, and this is a familiar experience for us. Why should Bilqis not use her mistake to change her general views? It is one thing to argue, quite rightly, that the mistake does not oblige her to change her views – and yet the mistake makes her decision comprehensible.

We are moving towards an appreciation of the role of architecture in representing a religious attitude. The sort of architecture designed by Muslims is often intended to make the sort of imaginative leap which Bilqis took. The thing worth noticing about the *sarh* is that it must have been very beautiful, the skilful fusing together of pieces of glass or some similar reflective material must have been a staggering sight. This is what we should notice about the story, not that Bilqis was fooled, but that she was fooled as a result of the beauty of the work. She quite naturally felt that whoever was its creator was worthy of her attention. One assumes that much Islamic architecture and design had this sort of purpose: to impress, to captivate, to entrance. This is, after all, a familiar feature of sacred art. One does not have to be impressed, a good example of someone who was not is Bel-Ami, in a very similar situation. He was annoyed when fooled by a visual illusion; Bilqis was impressed. But then, he attended a party with an entirely different attitude from that of Bilqis, who had come to see the King full of interest in what he had to show and offer her. Bel-Ami did not have the correct attitude to enable him to appreciate what he saw aesthetically; he dismissed it as a cheap visual trick to which he succumbed by failing to notice the rest of the room and its contents.

It might be said that Bilqis also had the wrong attitude for an aesthetic judgement. It looks very much as though she had gone to the palace ready to be impressed, and so had a practical end in mind, which stands in the way of the sort of aesthetic detachment necessary for a genuinely aesthetic response to a situation.

This is an interesting comment, but not a very helpful one. It is certainly true that in this book we have been using a notion of distance to establish what it is to see something from an aesthetic point of view, but it does not follow from the significance of this notion that the individual is not allowed to indulge her personal ideas or feelings at all. Bilqis was obviously in the right frame of mind for the *sarh* to have an effect on her; she had, after all, been the witness of many other impressive events in the royal court she was visiting. She could have been determined to resist it, like Bel-Ami in a similar context, but this also would not have been acceptable from an aesthetic point of view. The appropriate attitude for aesthetic judgement is to be open to the object but neither intent on appreciating it nor disliking it.

Bilqis was impressed by what she saw and as a result made a decision about her life and her religion. But she could have been impressed and left it at that. There is nothing inevitable about the religious direction she subsequently followed. It is not as though the art had suddenly revealed the truth to her in a manner which made it undeniable. Even after she admired the object she still had options, and that is a crucial aspect of the story, for if she had to submit then her submission would have been far less impressive. She chose to regard the aesthetic experience as the foundation for a decision about religion, and although that decision was not aesthetic, it could have been based on the aesthetic.

What comes to mind at the end of this extended discussion of a Qur'anic passage is how significant a role in the text art plays. Although we are told how antagonistic Islam is to art, here we have the great King Sulayman, a man of extraordinary wisdom, engaging the services of *jinn* and others to construct beautiful objects. If there is something unIslamic about art, why was the King so intent on producing it? We also find in the story an important pagan embracing Islam because of her confrontation finally with a superb aesthetic object, the imaginary lake inside the palace. There is no hint that the creativity of the King's servants or the *sarh* are in any way objectionable, on the contrary they are entirely praiseworthy, and if they were not then Sulayman would hardly have used them.

Islamic space revisited

One reason for not being critical of the trick that was played on the Queen is that really one could see all architectural devices as tricks. We obviously need buildings to shelter us from the elements, but their exact features are due far more to our desire to shape them in that way than to anything that we really

need to do to them. This is particularly clear when we take account of the elaborate decoration and geometrical patterning so common in much Islamic architecture and design. We have already seen that some commentators explain these features as due to their source in basic metaphysical and mathematical realities, such as the relationship between the planets and their movement, and basic numerical proportions expressing harmony. In her *Beauty and Islam*, Valerie Gonzalez suggests that there are two main features at work in the Comares Hall at the Alhambra. One consists of the contrasts which exist between the colours and shapes of the calligraphic and vegetable decoration. The other is the geometry of the structure, and this is more than just the fact that it is an attractive combination of shapes. It is supposed to be much more, Gonzalez and Grabar argue, it is supposed to be a representation of the ideal, through its instantiation of harmony and order, and its reference to the nexus between the infinite and the finite. As Gonzalez goes on to add:

> in the particular work of the Alhambra, conceptual geometry has a definite philosophical function, insofar as it necessarily activates, through the visual artistic medium, these philosophical connotations and resonances of geometrical thought and ideality. It emanates a geometrical vision of the world understood through the objectivity of mathematical thought which, by definition, transcends time and space; this transcendental ontology of geometry thereby confers on the Alhambra a certain universal value.[62]

How plausible is such an approach to architecture? In short, she sees the design of the interior as representing the vault of the heavens, and the whole building being a metaphor of an Islamic cosmogony. The structure is designed to elevate the mind of the viewer from this world to the world as a whole, from this limited area to time and space as such, from the experience we have of the world of generation and corruption to an ideal realm where order and harmony reign. Certainly we can see many devices that suggest this is the plan of the architect and the Nasrids who commissioned the work. But does that mean we have to see the building in that way? What is necessary about the move from viewing the shapes to having the appropriate philosophical attitudes to the structure? For one thing, it is not as though there were just one philosophical attitude that one could take to the work. She claims that mathematics transcends space and time, but this is not the view of all thinkers, some argue that mathematics, and geometry in particular, is relative to our operating in space, and arithmetic to our experience of time. These are concepts that we construct out of our lived experience of space and time, and while it is true that theoretically they are more abstract than space and time, that does not mean that they transcend space and time. They cannot transcend space and time because they only have meaning within an environment characterized by these forms of intuition, to use a Kantian expression.

Now I would not want to argue that one has to think of geometry and mathematics in this way, or that there is anything wrong in thinking of geometry and mathematics in the way that Gonzalez says we should. What is important is that we do not insist that anyone who looks at these architectural features has to see them in any way at all. Many modern visitors to the Alhambra have no idea what these theories even mean, so it is difficult to suggest that they can only appreciate the building if they do understand the theories. Unless, that is, it is impossible to form an aesthetic judgement based merely on sight alone. But there is another argument which lurks within the way this topic is often discussed, particularly by Gonzalez, and this is an argument with which we are familiar from the Ikhwan al-Safa'. This suggests that there is a basic mathematical order in the universe and we sense this, since we are also in the universe, and when we come to make aesthetic judgements we use it as a criterion of beauty, albeit not necessarily a criterion of which we are always conscious. And indeed this is the criterion, because it represents objectivity, harmony and order, and so the principles of beauty themselves. Even if we do not understand, or are unaware of, or disagree with, the theories on which the beauty of the building depends, we still actually use those theories in our appreciation of the beauty of the building, for otherwise we would have no route to that aesthetic judgement.

We were critical of this Pythagorean view earlier since we saw no reason to think it is true. It certainly is true that some people see basic mathematical principles underpinning the structure of the universe, and perhaps there are such principles, but it is not obvious that this knowledge, if it is knowledge, has any aesthetic consequences. It reminds me of an event when I lived in England and a teenager's grandmother came to look after her while the parents were out. She saw that her granddaughter's trousers had holes in them and she sewed them up. The next day the teenager was furious; the holes were supposed to be there; that was the fashion at the time. But the grandmother could not understand how that could be a fashion; how could holes in clothes be worth preserving? That is just the same question that people ask about art which consists of pickled cows, dead sharks, piles of garbage, unmade beds and so on. All these questions assume that there is something objective about art which these examples do not fit in with, and so they are only problematic examples of art. Now, the question of what is art is not the issue we are raising here, but the question of whether everyone has to agree what the principles of art are is precisely the issue. Does everyone have to accept that there are objective principles on which the structure of the world rests, and that those principles are also the principles on which aesthetic judgement rest? This makes aesthetic judgement much too much like a matter of being right or wrong, and that is not how it has to be seen.

When we come to look at architecture, we can adopt a number of attitudes to it. Some people are not at all comfortable with Islamic architecture. For example, there are many people today who are appreciative of some of the more minimalist designs on ceramics, for example, but who find the *muqarnas*, with its extraordinary duplication and elaboration, quite repellent. Now, we could try to get her to see this architectural detail differently, but there is no reason ultimately why she should. Pointing to the geometrical basis of the *muqarnas* may not help, nor may linking that with deeper mathematical truths which we say hold of the universe as a whole. Suppose the viewer says that as far as she is concerned the architectural feature is just a mess, there is far too much of it, and it actually obscures the vault of the ceiling, which by itself would be worth looking at for a long time, since it is beautiful without the accretion of any more details such as the *muqarnas*. She might also reject the things we say about the philosophical basis to the *muqarnas*. She might not believe it, or she might believe it but say that for her order and harmony are not aesthetic desiderata. She admires works of art which are chaotic and randomly organized, since that seems to her to be a better representation of the way in which things really are. We might talk about the interplay between the finite and the infinite in the use of geometrical shapes for the structure, but she might say that any shape, or no particular shape at all, is capable of linking these two ideas. After all, the lines in a painting of a human being are just as geometrical as any other lines, albeit more irregular than those generally used in mathematics, and so a painting of a human being might get us to think about finitude (what better object for that than a human being?) and its opposite, perhaps the natural setting in which he stands, which will in one form or another keep on going forever, or at least until the planet is destroyed. Then we can think of the particles continuing forever. The representation of time is very much a feature of many Persian paintings which show a scene being played out in several different places all at the same time, where a slice of space and time has been taken as it were, and we see how a series of related and unrelated activities can go to construct a tableau. It is both entirely static, and yet we know that it represents merely a moment in time, and everything we see in the picture is about to get up and go. One of the amusing aspects of such paintings is that quite often there is a theme on the page, and then there are subsidiary activities which are entirely unrelated to the theme, and that give an impression of how normal life continues despite the significance which we give to particular events.

What we need to be careful of here is having a nice neat theory of how Islamic architecture operates and then reading everything we see in terms of that theory. That is a very tidy way to operate, but really does very little to increase our understanding of the topic. Just because there is a subject called 'Islamic' architecture, we should not necessarily insist that the architecture we

give that name has something in common, and that that something is religious. No doubt the iconography of the buildings reveals many religious themes, and Islamic themes at that, but we should not conclude that these are necessarily the meanings of the buildings. They cannot be if others can view them and make appropriate aesthetic judgements, yet share none of the beliefs of the architect, nor even know what those beliefs are. It is the second point which is so crucial. Anyone viewing a great mosque or other Islamic public building will be aware from what she sees that something is going on with respect to a culture which perhaps she knows nothing about, but she will know from what she sees that it is beautiful or graceful or possesses whatever aesthetic quality she perceives it to possess. It is this that makes the iconography irrelevant aesthetically, although no doubt of great interest to the cultural historian and art scholar.

The miraculousness of the Qur'an

What is the miraculousness thesis?

Islam is in many ways an unusual religion because it has as one of its leading principles the miraculous nature of its central text, the Qur'an. Defenders of Islam often go through the text in detail and argue that nothing like it can be found anywhere. Those who convert to Islam both today and in the past often cite the influence of the Qur'an, and the idea that the leading miracle created by God is his own words gives Islam a pleasingly rational and aesthetic basis. After all, it then puts Muslims in the position of arguing for their faith at least partially in terms of its stylistic excellence, and does not involve putative believers in accepting anything implausible, just because it is said that God brought it about. If one doubts whether Jesus rose after three days then it is difficult to know what will satisfy such a doubt, since the event occurred a long time ago. Similarly, some Jews believe that the Torah comes directly from God and its transmission was witnessed by the whole community at the foot of Mount Sinai. Over the generations parents have told children of this event, and so the evidence that it actually happened is quite strong since it is based on what a lot of people saw, and what they reported to others. On the other hand, it was a long time ago, and many Jews today do not believe in *Torah min ha-shamayim*, that the Torah comes directly from heaven, so this view is not now central to many forms of Judaism. Nonetheless, there are many miracles reported in both Judaism and Christianity, and for many Jews and Christians those miracles are events which actually happened and on which their faith at least partially rests.

Islam is very different. Although there are indeed reports of miracles in Islam, the central miracle is taken to be the text of the Qur'an itself. Neither the Jewish nor the Christian bibles make this sort of claim. There are some very beautiful parts of both texts, but there are also some very tedious passages, and one has to have very strong faith indeed to believe that all such passages are really essential to one's grasp of the religion. Of course, it might be argued that the relatively factual nature of the two earlier religions is advantageous because it makes them rest on acceptance of a fairly discrete number of facts, which are

described and set out for potential believers to accept or otherwise. Islam by contrast is sometimes taken to claim that it ought to be accepted on the basis of the inimitability of the text itself, so what one is being asked to accept initially is not the truth of any proposition but rather one is called on to make an aesthetic judgement.

What is the difference between a proposition about matters of fact and a proposition about the beauty of something? Many would argue that the former is objective and the latter is subjective. So the argument that Islam is especially rational, since it is based on the overt properties of its central text, needs to be qualified. Determining the aesthetic properties of something is certainly an acti-vity in which reason is involved, but it is not clear how rational it is. This topic is a highly controversial one in aesthetics, of course, with some arguing that aesthetic judgement is almost entirely subjective and others arguing the reverse. Those who argue that the Qur'an is a miraculously beautiful work tend to support the objective view of aesthetic judgement, with its corollary that one can just *see* the beauty both of the text and of the world for which the text serves as a guide. The significance of the Qur'an as a text has played a vast role in Islamic life. It is no chance that of the huge number of names in classical dictionaries of Islamic intellectuals by far the largest category consists of grammarians and philo-logists (see for example ibn Khallikan's *Dictionary*). Given the vast importance of the Qur'an, one needs lots of experts to explain the text and how it is to be differentiated from other texts. At one stage it was suggested, and accepted, that there are obscure passages and to understand them one needs to understand the Arabic of the *jahiliyya*, the pre-Islamic period of ignorance, since this is the language in which the text is actually transmitted. Today such a suggestion may seem con-troversial, since it can be used to imply that the Qur'an is a book like other books, and has grown out of the environment in which the Prophet himself grew up.

The issue of influence

There is a significant problem with understanding the way in which one tradition influences another. Actually, there are two problems. One is in knowing why it is of interest. At conferences and in books one frequently sees or hears the claim that x influenced y, as though this were of any interest at all, and often it is not. Of course, if someone claims that he or she came upon a particular idea entirely by himself or herself, then the counter-claim of influence would serve to challenge that initial claim, and would in fact suggest plagiarism. This is no doubt why students are in many institutions told to specify precisely who their sources are, so that they can clearly distinguish between their views and those on whom they are relying to come to those views. We expect authors similarly to make clear who their sources are, so that we can be clear in our minds what

claims the author makes which are supposed to belong to the author, and what ideas and arguments belong to others. Sometimes the fact that someone else initially created an argument is so well known that it is hardly worth mentioning it, and its unacknowledged use would not give rise to any charges of plagiarism. Many arguments are like this, and the notion of a curriculum is based on the idea that certain ideas and theoretical positions are to be used generally to form a basis on which other ideas and theories can grow and develop. There is no difficulty in such cases in admitting that what one does is very much based on earlier work, and yet also suggesting that what one does might be original and innovative. There is a familiar scientific slogan that one can see very far only if one is on the shoulders of giants, by which what is meant is that one can branch out in new directions only on the basis of an existing and respectable theory, one which has made great strides of its own in its heyday and which now represents the combined efforts of many previous researchers.

Where controversy arises particularly strongly is where a system of thought, which is taken to issue from divine and supernatural sources, is given a natural and historical explanation. Perhaps one of the most notorious examples here is the way in which the origins of Islam are often linked with previous systems of thought, in particular Judaism. Of course, it is a vital claim of Islam that it is based on the direct word of God, transmitted in the form of the Qur'an, and the account of the giving of the Qur'an to the Prophet, via Jibril, makes clear that the role of the Prophet was merely initially as the channel of transmission. As we know, the development of the *sunna* (tradition) and the *ahadith* (sayings of the Prophet) gave him another and much more directly instrumental role, and we shall bring in the significance of this later on, but for the moment let us concentrate on the actual creation of the Qur'an and its context. The enemies of Islam have tended to criticize the account of its formation, claiming that Muhammad wrote the Qur'an, or that it emerged out of pre-existing ideas and is merely a compilation of such ideas. The defenders of Islam have replied that the central proof of the authenticity of the divine origins of the Qur'an lies in the text itself, which demonstrates its miraculous nature by dint of its style and content. Although commentators frequently discuss the notion of *i'jaz al-qur'an* (miracle of the Qur'an), insufficient attention is paid to how distinctive Islam is here by comparison with many other religions, few of which argue that the leading text of the religion is in itself a proof of the religion by dint of that text alone. We shall soon consider the strengths and weaknesses of the arguments on either side, but before we do that let us look at the whole process of defending and attacking a religion on the basis of its origins, perhaps in another religion or in some group of people not part of the religion itself.

Why should this be challenging to the religion itself? The answer is that if a natural or historical explanation can be provided of something, which is sup-

posed to be miraculous, then the miracle evaporates. A good example from the twentieth century was the reception of Egyptian literary analysts of the Qur'an like Taha Hussein and Nasr Abu-Zayd when they tried to treat the Qur'an as just like any other book from an analytical perspective. What might look like religious obscurantism at first glance, looks different when brought up against the arguments for the veracity of the Qur'an based on its style. If that style is to be linked closely with the style of *jahili* (pre-Islamic) Arabic, say, or with other sorts of language found in similar texts, then it looks as though the miraculous nature of the style soon disappears to be replaced by the sort of style one would expect in a religious work of its time and place. This is not to suggest that the various analysts of the style of the Qur'an necessarily came to the conclusion that the style was nothing special, but it is the very activity of regarding the text as just a text, to be studied by the rules which applies to any text, that was found to be objectionable by many.

It is a bit like watching a magician go through his routine, and not knowing how it is done. It might be thought that if one has no idea how he carried out his tricks then those tricks are much more impressive than if one knows that they have a perfectly natural explanation, or even if one knows precisely how they are done. After all, some viewers would even think perhaps that the magician has special powers, which he brings into play to carry out his magic. But most of us know that the magician has a technique, which makes it possible for him to make us think that it could only be magic which brings about his effects. And yet most people still enjoy magic, and in fact it might be suggested that they enjoy it even more when they do not believe it is real magic, because then they understand how difficult it must be to carry out such tricks. If I have magical power and can just wave my hands to make paper turn into a dove, then that becomes easy and not much of an accomplishment – I am just being me, a person with magical powers. If I make you think that the only explanation for what I do is magic, but we all know that there is no such thing as magic, then that is very impressive, since that shows how skilled I am.

So we can admire a smooth performer who tries to fool us about what he does. This might seem to be a poor analogy for religion, if one believes in the religion anyway, since comparing a religion to a magic show seems rather demeaning. What is important here is that we appreciate that it is possible to be impressed by something and yet at the same time not think that it came about in a supernatural way. That is not to say that religion did not come about in a supernatural way, but that its supernatural origins are not essentially part of what attracts us to it, or at least could be seen as not an essential part. It is like being in love and yet at the same time appreciating that the phenomenon of being in love has both a biological and a cultural explanation. Such an appreciation does not do away with the activity of being in love, although it does make it less mysterious.

One could use the scientific explanation as an argument in favour of completely deflating the state of being in love, ending up in the position of the cynic, who, as Oscar Wilde put it, knows the price of everything and the value of nothing. But this move is not inevitable. After all, knowing why a slice of bread tastes so good because one understands the physiological basis to that sensation does not have to result in the bread tasting less good than it would otherwise. Understanding does not have to get in the way of enjoying or admiring. This is a point which has been stressed throughout this book: we can understand a work of art and yet not allow that understanding to enter into our aesthetic appreciation of it. The latter goes further than the understanding since it can operate entirely independently of it.

These are significant points when we consider the phenomenon of cultural contact. Just because one cultural product owes a great deal to another, nothing is shown about the comparative value of either product. There is a social phenomenon which is relevant here and which is called the 'pizza effect'. When Italian immigrants from the Naples area went to the United States they took the pizza with them; it became popular in the new country, eventually being re-exported to Naples, but the export was not of the original pizza. It was the new Americanized version. Now no doubt many traditionalists decried the lack of genuineness of the American pizza, but that is not relevant; what is relevant is the ways in which one culture does not just take something from another and leave it unchanged. On the contrary, cultural transmission is a supremely creative phenomenon, involving change and development at every stage of the contact.

Let us take an example here. It is well known that Islamic philosophy owes a great deal to Greek philosophy, in that many of the leading principles of the former are direct developments of issues and problems raised by the latter. One could interpret this in a number of ways. Some historians of philosophy with a firmly orientalist agenda would argue that it shows that the Islamic world did not have sufficient intellectual resources to develop its own philosophy, and had to borrow it from a superior culture. So Islamic philosophy (by which they mean mashsha'i philosophy) is really just Greek philosophy in Arabic! This is a complete misapprehension. Much Islamic philosophy is highly dependent on Greek philosophy in just the same way that much French philosophy and British philosophy is dependent on the Greeks, because they did very much establish the basic curriculum in the discipline. Yet there are many types of philosophy in the Islamic world, which really have very little to do with the Greeks, and even mashsha'i thought is far from slavishly dependent on Greek thought. It is an interesting fact that there is this close relationship between Greek philosophy and much Islamic philosophy, but the relationship tells us nothing about ownership; it is not as though Greek thought possesses Islamic thought or exercises control over it.

We really need to be more sophisticated when it comes to understanding how one system of thought affects another. The imagery around this is often structured in terms of ownership of physical resources, as though the originator of an idea 'owned' it throughout its use by others. Yet knowledge is very different from other types of possession, as Plato points out in the *Theatetus* when he compares having knowledge with keeping birds in a cage (197c–198d).

To see why knowledge is different we need to look at something as simple as a conversation. In a conversation one person speaks and another responds, and the response is normally far from a slavish reiteration of the initial sentence. A conversation extends the starting point of the discussion, yet without perhaps moving very far from the initial premises of that discussion. Who owns the conversation? This is a strange question, and even were it to be answered it would not have to be said that the initiator of the conversation owns it. It is often the case that the second participant makes the more pertinent remarks, in just the same way that the plays of Shakespeare are invariably more impressive than the histories on which they are 'based'.

Not all conversations are really opportunities for a frank and genuine exchange of views. Often the participants are intent on some other end, perhaps dominating the conversation or doing something else through the conversation, where the conversation is a vehicle rather than a site for a real exchange of views. In some conversations the language of ownership does become more appropriate. There are certainly many instances of one culture setting out, and succeeding, in dominating another culture, in just the same way that a dominating individual overwhelms everyone else in a conversation. There are fairly objective criteria of when this takes place, though, and we can similarly tell when one culture comes into contact with another and is so dominated by it that it gives up its leading ideas. This is certainly something of a theme of many of the greatest Muslim thinkers in response to what they saw as the challenge of modernity, whether a thousand years ago or today. The whole ethos of the various *ihya'* movements is based on the idea that the *umma* needs to be strengthened both from within and from without, and this is because in the conversation with modernity Islam is becoming dominated by the ideas of another and profoundly secular culture. At different times thinkers as diverse as al-Ghazali, Muhammad Iqbal and Said Nursi sought to try to establish the conversation on a more equal footing, by showing that Islam has got a good deal to contribute to such a conversation and need not accede to what appears superficially to be a superior material form of life and/or intellectual system of thought.

It has to be said that Islamic thinkers are not always reluctant to try to shape the conversation in pretty aggressive ways. For example, during the early stages of the introduction of Greek philosophy into the Islamic world there was often controversy as to whether it is possible for a system of thought based on

the Greek language to analyse terms in Arabic, and whether Muslims in possession of the *sunna* of the Prophet, the *ahadith*, the grammar of the Arabic language, and the other constituents of the Islamic sciences, really need to look to unbelievers, and unbelievers of a long time ago at that, for information about the deep structure of their conceptual machinery and the whole process of argumentation and debate. Some apologists for the 'first sciences' (*al-'ulum al-uliyya*) invented a story according to which the Greek thinkers had learned everything they knew from prophets like Musa and Ibrahim, so the knowledge is *halal*, as it were, approved for religious purposes. Ibn Rushd knocks this argument nicely on the head when he points out that there is no requirement in Islamic law for the knife which someone uses to prepare halal food to be the property of a Muslim.[63] An unbeliever's knife is just as appropriate, provided it is capable of doing the job appropriate to a knife. The use of the example of a knife is suggestive here, since the point of logic is to analyse, to break a problem up into pieces, and the source of the logic is unimportant, like the source of the knife, provided that it is capable of doing its job.

Let us return to where we started, with a discussion of the origins of the Qur'an. Would it be damaging to the claims of Islam were it to be argued that the way in which the language of the Qur'an was structured is not entirely unrelated to the surrounding cultures? Of course not, and in fact it is one of the main themes of Islam that the world was not without guidance before the Prophet came. On the contrary, God sent earlier prophets and although the Prophet Muhammad is the final prophet, there was nothing wrong with the earlier prophets. So it would be hardly surprising were the language of the Qur'an not to be entirely distinct from other forms of religious revelation. This is not of course to suggest for a moment that it is derivative on those forms of revelation, but it is clearly not unrelated to them, and this is by no means a critique of Islam or the Qur'an. In fact, Islam is in a uniquely favourable position when it comes to comparing it with other faiths in this respect, since it does not see itself as a competing faith, but a culmination of (some) earlier ones. So the issue of influence or derivation is not really a live one, when it is put in the form of whether the construction of Islam owes at least something to earlier and contemporary factors.

But it might be argued that this is not the sort of charge which is brought against a religion. It is argued not that there has been a degree of influence from elsewhere, but that there is nothing original about the religion at all, and so any prospect of claiming that its divine origins are obvious from examining the language of the Qur'an is otiose. The role of the miraculous claim is interesting, and as we have seen quite unusual in religious apologetics. Would an argument pointing to the style of the Qur'an being influenced by outside cultural influences be damaging to this central claim? Clearly not. It is obvious that the

language of the Qur'an is closely linked with the language of the *jahiliyya*, since were this not to be the case there would be no possibility of Islam gaining adherents as swiftly as it did. Along with the language, the Qur'an used some of the ideas of the *jahiliyya* also, and again were this not to have happened the text would have been indecipherable and no *umma* would have come about. When we looked at the institution of the Hajj at the start of the book we pointed out that the pilgrimage practice of Islam built on earlier traditions of pilgrimage, and Mecca itself was a longstanding centre of pilgrimage, both monotheistic and otherwise, long before the time of the Prophet.

There are certain sorts of influence which were they to be discovered, or established, would lead to the discrediting of what had been influenced. For example, if it was discovered that the Qur'an was in fact composed by a particular non-divine individual, then we would have to discount the account of its origin which the text itself gives. Or if much of the text itself was found to be derived from other texts and religions, and if the style of the text was nothing special, this would be a serious attack on the extraordinary status which the text claims for itself. It is certainly the case that in principle we could make such discoveries about any religious text, and they would seriously devalue the significance of the text and the corresponding religion. Islam has been attacked in this way, as have many other religions, and it is important that the defenders of Islam set out to respond carefully to such attacks. The first point that should be made about defending a text like the Qur'an is how improbable it is that anything which has captured the imagination of such large numbers of adherents could be nothing more than a hodge-podge of already existing ideas, or that the enormous volume of commentary and analysis which has been produced surrounding that text would be possible for something which was ultimately highly derivative. It could be argued of all the great religious ur-texts that for them to operate in the ways in which culturally they have, they must at the very least be constructed with sufficient depth and rigour to play the roles that they do in their communities. This says nothing about their divine origin, of course, but it does say a lot about the scope for claims of influence to become accusations.

This brings us back to conversation as the conceptual vehicle for understanding influence. As we have seen, it is a delicate matter where intervening in conversation is acceptable, and where it is too aggressive. Often one has students in the class who speak rather too much, and it is difficult to know whether one ought to tell them to be less ready to address every point in public, or whether it is better to leave them to express themselves as they wish. The trouble with such people is that they may serve to put off the more timid students from talking at all, and yet by asking them to talk less one is perhaps stifling discussion. A point about conversation which is clearly relevant to the discussion here is that it is not only what is said, but also how it is said which is important. When we

consider how one influence can impinge on something this becomes significant. Someone can often make a point which in itself is not that threatening, though the way it is said is. This is why when a religion is said to be influenced by something outside it, worries emerge about how that influence is to be understood. These worries often have more to do with difficulties in adopting an objective attitude to the religion, as one among many others, as opposed to being the only viable faith. Yet Islam does not see itself as the only viable faith at all, it gives a role of respect to at least some other religions, and the fact that some Muslims feel threatened by the suggestion that Islam has been influenced by other cultural forces is not really appropriate as a response by defenders of Islam. Also, the fact that some Muslims feel threatened by the idea that one can study the structure of the Qur'an and other Islamic texts by using the techniques of contemporary literary criticism is also not an appropriate response. On the contrary, one would expect the application of such techniques to reveal something of the spectacular nature of the text. In arguing that it is miraculous, and one must remember that it is an argument, something that is to be proved and defended, one is not suggesting that the text is beyond analysis. Indeed, the shelves of libraries are happily full of commentaries and discussions of the key Muslim books, and these are replete with analysis and argument.

One other feature of conversation which is relevant but has not yet been brought in is the potential for misunderstanding and change of emphasis without the participants even noticing it. Often someone will respond to a point by raising another issue which is not really directed to the same subject at all, although it may seem to be. Religions are often like this also, in that one religion seems to be addressing the same issue as another, and in a similar way, but really is not. For example, both the Jewish Bible and the Qur'an refer to miracles, but they refer to them in entirely different ways. The Qur'an tends to poke fun at the concept of the miracle as a sort of supernatural trick designed to impress an audience, which is very different from the way miracles are described in the Torah. Do miracles mean the same in the Qur'an as they do in the Torah? Well, it might look like the same concept was being used, but if it is being used very differently the very real question arises as to whether it is the same concept or something rather different, perhaps an extension of the old concept or even an entirely new concept altogether. After all, a bicycle and a supersonic jet are both modes of transport, but the fact that they are both modes of transport does not mean that they are both the same. The fact that something more modern may have been derived, at least in part, from something older does not show that they are basically the same, or that the later thing is based on the former.

We really need to think in more sophisticated ways about how different sorts of language relate to each other. We do this all the time when speaking to each other, in that we are capable of making all sorts of complex distinctions

between what is being said, how it is said, what implications what is being said have, how far the subject has been changed or indeed entirely subverted. The next step is to bring these familiar details of our everyday conversation into our understanding of how systems of thought such as religions relate to each other. If we manage to do this, the notion of influence will swiftly decline from its present intimidatory status to a more accurate and mild comment on how one way of talking affects another.

The Qur'an as literature

It is a commonplace among Jews and Christians to see their central works as literary texts, and to analyse them as such. This does not imply that they are not divine in origin, but it might be thought that this process tends to naturalize the texts. Muslims tend to resist such a process strenuously, arguing that the language of the text is itself a proof of the religion of Islam, and many would refuse to call a translation, the Qur'an, preferring the term 'interpretation' or 'version', because a rendering of the text into anything except the original Arabic is not a reproduction of the text into another language. It is impossible to reproduce the text, since the text is essentially Arabic, and it was in that language that God transmitted it. We need to ask the question, though, why God did deliver the text in Arabic. Jahiz (d. 255/869) and Shah Waliullah (d. 1176/1762), two thinkers from very different historical periods, suggest that a reason is that the Arabs were so proud of their language that a prophet who appeared with a document in such prose would immediately impress them. Earlier prophets had taken advantage of similar techniques appropriate to a particular community. So for example Moses produced trick-like miracles when in an environment (Egypt) which appreciated magic, and Jesus carried out miraculous healing when in a culture that valued healing especially. There certainly are many Muslims who do not understand Arabic and whose reading of it is incomprehensible to them, and in many communities a great deal of attention is paid to versions of the text in the local languages, although for ritual purposes the Arabic is always used. Since the Arabic of the text does not just happen to be the language which God used on a particular occasion, but is the actual language of God, it is rightly accorded a great deal of respect, and the fact that for most Muslims today Arabic is not their native tongue has not in any way diminished allegiance to Islam nor conversion rates. There is a lot to be said for a religion which has as its central text something that claims to reproduce directly the words of God himself, clearly such words can easily be assumed to have a great *baraka* or blessing attached to them as a consequence.

Is it acceptable to say that the Qur'an cannot be translated? This of course is a claim that is made more generally – that to translate is to destroy, that a

translation is only ever an approximation – and there are certainly texts which are fiendishly difficult to translate. Poetry is one such example, and there is of course plenty of poetic language in the Qur'an, although it would carefully distinguish itself from the Arabic poetry of the *jahiliyya*. Religious texts are also not easy to translate, since they generally import a whole range of meanings that cannot be translated, or even the very sounds of the text itself. This is particularly the case for the Qur'an because many argue that its sound is so important to understanding it and we must remember that in the early years of Islam it was probably memorized and the written copies were only used to help the believers recall a passage when they were in doubt about how it went precisely. One way in which the oral reading is important is that the Arabic text as originally written is rarely marked and so the vowels would be in doubt unless one knew the precise meaning of the term. In Arabic there are many words which consist of exactly the same letters, and whose meaning is determined by the vowels which are added, and so unless one knows the meaning one does not know which vowels to add. The context sometimes makes it obvious, of course, but sometimes the reverse is the case, and a variety of possibilities exist, some quite significant.

But it is often said that the Qur'an is such a complex text that a translation is just not feasible. There are so many layers of meaning, so many cross references, hidden implications, plays on words, and most of all perhaps the emotional impact of the recitation, that a translation is not possible. There is also the status of the text as a living moral document, one which is supposed to lead a community and instruct its behaviour, and so not just a piece of literature but a part and parcel of actual lives. One cannot emphasize enough the significance of the Qur'an as a work designed to be heard rather than read, and a great deal of attention is paid to its recitation. There are instructions about the ways in which the text should be recited and also how it should be heard, and these are important parts of the Qur'an, not just incidental features which have grown up around it. If one accepts that the Qur'an is in fact at the centre of a whole range of religious practices and experiences, the idea that it cannot be translated becomes a bit more plausible.

On the other hand, it is not that plausible. Even if the Qur'an is quite exceptional as a literary product, sent to impress the Arabs for whom poetry was an art form which they held in great respect, we need an argument that poetry of exceptional quality cannot be translated. This must be more than the argument that no poetry can really be translated, but presumably that the epitome of poetry is not accessible through translation. We may accept that translation is difficult, and requires supplementary explanation, but this does not mean that the task is impossible. It depends of course what one means by translation. If one means the direct conversion of *all* aspects of the meaning of a piece of lexical

text from one language into another, then no translation is possible of the Qur'an. This is not what is meant, though, since the claim is rather that the Qur'an uniquely is incapable of translation.

This is a claim that can actually be assessed. The way to do this would be first to look at other religious texts and wonder whether they can be translated. Surely they can, albeit we may argue over different attempts at translation and also insist on some supplementary material to bring out the complexity of the text. The translatability thesis is linked with the inimitability thesis, since it is argued that an aspect of the uniqueness of the text is its untranslatability. This is not as a result of the general untranslatability of religious texts, but a result of the untranslatability of a unique text. If we accept that the text is unique then we are on stronger grounds to argue for its untranslatability, since there are no general rules we can employ for something unique. By definition, if something is one of a kind then we are at a loss to use our knowledge of other things to interpret it. We saw when we discussed the issue of influence how some Muslims have argued that looking for what influenced the Qur'an is totally besides the point, since it is not one religious text among many others. It is the culmination of religious texts, and as such not to be analysed in the same terms as all the others.

Miracles and their criteria

Let us come back to examine the miraculous nature of the text. The right sort of miracle for the Arabs, with their mastery of language and composition, was a work whose mastery of language and composition outdid anything presently available. In the same way that the serpents Moses produced from his staff gobbled up the serpents produced by Pharaoh's magicians, the Qur'an easily bested alternative pieces of literature then on the market. A significant difference between the miracles of Moses and Jesus and other prophets is that they only lasted at their time, while the Qur'an has lasted ever since. The earlier miracles were one-off events, having an impact at their time but now only having the status of reports. Of course, since these reports are in the Qur'an they are to be believed, but otherwise one could easily doubt them. But if the miracle of the Qur'an is indeed a miracle, then it is present to anyone who approaches the text, at any time, and this ever-present miracle is then by far the most potent of miracles, since it is the most pervasive.

Could Muhammad not have written it himself? We are told that he was *ummi*, which is often taken to mean that he was uneducated, and so such a complex text would have been far beyond him. There are a variety of ways in which *ummi* may be understood, so perhaps too much should not be made of this point, but it is relevant to ask the question whether the work could be thought of as humanly created. There are many reports about those hostile to Islam

hearing passages from the Qur'an and becoming instantly converted, and even today some Muslims seem to expect nonbelievers to be convinced, or at least impressed, by the text once they come to hear it. What stands in the way of general acceptance of Islam, it is sometimes argued, is the fact that most people do not know what it is, and once this is rectified they soon come to embrace it. They are compelled to embrace it by the power of its language and its evidently divine origin.

There are a number of features of the miracle which we are encouraged to note. There are issues of the beauty of the style, and also issues of the truth and appropriate guidance in the text. It is sometimes said that it is the connection between these different facets that gives the work its unique character, but here we shall concentrate on the aesthetic issue of its beauty. The challenge that the Qur'an sets is to produce a work like it, or an easier task, to produce a chapter like those in the text (2.23–24). Not even if the whole of humanity allied with the *jinn* (often seen as skilled artists and stylists) were to try to accomplish such a task, would they succeed (17.88). The consequences of rejecting the signs which God sends are, we are told, severe and long-lasting, so if we do not accept the Qur'an we are to suffer dire consequences. There are many threats in the text itself, of course, and this might be regarded as aggressive as a persuasive strategy, but the answer is that if God sends a miracle and presents it precisely in a way that is guaranteed to maximize its accessibility, then it is our fault and certainly no one else's if we do not accept his guidance and assistance. If a physician prescribes medicine for us and explains to us very carefully and appropriately why we should take it, and we do not, then it is hardly his fault if ultimately we fall sick or do not recover from our illness. And it is fair and reasonable of him to warn us of the consequences of what we are doing.

But in this case what we are being punished for, apparently, is our failure to agree to an aesthetic judgement. That is, if we read or hear the Qur'an and decide after pondering on the text that it is not the most wonderful piece of composition which we have ever come across, then we may reject the message which it contains, and so earn the punishment that is consequent on such rejection. Actually, there is another option here, which is that we accept Islam but do not accept it on the basis of the miraculous nature of the Qur'an. We might find the message in the Qur'an to be the correct message as far as we are concerned but not be particularly impressed by the medium in which the message is to be found. That is, it is the meaning of the Qur'an which we value, not its particular expression in the text. This would suggest that the miraculousness of the style is not such a crucial issue after all. It is worth bearing this option in mind when we examine further the nature of the claim that the Qur'an's style is miraculous in nature

The miraculous claim and the Arabic language

The argument of the miraculousness of the Qur'an is in many ways a typical argument from design. These are familiar in religion. They work by selecting something in the world, here the Qur'an, and then asking whether it can be explained as having come about through natural or human means. It may be a wonderful mechanism like the workings of the eye or something much larger like the organization of nature as a whole. The argument suggests that since there is no other plausible explanation for the phenomenon than that it originated in the divine, we are rationally compelled to come to that conclusion. There are many problems with such a general argument. For one thing, people may disagree as to whether what has been allegedly designed really has the qualities it is said to have. This strikes at the heart of the miraculousness debate. Is the text really so wonderful? Suppose someone was capable of reading it in the original and thought it was not. It could be because he is mean-spirited or prejudiced against it in some way, of course, but surely we must allow for people to read and understand the text, but not appreciate it aesthetically. As is well-known, we cannot compel someone to come to a particular aesthetic judgement, and any glance at the visitors' book in a gallery will reveal a variety of views on any exhibition. The quality of the text, which seemed initially such a strong argument for its inimitability, now seems less powerful, since in so far as the evidence rests on issues of beauty, it appears to be entirely defeasible. We can understand why the love of the Arabs for their language and for what is *fasih* (eloquent) should have made the Arabic of the text so important, but are not judgements of style and beauty rather subjective issues? There are many references to it being presented in Arabic (12.2; 20.113; 39.28; 42.7; 43.3; 46.12) so that it could be understood, and the way in which it was presented is designed to ensure that the message is identified as coming from God, and not from a human creator, but if the style is an aesthetic issue then could we not be unimpressed by it?

We should not forget that even in the days of the Prophet there existed more than one variety of Arabic, and more importantly, more than one way of reading and reciting the language. There are many *ahadith* in which people complain to the Prophet that they heard someone reciting in a strange accent or dialect, and he responds by suggesting that the Qur'an was revealed in seven different ways, in the sense that the ways of speaking the language followed by the different tribes were all acceptable. In retrospect this is important since if only the dialect of the Quraysh (the Prophet's) tribe was allowed, the message would not be easily accepted by the other tribes, and in time by other nationalities altogether. Certainly Mecca and the Quraysh had a significant status even in the *jahiliyya*, since this was a large city in the region and the centre of a longstanding pilgrimage. The leniency of the Prophet to those of other tribes, and

ultimately to all humanity, reflects well on the universality of the message. Although the interpretation of the text by the people who know the language, the *ahl al-lisan*, is always going to be very important, since it is they who have the best grasp of the language which the text uses, it is not necessarily those people who have the last word, since there is far more to the Qur'an, many would argue, than just the language.

The miraculousness claim and the nature of meaning

There was in Islamic theology a long discussion about what it meant for the Qur'an to be miraculous, and what the semantic implications of this claim are. For the Mu'tazilites, the Qur'an was created and produced by God at a particular time for a particular purpose. They argued against the view that there are un-created letters, *huruf*, out of which words and sentences, what we would call discourse (*nazm*), are to be derived. One motive they had for this argument was that it seemed to them to be the only possible view that preserved the unity of the divine, since if the Qur'an were eternal and God is eternal, then there would be in existence at least two eternal things, seriously diminishing the absolute unity of the deity. Their opponents, the Ash'arites, advocated the co-eternity of the Qur'an, accepting that the linguistic expression of the text (*kalam lafzi*) is temporal and created, while the inner expression (*kalam nafsi*) is uncreated and is an eternal part of God himself. It is sometimes referred to as being inscribed on a preserved tablet (*al-lawh al-mahfuz* 85.21–22). The problem with the Mu'tazilite view is that it does not give any scope for a speaker to think about what he is going to say except by using the language in which he expresses himself. That is, they want to argue that the Qur'an is a created thing because speech is created and really there lies nothing behind it. Even when we think about what we are going to say, we are still speaking, albeit to ourselves, and so we are creating at any particular time particular combinations of phonemes. The suggestion is that when we think about what we are going to say we think in language, and even if we have to think about what word to use, we are still using other words to help us get to our word. Here the idea that speaking is a skill is significant, and one would indeed not want to call someone a good speaker if she had wonderful ideas about what to say but could not say them.

The alternative view produced by the Ash'arites is that what makes lan-guage meaningful is its obeying certain rules. Both the syntax and the semantics of a particular language are based on fixed principles, a *taswir* or a shaping of matter into a particular form. What turns the words (*alfaz*) into having mean-ings (*ma'ani*) is our using the former in specified ways, in the ways we wish to employ. The more sophisticated the language, the more complex the thinking process involved. For relatively simple uses of language all that is needed is to fit

one's speech and writing within the rules of grammar, but where style becomes important, much more deliberate choice has to be made. In what language does this choosing take place? For the Ash'arites, this takes place in no language at all, or at least not in natural language, since it is what precedes such language. The actual arrangement or *nazm* of the words is merely indicative of a much deeper process of thought, and when that process originates with God the *kalam lafzi* is obviously going to be of a particularly impressive pedigree. The text is miraculous because the ideas which lie behind it are miraculous, and what is available to us in the form of language is merely an indication of that deeper level of meaning accessible in its complete state only to God. This level of ideas is rightly said to be co-eternal with the deity, since it could hardly be the case that an eternal and omniscient deity would suddenly think certain things, as though up to that point he did not know them or was not aware of them.

The Mu'tazilite view is often taken to be the more radical since it does not really take seriously the idea of the text challenging (*tahaddi*) others to produce something like it, or better than it. If the idea of a level of understanding which lies behind language is rejected, what role is there for an evaluation of the Qur'an as a text which is superior to other texts? All that can be compared is syntax, and that is a rather weak point for comparison from an aesthetic point of view. It is the rich interweaving of a range of semantic values or meanings that one would expect a wonderful piece of language to rest on, and for that we need to be able to talk about a deeper level of significance on which the language rests. Of course, for the Mu'tazilites the Qur'an is created by God, it is not part of him, and so the implication is that it is not as perfect as he is. However, since one of the aims of this doctrine is to preserve the perfect unity of the divinity, it tends to rule out questions that we might raise about *i'jaz* and which in turn would require answers in terms of God's thinking processes. The Ash'arites have few problems in referring to a process of thought which lies behind the language, and so can talk about what motives God might have had in phrasing a passage in a particular way and so on. The fact that the Qur'an is seen as co-eternal does not mean that it is beyond analysis, quite the contrary. Ash'arism invites questions about the purpose of the text, whereas Mu'tazilism refuses to go beyond the text in anything more than a superficial sense.

It is something of a truism in Western accounts of Islamic theology that Mu'tazilism is progressive while Ash'arism is the reverse. Western commentators are often desperate to find something in early Islamic theology and political theory which looks familiar, so they class the Mu'tazilites as the goodies or the liberals, and their opponents, the Ash'arites, as the conservatives or reactionaries. This is a crude generalization, and like so many such generalizations not accurate (an account of the problems here can be found in my chapter on ethics in *Brief Introduction to Islamic Philosophy*). It is worth remembering that the critic

of philosophy in the celebrated Baghdad debate in the fourth/tenth century was a Mu'tazili thinker, Abu Sa'id al-Sirafi. This debate was really about whether there was a role in Islam for philosophical ideas that had come from languages other than Arabic. In particular, was it worth translating lots of Greek philosophy into Arabic, since one might worry that Greek philosophy is relevant for issues that arise in the Greek language but not in any other? The argument was that only a native Arabic speaker could really understand the grammar of Arabic and that there is nothing behind language except the principles of that particular language. In fact, each language should be thought of as having its own logic, so there is no general logic which lies behind all the different languages. Al-Sirafi's opponent argued that behind a discrete language lies the attempt by speakers to establish meaning through their words and actions, and in order to understand the language we need some grasp of the meanings on which the language rests. These meanings are entirely general and so may be held to be independent of any particular language.

This brings us to an interesting difference between the schools of theology with reference to inimitability. For the Mu'tazila, we are only allowed to examine the syntax of the Qur'an and we are restricted to fairly superficial aspects of style in our analysis. Although they would be happy to use the slogan *al-lafzu yadullu 'ala ma'nan* ('the word indicates a meaning'), the meaning or concept refers to the level of syntax rather than to anything deeper. Asking deeper questions implies that we are asking questions about God, and treating his characteristics as though they were separate from him. That is a very dogmatic claim to make, and it is surprising that the Mu'tazila are identified with taking up a more critical and independent attitude towards religion. The Ash'ariyya, by contrast, have no problem in asking why God produced the Qur'an in the way in which he did, since for them that production is part and parcel of what it is to be God in the first place. And we can ask those sorts of questions, like why it is that a God like the God of Islam would make a certain claim or present an argument in the way in which he did because we can speculate on the nature of God and link those speculations with our attempt at gaining a rational understanding of God. This hardly sounds like a platform for obscurantists in religion, in fact it appears to be much more suggestive as compared with the Mu'tazila, who are restricted in their approach to the Qur'an to raising aesthetic questions about syntax, about appearance rather than the reality which lies behind that appearance. We might recall that in the debate with Bishr ibn Matta, a Christian whose mother tongue was not Arabic, Abu Sa'id al-Sirafi, the Mu'tazili, argued that each language had its own semantics, and so there is no general logic underlying all distinct languages.

In that case the sorts of questions which the philosophers raised about syntax resting on semantics are out of place, only someone with a deep knowledge

of a language could understand what sentences in that language mean. Al-Sirafi used this argument to undercut the idea that philosophy could deal with general theoretical issues arising in any language at all. It has an interesting impact on theories of the Qur'an, though, in that it suggests that one can look no deeper than language in working out what the status of the text is. Yet the challenge which the text makes is to compare it with other texts, and presumably not just with Arabic texts, nor even just with texts written in Qur'anic Arabic.

The miraculousness challenge: syntax vs semantics

Is it possible to use the syntax of the Qur'an and set the *tahaddi* or challenge to the world to find better syntax? It is possible, but is unlikely to be successful. However wonderful that syntax is, and it has to be said that the language of the Qur'an is very impressive, there is plenty of writing which is just as impressive, in the opinion of at least some native Arabic speakers. This is a difficult question, since we need to distinguish here between the Qur'an as an event which occurred at a particular time, and the Qur'an today. The Qur'an is written in Arabic, but of course it subsequently played a huge role in constructing Arabic, since it had such high status. At the time it appeared one can easily see how it must have created a stir. It just was an extraordinary linguistic event in and of itself, regardless of any implications that this event is taken to have. But fourteen centuries later one wonders how fresh the miracle remains. It is actually a familiar issue in a work of art that the initial reaction to it is very different from subsequent reactions, since familiarity results in different understandings of the work. Many texts repay close attention and many readings, and the Qur'an is no exception here, but it would be wrong to think of it as having the same impact now as when it first appeared. It would be wrong to think this of any aesthetic object. That does not imply that it can no longer be seen as beautiful, on the contrary our aesthetic understanding of the object may have deepened over the intervening centuries, but it is worth pointing out that whatever that understanding is, it will change over time.

This raises a problem for the argument that the Qur'an, by contrast with less significant miracles, is a continuing miracle. Familiarity breeds contempt, as the English expression goes, and many of the phrases in the Qur'an have entered the run of ordinary Arabic now, so can hardly be expected to elicit the same reactions as in the past. In some ways that shows its job has been done, since it has become so firmly encapsulated within Arabic culture that some of its linguistic forms are used automatically by speakers of the language. This does not mean that it can no longer be regarded as miraculous, but it does mean that it is harder to establish the case. For one thing, what was fresh and new is now less so, unless it can be argued that despite the many centuries of use the language

of the text still preserves its pristine nature. Some would argue that, but it is not an easy argument to make, especially if all that one has to go on is syntax.

To develop this point, the argument for the miraculousness of the text is an argument subject to refutation, and it has been refuted in the opinion of some. For example, there are readers of the text, even readers of it in Arabic, who are not that impressed with it. Some have called it grandiloquent, verbose, incoherent, rambling and so on, and clearly these are individuals not captivated by it. The blend of the lyrical and the narratory which so many find delightful is regarded by others as confusing and inept. It might be said that there is something wrong with them for coming to such negative views, but on the other hand this is always a danger if one makes an argument rest on aesthetic foundations. There will often be those who do not share the aesthetic attitude of the majority, or of the official keepers of the flame. We could rule them out morally and even suspect their motives, but this seems harsh. There is surely scope for disagreement about issues of style, and what some regard as very positive aspects of style others do not. We must allow that at least some of those who approach the Qur'an may be sincere in their lack of appreciation of it stylistically, and this seriously threatens the whole basis of the miraculousness proof.

If we broaden our notion of the style of the Qur'an to include semantic issues, what the deeper meaning of the text is, then perhaps we shall be on firmer ground to establish the miraculousness claim. The Ash'arites see the Qur'an as resting on the purposes of God, and so it is easy to think of it as having a range of meanings, only some of which we can grasp. This gives scope also for mystical interpretations of the text, and we shall look at some of those in this book, since the text like many religious texts is easily esotericized. We could regard this whole layer of meanings as being what the Qur'an represents as a text, and not even have to be very specific about which particular meaning we regard it as finally having. We may even reject the notion of its having a final meaning. This makes for a far more plausible basis to the miraculousness thesis, and as a challenge it is harder to meet. On the other hand, it results in changing the nature of what we regard as the text, as it is ordinarily understood.

But we have to be clear about what is and what is not included in the challenge. Does it include any of the non-aesthetic features of the text? There is a temptation to say that it does, since the Qur'an is not just a work of art. It also contains important moral and religious advice and instruction, and these cannot be removed from the text as though they are incidental features of it. One of the proofs of the text is supposed to be the excellence of the practical philosophy it contains, but it is difficult to judge that material unless one is already convinced that it is on the right track. That is, the rules about human behaviour in the text might only be seen as positive rules if we are convinced of them through the beauty and power of the text itself, so we can hardly use those rules

as evidence of the wonderful nature of that text. One of the miraculous features of the text is that it persuades people to do things which they rather prefer not to do, and so we can hardly bring in evidence of the putative attractiveness of the rules in support of the persuasive power of the text.

We could still bring in evidence of the deep layers of meaning and allusion in the text and argue that this greatly increases the aesthetic value of what we read and hear. This does not imply either that we accept the existence of levels of metaphysical reality about which the text instructs us, for this also would be circular reasoning if we were to use our awareness of those levels as an argument for the impressiveness of the text. What we need to argue is that the style of the text rests on differing layers of meaning, and that the richness of the text is linked with the interplay between those layers, and what they reveal to us of the workings of the divine mind. The Qur'an is taken to produce such a staggering combination of language and ideas that something of this richness is revealed, albeit obliquely, and this enables the text both to provide us with aesthetic pleasure and also stimulate us to search for ever more complex ideas which the Qur'an hints are there to be found. This is a far more plausible candidate for miraculousness, that the aesthetic value of the style is linked to something on which the style is based, as it were, a range of meanings and principles which gives the style far greater significance than merely being beautiful.

The Qur'an admonishes its reader to recite, reflect on and understand the text (*kitabun anzalnahu ilayka mubarakun li-yaddabbaru*) (38.29). This is an interesting combination of instructions. None of them is directly aesthetic, although it might be claimed that they all could be, and the notion of recitation is certainly capable of creating an aesthetic reaction in both audience and reciter. There are special rules to reading the Qur'an, as we have seen. But it would be difficult to argue, although that does not mean that it has not been argued, that the combination of the sounds and words is obviously far superior than any other similar kind of Arabic writing, or any other kind of religious and secular product that is available to us.

But suppose we broaden the notion of the basis of the words and sounds to include much deeper levels of meaning, hidden (*batin*) meanings which lie beneath the *zahir* or exoteric level, and those, together with the words and sounds could be said to make up a perfect combination of what delights our senses (the sounds) and what stimulates and satisfies our moral and intellectual consciousness. It could be argued again with some plausibility that this particular combination is more effective in the case of the Qur'an than are any of its competitors in the ranks of literature, in particular religious literature. To prove it, though, is not easy, however impressed one might be by the sounds and meanings of the text. For one thing, what makes one so impressed is what one takes to be the meanings, and these meanings are only grasped as impressive if they are taken to

be true. This is especially the case if they are hidden meanings, since to identify them one will need to apply some sort of theory, and that theory will presumably be based on accepting the text as the word of God. Actually, this is not the only conclusion we could draw, since it might be argued that the combination of hidden meanings and the sound of the text makes for a product that is immediately convincing, one which has certainly in the past been found to be so. This would fit in nicely with the idea of *tawhid* or unity, so important in Islam – with the unity of the natural world (our love of sound) and the intellectual adherence to a set of beliefs (our rational character) blending in the Qur'an – a unique combination of these features resulting in God making it easy for us to understand and accept his message. Before we assess this idea let us look at the rather different notion that it is actually the individual parts of the Qur'an which serve as incomparable examples of divine validity, not just the whole body of the text.

The miraculous challenge: parts vs whole

This is the challenge which has been made, and actually the challenge is much easier to settle than would be involved in comparing the whole of the Qur'an with the whole of a competing religious or literary work. The challenge is sometimes only to find a sura which is of equal excellence as any of the suras in the Qur'an, or to find ten such chapters. That really is a confident claim, and difficult to justify. Some commentators like Said Nursi (d. 1379/1960) even go to the extreme of producing a few words of the Qur'an and argue that nothing like it could be produced, nothing by human beings, that is. That sort of challenge really does look back to the idea of the text's Arabic as the product of great skill, so that a wonderful chapter is like a perfect painting or piece of music, something which cannot be improved on. But this is surely going too far. It is one thing to argue that a particular sura within the context of the whole world of meaning of the Qur'an has enormous grace and significance, but to take it out of context and claim that just on the basis of its literary style it overwhelms any possible competition is implausible.

Yet do not people claim to read or hear just one or two verses and embrace Islam as a result? They are surely genuine in what they say, and we have no reason to disbelieve them. We would have to say of cases like this that a lot more lies behind their conversion than just those one or two verses. It is like looking across a room and falling in love with someone just because of her smile, or the colour of her eyes. That may be what does it, but it needs to be supported by further evidence. For example, the smile may be the initial attraction, but it cannot be the only attraction. There has to be something else, and probably a lot more, for love to be possible as a serious long-term option. That does not

mean that the object of love has to encourage the lover, but there has to be something more in the object for the attraction to continue and become a settled disposition. This reveals what is mistaken about the approach of concentrating on just a few lines of the Qur'an and saying that they are enough to establish the miraculousness of the text as a whole. We need to know the whole text before we can assess its miraculousness, and a few lines may be suggestive, but could not be conclusive.

To be fair, those who argue for the miraculous nature of particular verses do also argue in depth for the miraculous nature of the whole. It is not just the style on which they focus, but·on the truth of what is revealed and the incomparable way in which it is expressed. The words are taken to have a power which human words do not possess. For example, Said Nursi compares human orders with orders coming from God.[64] The latter says:

> O earth, swallow up your water. And O sky, withhold [your rain] (11.44)
> And he said to it and to the earth: Come together willingly or unwillingly. They said: We come in willing obedience (41.11).

Human beings would express these verses thus:

> Stay still, O earth. Stay closed, O skies. Let the resurrection of the world start.

Nursi claims that the orders are totally different, because one is given by a mighty ruler and one by a common soldier, as it were. The form of the words they use may be the same, but the meaning very different. He goes on to quote passages describing how God says 'Be' and the world comes into existence (36.82), where he commands the angels to bow down before Adam (2.34) and finally an account of the resurrection (50.6–11). In all these cases the descriptions of what God does and says is much more noble and powerful than what we could say. One might be sceptical of this conclusion, since it might seem that when Nursi claims that we could use the same language but not apply the same meaning to the words he is just wrong. After all, when a general tells the army to move surely he means the same as when an ordinary soldier issues the same command. The only difference is that when the general says it the army moves!

But Nursi has his finger on an important point here, that of performative meaning. When the general issues a command it is the same command as when anyone else issues it, but it has a different meaning. In issuing the command he is not just expressing a wish that something will happen, he is actually bringing it about, whereas the soldier may share his wish but cannot bring it about. This is not just a matter of someone having power and someone else not having the power, it is a matter of someone being the right sort of person to express a particular sentence. When I put a grade on one of my students' essays, the action has a certain meaning. Someone may wander into my office, find the essay on

my desk and grade it, and the grade they give it may be the same as the one I give, but that does not have the same meaning. Everything about what is done is the same, except that the person who is carrying out the action is the wrong person for that particular task. Or to take an even more interesting example, suppose a student walks out of an examination because she just feels too tense to take it, goes home with the paper and writes her answers in the same period of time as the other students, but just not at the right time or in the right place. Then she gives it to the examiner. Has she satisfied the requirements for the course? Well, the examiner may say that even though he believes that she did not cheat, and that she did exactly what the other students had done, because it had not been done in the right place or at the right time he could not accept it as a satisfactory performance of the task at issue. The context is often crucially important in defining what has actually taken place, even though the facts about what takes place themselves are identical.

So Nursi has a strong argument for the point that just because two different people say the same thing, it does not mean that they are doing the same thing with that statement. But this will only work as an argument for the miraculousness of the text if we know already that the author of the Qur'an is divine. If we know that only he is in a position to make the claims that the text does make, then we can appreciate how foolish it would be to apply those claims to lesser creatures. But this is what the text itself is supposed to prove. The magnificence of the text is supposed to force us to conclude that only God could have produced it. Nursi does produce detailed arguments for the excellence of the text as a whole, and yet even he seems dissatisfied with his ability to convince the doubter that these arguments establish the miraculous nature of the text. This brings out the central problem with using miracles to prove anything, in that it is always possible for the sceptic to find a natural description for the miracle. The claim that the sceptic could not do this when confronted by the text is just wrong.

Perhaps, though, this is setting the standard of proof too high. The argument might be made that the Qur'an can be seen as miraculous, but does not need to be. There are good grounds for accepting that its language is an extraordinary creation, and so it could well be the product of the divine, without arguing that anyone who reads it must accept it as such. This would really do justice to the aesthetic nature of what is meant by the miraculousness thesis, since in aesthetic argument one can do all one can to make a particular judgement persuasive, but not conclusive.

But if the miraculous argument is not conclusive, does that not mean that a central Islamic claim is false? It has to be said first of all that aesthetics is a very flimsy basis to proving anything. We can adopt a variety of aesthetic responses to the same phenomenon, something which the Peripatetic philosophers found a constant problem in their attempts at translating aesthetic language into

logical form. On the other hand, perhaps the language of proving a conclusion is the wrong language to use in discussions about religion. Seeing the world in a certain way is common to both religion and aesthetics, and so there is nothing strange in linking these two approaches. What is misleading is the idea that issues of style and our aesthetic assessment of that style can prove to be a decisive and irrefutable argument. What is not misleading is that it is possible for issues of beauty to be at the centre of religion. Islam announces that aesthetics lies at its heart, and this is something we must remember when we look at the religion and how it represents itself.

8

Philosophy and ways of seeing

Philosophy plays a large role in defining how we see and what we see. This is because the concept of seeing is far from a simple concept, it requires explanation and analysis, and this will vary depending upon philosophical principles. There are three main philosophical schools in the Islamic world, the Peripatetic (mashsha'i), the Illuminationist (ishraqi) and the Mystical (sufi), and each school has distinct approaches to the notion of representation. Actually, even within each school there is no unanimity of view, and different thinkers who share many of their opinions have distinct ideas on representation. It would be interesting to examine what some of these opposing opinions and arguments are, in order to understand better the theoretical ideas which lie behind very concrete artefacts such as paintings. We have discussed up to now many of the religious ideas which are held to lie behind such cultural objects, now it is time to consider their philosophical background.

Of the three schools the most difficult to classify is the illuminationist or ishraqi school. This school, largely based in the Persian cultural world, sees itself as coming some way between the rationalism of Peripatetic thought and the mysticism of the Sufis. Like the former it employs logical and objective forms of argument, and yet like the latter it assigns a high value to personal subjective experience. The ishraqis are critical of Aristotelian thought, but they seek to replace it with other strategies of rational argument, and indeed complain that Aristotelianism is insufficiently logical. After all, the basis of Aristotelian philosophy is the notion of definition, and this occurs in the premises of the syllogisms, the forms of argument in that philosophy. A definition gives the necessary and sufficient conditions of whatever the concept is, so that we start off with a clear and complete idea of what is being analysed. But the ishraqis suggest that this is going too fast, since if we know the definition of the concept right at the start of the reasoning process, what is the need for the reasoning at all? Reasoning is designed to help us establish definition, and so cannot be used on the assumption that that definition has already been established. The basic categories of Aristotelianism are likewise regarded as unreasonable, and they require replacing with concepts that better represent our metaphysical position

in the scale of reality. One of the key concepts here is that of light, for it is light that comes from the higher world that makes both life and thought in our world possible. Instead of seeing the world as consisting of subjects and objects, ishraqis use the language of what is lit up and how it reflects that light. This is not the place to assess this form of thought as compared with its competitors, but it is now appropriate to look at what an ishraqi aesthetics would look like.

What is different about ishraqi attitudes to aesthetics? The aspect to concentrate on here is the particular significance attached to imagination, but not in the sense of imagination as used in many other forms of thought about the mind. We tend to see imagination as being linked with what is unreal, with what does not really exist, and in his translation of this idea Corbin (d. 1978) tried to get away from this implication by using the term 'mundus imaginalis' or imaginal world. This approach has been criticized, because it has been claimed that imagination in English and French is sufficiently flexible to be used in the ishraqi way as it is, but the important point that Corbin made remains important, and that is that within ishraqi metaphysics there is a range of thought which is rightly identified with the imagination and which is at the same time descriptive of a particular ontological realm.

In the work of Suhrawardi he takes a particular stance in psychology by refusing to accept the sorts of distinctions which were accepted by the mashsha'i thinkers, although it is not immediately clear what the significance of this is. For example, while Suhrawardi clearly adopted all the psychology of ibn Sina to set out his understanding of how the human psychological faculties operate, he rejected the complexity of the system, as though that complexity hides the fact that it does not really explain how thought is possible. He even goes so far as to fail to distinguish between the theoretical and the practical intellect, between our capacity to know what is true and our capacity to know how to act because he wants to deny that this really explains anything. It is the rather untempting label of the 'fourteen coffins' (arba'at 'ashar tabutan), which he applies to the physical faculties, that gives an indication of the lack of respect with which he holds these parts of human beings. Of crucial significance is the dethroning of the active intellect from its position of influence in philosophical psychology. For the falasifa this is the level that represents our highest point of intellectual advance, and is a stage in human thought where we manage to create ideas and concepts which to a degree replicate what is done at a much higher level by God. There was a big dispute as to the precise nature of this form of intellect, what links it has with the other forms of human thought, and so on, and Suhrawardi threw this all away by abandoning the active intellect and insisting that we as human beings could range much higher up the ontological scale as far as our thinking goes. It would be interesting to look at his arguments for dethroning the active intellect, but what we should do here is see what implications

this has for aesthetics, and this perhaps gives us some indication of the merits or otherwise of ishraqi psychology.

The first thing which has to be said is that ishraqi aesthetics is a thorough-going realist doctrine. It is based on the idea that beauty is an objective feature of the world, a feature which has its feet set firmly in the real nature of the world, and its moral structure. That might give us reason to prefer one artist to another on purely realist grounds, that one embodies better in his work the way things really are. Or this might be understood as one sticking more closely to the rules surrounding aesthetic production provided by religion. One of the inter-esting features of light is that it reveals different things in different ways. In Safavid painting, light is fairly evenly distributed around the canvas, so that no particular object is illuminated by contrast with any other. It seems to be something of a theme of art in what might be called ishraqi thought that it plays little if any attention to light itself! Why is this? The answer might be that for ishraqi thought an object is only really an object if it is lit up, and on the mundane level all objects are the same, as it were, in that they all have the same basic amount of light. The basis of differentiation will have to be different, and indeed we see that it is different, and some of the distinguishing features here are a concentration on detail and not on composition.

What implications does this have for how objects are represented? One implication is that looking at the everyday world does not involve using con-cepts which are very different from thinking about or even observing higher worlds such as the 'alam al-khayal (the world of imagination) or accessing the tawhid (unity) that underlies the whole of reality. This is especially the case with Mulla Sadra, of course, because for him there are no essences existing at different levels of reality to be lit up and seen and then brought into existence. This is the precise opposite of the position of al-Suhrawardi, but Mulla Sadra argues that the lighting up, as it were, or the application of concepts, is brought about after the objects themselves exist. We can see this in the paintings we have discussed, they do not seek to exhibit anything which is unreal as unreal, nor do they repre-sent being as having a shadowy nature. On the contrary, the objects in them are firmly there, they have a firm grip on the world and only suggest to us that they are observed, not that their being observed is what makes them what they are. What they share with the al-Suhrawardi view, though, is that we are not limited in our thought by the active intellect, and so we can roam quite freely around the realms of reality. We can see evidence of this in the paintings of Mir Sayyid 'Ali (tenth/sixteenth century), as described by his colleague 'Abd al-Samad. According to the latter, Mir Sayyid 'Ali moved away from an art based on form (sura) to one based on meaning (ma'na). This is very much a Sufi distinction, and places the emphasis on showing things as they really are, not as they might be or could be in some possible world. This principle leads to precise recording of the

detail we see around us, a concentration on the surfaces and shapes of things, and it is often said that artists who work in this style represent very ordinary things in loving detail. On what might be regarded as the more problematic side, a consequence of this approach is to represent the human subjects in a dry manner, since there is no attempt to paint anything that is not present on the surface. Wondering what the personality of the character is like is to reject the orientation towards meaning, since it involves painting in accordance with an idea of the form of humanity, and representing human beings accordingly.

Let us look at the state of Persian art before the turn towards a Sufi aesthetic. Compositions tended to appear in a flat surface, they merged with each other both horizontally and vertically. There was an emphasis on decoration, and the effect of the whole composition is often quite dazzling. The emotional range of the subjects is not large, but it does exist, and is generally indicated by some stereotyped gesture, say the placing of the finger to the mouth. The proportions of the body are often inaccurate, and space two dimensional. There is very much of an emphasis on the ornamental balance of the forms in the picture, an organization of the surface which makes frequent references to allegorical meaning and suggestion. Such pictures clearly make demands on the intellect of their viewers, since they are not realistic and require some way of interpreting them given their complexity, artificiality and symbolic nature. This style came to be replaced by a far more realistic way of representation, which produces images that are simpler, clearer and more easily comprehensible. More natural environments are produced and the figures in them look more like natural objects. In these paintings we see a glorification of the ordinary world in the sense that this world is a reflection of the divine world. Many paintings seek to capture the passing moment in both word and image. There is a way of representing change by presenting a stationary object in great detail, so that it almost breathes as we observe it, and in that breath lies movement and the idea that this is the picture of someone who acts and thinks and loves. The argument here is that realism in Persian art can be seen as a consequence, to a degree, of an interest in and commitment to Sufism.

This might seem a strange suggestion, since many accounts of Sufism see it as the doctrine that we have to see the world in a very different way from the natural way if we are to understand it and our role in it. For example, the notion of *wahdat al-wujud*, the unity of being, which Sufis often take as the appropriate analysis of divine *tawhid* or unity, is very different from our ordinary interpretation of the world. We tend to separate things, we experience the world as a series of discrete objects, and so it is not easy for us to see it as a unity, indistinguishable basically from God.

What are the implications of this view aesthetically? If we put the emphasis on remembering God, arguing that it is difficult for us in our everyday approach

to the world to think of God, and our dependence on God, then this might call for a new way of looking at the world. Most of our actions are premised on the idea that we are responsible for ourselves and that the results of our actions are brought about by human and natural causes. We are generally so busy that we do not have the opportunity to think of God. What we need to do is to participate in ceremonies and processes of thought which reverse our ordinary way of thinking, and as a result we shall think about what is really important, our relationship with God.

What is worth noticing about these views is that Sufism is not a system of thought of which there is only one interpretation. It is just as complex and controversial an approach to understanding important issues about how we should live and what we should do as any of its competitors in the intellectual and practical sphere. There is no one Sufi view of how the world should be represented aesthetically, although many thinkers seem to assume that there is such a unique reading of Sufism in this respect. We have just looked at a Persian approach to Sufism and painting which argued that the Sufi approach is to present the world in as realistic a way as possible. When we look at some of the paintings undertaken in Mughal India we can really see how this principle may have been put into practice, because the realism is of a very high order indeed. One can count the number of leaves on the ground, the hairs on the head of the cat, every fibre in the turban on someone's head. This seems to be in direct contravention of the principle that Sufism is all about emphasizing what lies behind the world of generation and corruption. So how can it inspire painters to represent that world realistically?

It could be argued that when we look very closely at something, we see it as more than what it is, while at the same time it is exactly as it is. Aristotle suggested that when we know something, there is identity between the object of knowledge, the knower and the act of knowing, and this can be used as an explanation of how the observer can be sucked into the object, as it were. She may find her identity compromised by her awareness of the object, if she enters deeply into it. This is a common sensation of those who meditate, and it is presumably only because our body eventually requires us to attend to it that meditation need ever come to an end. One of the techniques of meditation involves concentrating on an object to the extent that one forgets who one is, the I becomes transformed, albeit temporarily, into the it. To use a less spiritual example, individuals at rallies often report feeling their individuality has dissolved into the mass. Concentrating on an object means paying close attention to it, to its appearance. It is important to distinguish here between the actual object and the type of object it is. What we do when we concentrate on it, at least in the account provided here, is not to attend to what sort of thing it is, but only to what it is in itself. This will give the clue as to why this is supposed to be

a sort of knowledge which is of interest to the mystic. For Kant, knowledge of
how things are in themselves is not available to us since such knowledge takes
us beyond the conditions of knowledge, and so is a realm of knowledge we
cannot achieve. Things in themselves are actually in some sense 'behind' our
experience, and so we cannot use that experience to access them. Now, the form
of Sufism we are discussing here seems to assume that the thing can be known in
itself through our experience; what we need to do is to concentrate hard on a
particular object and then we know it. But actually that is not really the theory,
it is only the start of the way to acquire real knowledge. In concentrating on a
particular object we start to recognize how extraordinary it is that there are
objects at all, that anything exists, and we begin to appreciate that the existence
of even very ordinary and boring things is in fact quite remarkable. The
whiskers of a cat, the moss on a rock, these are all things to which we rarely pay
much attention, but they are wonderful things, if we see the world as a place
which has more than a natural explanation.

But if we see the world as having an explanation which lies behind it, a
good definition of mysticism, does this not mean that when we look at indivi-
dual objects in the world we in fact bring some theory to those objects, and we
do not just concentrate on the objects themselves? If we start to lose ourselves in
the object, as it were, and so come to see ourselves and the world differently, we
are surely acquiring a theory of how things are and we are applying that theory
to the world, and so we seem to be doing what we say we are not doing, which is
to present reality in such a way that it needs interpreting. That is supposed to be
the style that Sufi aesthetics replaces, and the other style is one that emphasizes
symbolism and the significance of interpretation by the viewer of what he sees.
The truth is, of course, that everything we see requires interpretation, and there
is no such event as simple seeing, in the sense that what we see gives us its
meaning just like that, without any intervention by our conceptual machinery
and form of life. Different forms of art can stimulate different concepts, different
ways of looking at the world, and this is perfectly acceptable. The Sufi attitude
to the object is not an attitude without preconceptions, it is not an atheoretical
attitude, we have just looked at the arguments behind it, and so it is not a way of
looking at objects which the objects themselves demand. In any case, as we
have seen, there is no such thing as *the* Sufi approach to viewing objects, but
rather there are a variety of approaches. Different theories of Sufism argue for
different approaches to the object, and each has aesthetic consequences. Perhaps
even more significant is the fact that most varieties of Sufism actually stand in
opposition to a single explanation or understanding of the world around us as
being the only explanation, or the only acceptable explanation. Sufism tends to
stand for the view that the truth may be variously constructed out of the
experience which we all have, and we should respect all those different ways of

seeing the world. In reality, Sufism does not have such an accepting attitude to non-Islamic points of view, it definitely prioritizes the Islamic. There is no reason why it should not do so, Muslims quite reasonably see their own religion as the best form of religion available to humanity, and it is then their duty to inform everyone else of this. But in some contexts Sufis are prepared to pray with those of other religions, and in Northern India for example there are tombs of saints who are venerated by both Muslims and Hindus, and which are visited by both. This does not mean that all Sufis think that Hinduism is a perfectly valid religious response, or even one in fact which Muslims should even con-template accepting! But there is a theme in much Sufism to suggest that all religions have a common strand of spirituality and this needs to be recognized and valued, since presumably much of what is valuable in Islam can be found in these other faiths also. What this tends to suggest from an aesthetic point of view is that the idea that just one approach to the nature of the object could be the Sufi approach is misguided.

One of the most remarkable painters in the Islamic world lived in the period 1450–1530. Bihzad worked for the Timurids (1387–1502) during their period of decline, and when they had decided to support Persian painting perhaps in an attempt at boosting their prestige in what was a highly contested part of the world, where different empires and kingdoms vied not only for power but also cultural influence and status. His work is characterized by a number of features, although there are many extant illustrations whose precise authorship is in question, and the existence of such dubious attributions of course rather weakens the claim to know precisely what his style is. Although his work is clearly within the tradition of Persian painting, there is quite a bit of originality in his composition. In particular, he treats the human figure as more than just a general type of figure but as the image of a particular person. His work is more natural and realistic than what preceded it; there is a more sophisticated treat-ment of movement and also an interest in everyday activities. It is worth point-ing out that the illustration of manuscripts was an important way for the Timurids to play a wider role in the eastern Islamic world. By presenting and disseminating a picture of their royal house within the conventions of Persian miniatures they could try to persuade others that they were appropriate rulers of the Persian world. In the early tradition of such illustrations we find a very different way of doing things than in the work of Bihzad. The early Timurid paintings are highly artificial. The figures are ideal, the space two dimensional, colours are vivid and fantastic, and most important of all perhaps is the total absence of movement, as a result of a commitment to order and balance. The setting is so conventional, the technique so artificial, that any idea of accurate representation of the world is obviated. What these paintings really resemble are theatrical displays, and what they dramatize is the fixed order of the court

and the state ruled by the court. The court is represented as a perfect place, perfectly stable, and even potentially dramatic events like the hunting of animals are carefully stage managed to show the total control that the elite has over even nature itself.

It certainly would not be true to say that the work of Bihzad represented a radical change from the early Timurid genre, but it did bring about a significant change in orientation and expression. Quite why this change occurred has been much discussed in the literature, sometimes attributed to the growing influence of Sufism and sometimes to the decline of the Timurids themselves. The latter reason is not compelling. Regimes that are weak and in a state of collapse are just as likely to be represented aesthetically in terms that recall their grandeur; in fact, there is often an increase in conservatism in design when times are regarded as bad. There is after all a security in the familiar, and in order to innovate, one has to be confident of the future. Bihzad employed techniques in his work previously almost unknown in Persian art, techniques such as colour, three-dimensional space and an interest in motion. Previously the emphasis had been on clarity and detail, as though issues of perspective were really of no significance in a painting. In Pamuk's book *My Name is Red* this older style of painting is regarded very much as representing God's view of the world, as frozen and static, since he is above time and space. Emotions and even expression were conventionally expressed in stereotyped ways, as though the appearance of feeling and its transient nature would upset the equilibrium which was so much part of the early Timurid visual world. Bihzad represented individuals not abstractions in his paintings, and these are pictures of people with whom we can identify, not ideal types representative of something which has meaning but lies behind the visual.

A comparison is often made between Persian painting and poetry, and this is appropriate (see Yarshater). There are clearly a whole variety of formal operations taking place within the structure of poetry, and early Timurid painting was like that, you have to understand the way in which things are presented, the sort of rules and conventions which are being undertaken. Of course, this is true of all art, there is nothing so unnatural as naturalism or so unrealistic as realism, in many ways. As we have seen when discussing work which is realist, it can give the audience an impression of the uncanny nature of the real, its unreality in fact. We smile when we hear of people confusing the real and the artistic, as when someone from the audience jumps on stage and prevents an actor from 'killing' another actor. They do not know the rules, we think, because they do not realise that what they are watching is a performance, not real life. But this could be turned around the other way, and the person from the audience who leaps on stage could be regarded as having got it right. He is not prepared to sit back and watch a crime being committed, even as part of a play, he is so

horrified by what he sees about to happen that he intervenes. The sophisticated audience who remain in their seats have possibly lost the ability to link what they see with their personal lives in this dramatic way. For them the play represents a genuine catharsis of their emotions but for the interventionist these emotions are felt in such a raw way that he cannot just sit back. It might be said that it is obvious that he has made a mistake, since he is no longer able to maintain that aesthetic distance which is so important a part of viewing something aesthetically. On the other hand it might be said of the other members of the audience that they have allowed their aesthetic distancing to distance themselves even ethically from what is taking place before them. This issue arose when we considered some Islamic positions on censorship and art. The idea that the artist should be free to express herself in whatever way she wishes fits in nicely with the liberal conscience, but not necessarily with the religious attitude. Liberals will call the religious believers who insist on rules against blasphemy narrow and intolerant. The believers will accuse the liberals of not finding anything serious enough to be banned because they no longer find anything serious at all.

This may seem to be taking us a long way away from the account of Timurid painting. But actually it is not, since we are comparing two styles of painting, the early style, which was detached and idealized, and the more modern style, which represents its figures as existing in something that resembles more closely real space. It is tempting to suggest that Bihzad's work can be seen as much more emotional than the earlier Timurid paintings because the former, unlike the latter, rejects formalism and embraces the representation of objects as beings in space and time, in a space and time which can be represented. Instead of flat and archetypal figures we get something much deeper, much more like us. To our modern sensibilities Bihzadian painting is superior to what preceded it. We live surrounded by images of the world, and we look for either a totally abstract and conceptual approach to art, or something fairly realistic. We do expect a grasp of the rules of perspective, at least, and the ability to represent motion in painting, and certainly there is far more of that in Bihzad than in earlier Timurid artists. it does not follow that Bihzad is better, though. We tend to think he is because his work resembles to a degree the sort of painting to which we are today accustomed, and also because he seems to have been an innovator. The latter is regarded very much as a virtue in modern culture, which values highly creativity and radical new directions in art.

This does not provide us with a reason for that reason to value Bihzad more highly than his predecessors, although there are no doubt other good reasons for doing so. For one thing, we should take seriously the point that these paintings were made to illustrate books, and that they were relatively small. So readers, and they are of course to be read with a text, would look closely at them, and

there would be a lot of space around them which has nothing to do with what the reader is looking at. Given that these are miniatures, it might be argued that the early Timurid style is actually more successful, since there is little to be gained by a realistic depiction of space where scale is seriously reduced. Looking at something that is small has a simplifying effect on what is seen, and so simpler images are perhaps better designed for this medium than are more realistic ones. The earlier artists may have realized that it is far more feasible to get over a fairly simple message in a miniature than to undertake the complexity of a realistic depiction of a scene, for the realistic depiction, when seen from a close perspective, may not appear that realistic at all. The small scale makes scale irrelevant, and so the rather two-dimensional space created by the early Timurids may be just right for that sort of context.

In addition, we must also take seriously the fact that this work was designed to accompany text in books. There was a development of how this was done over time, initially the pictures closely followed the texts, in due course they became freer and one imagines in many contexts that the pictures were viewed and admired without the text. Still, they are there to illustrate a text, and one imagines that the reader of the text examines the words and the pictures together. The words would be read, the picture looked at, or the other way round, but the important point is that they go together. So the picture does not have to do all the work, as it were, the words are there to help it out, and in those circumstances it might be thought appropriate to produce formulaic art, since the detail and emotionality of the whole work is present in the words. To place it in the pictures as well might be thought to over-burden the aesthetic sensibilities of the reader, since the whole balance between image and text is then upset. Balance is of course a highly significant principle in Persian art. Although the Bihzadian pictures might work well in isolation from the text, whether they work quite so well with the text is an interesting question.

As we have seen, one explanation for the growing realism of painting was the increased support for Sufism. The more formal attitudes to painting suffer at the hands of Sufism since they emphasize qualities like courtliness, military prowess and the social hierarchy, all ideas antagonistic to many versions of Sufism. The latter is intent on advocating a simpler, less formal, lifestyle, and is suspicious of differences between people based on their social position. On the other hand, it must be said that the earlier paintings do have within them features that might be thought attractive to Sufis. They are timeless, for example, there is no suggestion of anything happening in them, or at least nothing in them is represented as changing. They present a picture of perfect order, an ideal world in which everything happens in accordance with a system of logic that lies outside the world. All these ideas have considerable mystical relevance, one would have thought, and even the features of the illustrations which are

replete with social and political hierarchy could be given a more spiritual inter-
pretation. What need is there to represent things realistically if the principle of
mysticism is that the meaning of the world lies behind the world? One of the
delights of the earlier Timurid paintings is that one does get the impression that
everyone is waiting for something to happen to get the whole process operating,
that all the actors are assembled and waiting in the wings. This could be taken
to express the idea that we are utterly dependent on an external force to allow
us to act and the world to operate. Sufis propose that we should appreciate our
utter dependence on God, and one of the purposes of Sufism is to help remind
us of this fact.

Another feature of these earlier paintings that we have noted is their
systematic nature. They present the world as a system, they make little or no
attempt to present it realistically. Faces are emotionless and all look the same, or
at least all in the same direction, and with an identical tilt to the head. Hand
gestures are minimal, and clothes are perfectly draped around invisible bodies.
Nature is there but with colours and scenery that bear little relationship with
real nature. Of course, much of the symbolic meaning to be derived here is to be
found in the accompanying text, but one aspect of them which is not to be
found in the text is the idea of cohesiveness in the painting. They are not like
the real world in which diverse activities take place. These paintings represent
an ideal world in which everything is linked, in which being really is one, and
seen to be one. If one thinks that everything is really part of God then these
paintings are in fact more realistic than paintings which offer a more accurate
version of how the world appears to be.

It is worth pointing out here how one could see flatness as an important
aspect of painting, since it is something which painting shares with no other
artistic medium. Realism might be seen as irretrievably literary, since the illu-
sion of depth which it utilizes engages the viewer in a variety of narratives. Yet
in the illustrated books it is not the pictures which are supposed to provide the
story – the story provides the story, and the flatness of the picture perfectly
complements the liveliness and earthiness of the text. The realism which we
observe in some such paintings could be criticized for being impure, for adding
too much emotion to the dual composition of image and text, and so leading to
an ultimately unsatisfactory product. We might prefer a flattened composition
where the face is a rectangular block and many of the objects in the space are ill-
defined. Instead of details we have simple shapes and colours, we can see no
identifiable body parts, no definition in what is in the picture. We can speculate
that the artist wants to concentrate on shapes and colours, and he is prepared to
leave other details out in order to allow this to happen. If we imagine that this
painting has to work by itself we can see that it requires a whole grammar of
looking to be mastered by the viewer before it can be understood, as all

paintings do. But if it was painted to accompany a text, it would be even more accessible to the public, since the details which are missing here would be found in the text itself.

Let us try to contrast an image seen from an ishraqi point of view, and a mashsha'i point of view. What different aesthetic processes can be seen in operation here? A mashsha'i image is imaginative, but imaginative in the sense of linking different parts of a reasoning process without displaying all the links. So a good example of mashsha'i art is something that is often displayed as paradigmatically Islamic, calligraphy. Another good example is art where the representation of the world is clearly perceived as symbolic of a deeper structure which lies behind the appearance but in the sense of being an aspect of the organization of the world, not something behind it.

Ishraqi art is more elusive. It takes a self-consciously realist attitude to what it represents, but in that representation we get the impression of a divine order which is present in the everyday world. According to ibn al-'Arabi, a highly influential figure in the thought of Mulla Sadra, this is because the real world is not something behind the ordinary world, rather, it is continuous with the ordinary world. The ordinary world is part of the real world, and to deny the reality of the ordinary world is to fail to understand the nature of divine *tawhid*. This leads to a form of thought which emphasizes the significance of the every-day world, while appreciating at the same time that the everyday world is not to be seen as something only ordinary. It is both ordinary and extraordinary, and the psychological problem which this sets us is to respect both aspects of reality while concentrating on just one world of experience. We could refer here to the debates surrounding the *Nahj al-balagha*, a wonderful literary creation which attempts to balance asceticism with an appropriate attitude to the everyday world. The *Nahj* criticizes extravagance, but it also criticizes having no concern for the everyday world; like Islam it tries to strike a balance between these two approaches. But of course this sort of balance is very difficult to strike, both in our lives and more importantly in our thought, because we tend to go to one extreme or the other. We tend to regard this world as of overwhelming impor-tance, or we may reject this world and regard the other world, a world seen to be behind this world, as the only realm worth considering. In paintings we can see this approach exemplified by images which have marginal features suggesting that the image and text are only one aspect of what is going on here. Many of the illustrations are like this; they literally burst out of their frame into the text, and vice versa.

Some pictures are quite clear while others are more mysterious. Some accord with mashsha'i processes of reasoning because they represent the reasoning process itself, the point of the whole process and the result at which the process is directed. So we will see a sequence of events, and we will be able to understand

why they occur in that order. Yet some pictures are more enigmatic, and operate at a greater imaginative level. The conclusion is implicit in what we see, but it does not follow inevitably, and we can imagine a whole variety of alternative endings to the scene. The people in the scene are surprised at what they see, because it is unusual and also because they have little idea how it will end, the idea being so important in ishraqi psychology that the outcome is not necessarily implicit in the events which precede it. This is because we have to wait to see what happens, what illumination will be available and where it will fall.

A particular ishraqi objection to the mashsha'i concept of thought is the latter's emphasis on theoretical reason. In mashsha'i thought there is no acknowledgement of the relationship between *ma'arifat allah* and *ma'arifat al-nafs*, between knowledge of God and knowledge of the soul, something which is of great significance for the ishraqi. There are many passages in Suhrawardi, Rumi and in the text that was so important for them, the *Nahj al-Balagha*, which describe losing the self, and by this is meant not no longer knowing who one is, but concentrating on parts of ourselves that do not constitute our core, forgetting who we really are. Rumi has a charming story here of a man who builds a house, and takes many careful steps to construct it properly, he buys the materials, assembles the workers, checks the quality of construction, and yet when the house is built he realizes that it is built on land which he does not own, i.e. he has spent his time on a task which does not address his spirituality but which by contrast only attends to his physical and material needs and ambitions. So for the ishraqi thinkers the soul and human thought cannot be divorced from our roots in a divinely created world, psychology cannot be seen as an entirely technical issue. We think as we do because of how we have been constructed, and to ignore this is to make both an intellectual and a spiritual error.

This comes out nicely in the art of this period, in the poetry and literature of course, but also in the painting. One characteristic of the visual arts, especially within the Persian tradition, is that it is far from what one would expect of a culture with a commitment to mysticism. There is little in the way of the representation of secrets behind the appearance, of another higher world behind this world, and there is even very little use of light and shade as a technical device. In fact, the painting usually eschews the strange for the normal, the mysterious for the mundane, and we argued that this is because of an important feature of ishraqi thought, that the links between this world and higher worlds is continuous and far from mysterious. We reach the next world not by denying this world, but by understanding how this world represents a channel to the next world, i.e. by understanding how extraordinary the ordinary is. When extraordinary things happen, we can often find a logic to them that is otherwise invisible. For example, it may be that if flying creatures are able to carry us into the air we shall fly, although the picture of animals flying may be highly unusual, unless

they are normally flying creatures. If we follow the story we appreciate that this flight comes about through holding onto a support and rejecting the opportunity on that occasion to do the normal thing, perhaps to speak, to open the mouth, if the animal holds on with its teeth. We should all hold on to what is there to help and support us, and if we do so we shall soar, we shall leave far behind us what it is that binds us to the earth. Once we return to a normal belief in our powers and open our mouths, we fall. There are many texts and pictures to accompany them that illustrate such stories. In radically new circumstances we must eschew our ordinary behaviour if we are to survive and prosper, the implication seems to be.

The ishraqi view is more ambitious than the mashsha'i approach, since the latter establishes as a limit to human thought the active intellect, and imagination is essentially limited in its epistemic range. It is the notion of imagination which is so significant to both schools of thought, and they provide us with a useful means of distinguishing between them. Of course, this gives rise to another and more complicated question, how far one can distinguish between the ishraqi view of how we think and a sufi approach. Ishraqi philosophy is in some ways in between the sufi and the mashsha'i, but when it comes to discussing the nature of thought it is closer to the former than to the latter. The mashsha'i account serves merely to describe the lower faculties, and so is very limited in what features of our thought it can describe. The different ways in which we read images are intended to bring this out, and if it is persuasive will have demonstrated some aesthetic distinctions between the two forms of philosophy.

9

Interpreting art, interpreting Islam, interpreting philosophy

How important is history of art for art? Is it possible to understand art without understanding its history, its context? In order to understand philosophy of art, how important is it that we understand the history which surrounds the theory? These are very important methodological questions, and it is important to say something about them, since the form of the analysis depends on the decisions that have been taken about methodology.

There is a well-known argument which suggests that history and context are not important in understanding art, and this appeals to the intentionalist fallacy. The fallacy, if it is a fallacy, is to think that knowing about the history of a work of art helps us understand it or appreciate it as an aesthetic object. Although we would normally think that this sort of information is helpful, it was pointed out that we can appreciate an aesthetic object and know absolutely nothing about its history, where it comes from, who created it, why and so on. No doubt, it would be argued by those who think the intentionalist fallacy is a fallacy, a knowledge of history and context would be interesting and useful in itself, but it adds nothing to the aesthetic depth of our comprehension of the object itself.

Many modern writers on Islamic art are interested in history rather than theory and aesthetics. The same is true of writers on Islamic philosophy. There are good reasons for this. One requires a significant scholarly apparatus to say anything interesting about Islamic art, and about Islamic philosophy. Few texts are actually available in Western languages, so one would need to know a range of oriental languages in order to read the works themselves and discuss their cultural context. There are even, it has to be said, relatively few critical analyses of these works of anything except the leading texts, so readers are required to display a certain degree of exegetical and linguistic skill. The theological background of these artefacts and texts are often unfamiliar and these need to be explained, and since many of the leading artists within the Islamic world were keen on theology of one sort or another, not to mention mysticism and jurisprudence, it takes some work to establish the precise nature of what goes on. One would expect a commentator to look long and hard at the context within

which these images and texts have arisen, in order to establish precisely what arguments and themes are in operation and how they function.

I would point to a serious problem which has arisen as a result of these very worthy principles, and that is that Islamic philosophy is often seen as being of mainly historical and not philosophical interest. Exactly the same point is often made about Islamic art, that it is of cultural rather than aesthetic interest. Many commentators on Islamic art are rather disparaging about the aesthetic credentials of their subject, pointing to limitations in the creativity of the artist and the lack of sophistication in the style. This is perhaps surprising from people who are experts in those objects, but the implication is that the art is more interesting from an historical point of view than strictly aesthetically.

As far as Islamic philosophy is concerned, this to a degree has been due to the long-standing, and to my mind baleful, influence of Leo Strauss and his many followers, who have suggested that this sort of philosophy rests on a secret code which needs to be cracked before one can have any hope of understanding the texts themselves. It is also a factor of Islamic philosophy often not looking like ordinary philosophy, but something much more closely linked with religion or law, and so appropriately analysed by those with an expertise in those areas.

Exactly the same thing may be said of art, of course. We may look at a piece of ceramics from a culture about which we know absolutely nothing and yet respond to its beauty and lustre in ways which apparently render its cultural background irrelevant to anyone except the specialist in precisely those features of it. This brings us to an interesting point of comparison between philosophy and art, namely that we tend to think that if it is impossible to appreciate a work of art without understanding a lot of its history, then it is an inferior work of art. I remember, when an undergraduate at university in England, attending a lecture on English metaphysical poetry, being assured by the lecturer that the fact that one has to spend so much time working on the allusions of such poetry, allusions which are obscure to us and probably were to the contemporaries of the poets themselves, is a very real criticism of such poetry. There is no need now to enter into this precise topic, but there is a serious point here. We tend to think that art that only works after lengthy explanation is not the very best art. Like a joke that one can only grasp when supplemented by much information about its context, art that only works with something else being added to it, as it were, loses much of its spontaneity and character. It might be classified as inevitably minor, interesting certainly but not of the first rank.

Should we say the same thing about philosophy? The answer seems to be affirmative, because the greatest philosophy seems to present us with ideas and arguments which are difficult in themselves to assess logically, but not that difficult to understand. That claim might seem just wrong, as though it is the assertion that the central claims of philosophy are easy, which of course they are

not. But they are easy to understand, on the whole. The good man cannot be harmed, intuitions without concepts are blind, the free man thinks of death, these are some of the central claims of great philosophers, and they are clear. The most complicated and difficult ideas and arguments actually start off as rather simple propositions, which then are worked on time and time again until they become very complex. It is what seems to be a compelling but perhaps puzzling statement which gets the whole process off the ground, but what is important about that statement is that it can be understood, or apparently understood, without too much stage-setting being necessary.

This is why we might be suspicious of the role of history in the understanding of philosophy: does it not complicate the central statement or problematic, make it far less perspicuous and so less appropriate for philosophical consideration? Precisely the same comment may be made of an art object too, that looking to issues which deal with its history takes our attention away from the central meaning of the work, or what might be seen as its central statement. History brings in considerations of a whole range of other statements, and involves the study of background detail which can only complicate what the object is all about. The issue arises, and it is surely the crucial issue here, as to whether history which gives us more information actually deepens our understanding of the issue or merely makes it more complicated, what in Islamic philosophy is referred to as the distinction between horizontal or vertical detail. The former merely adds more facts or background, where the latter produces a new perspective on the topic, one which strikes at its core, as it were, and not merely the periphery. A work of art can be impressive even if we do not understand everything, or indeed anything, about its context, and we frequently admire works that are entirely obscure to us with respect to their origins. That is even true of a natural object; we may come across a stone that has a beautiful shape and colour, or a sunset may strike us dumb with amazement, and yet we may understand nothing about these phenomena from a scientific point of view. They are just there, as far as we are concerned, and we are involved with them aesthetically, and only aesthetically.

Many who work in the discipline of Islamic philosophy feel it is important to explain in vast detail the historical background against which the particular text they are considering operates. Indeed, there is an important, although fortunately no longer dominant, school of interpretation which suggests that unless one grasps the way in which the writers of Islamic philosophy have concealed their real opinions in their work one has no chance of appreciating what this area of philosophy is all about. If this school was right then of course it would be true that without cracking the code, the meaning of the text could not be grasped. But there is no code to be cracked, all we have are the arguments of the thinkers themselves. Of course we need to understand what they saw as the

leading issues of their time, and without this information it would be difficult to know what they are talking about. Since many of them operate within a philosophical framework that is to us today relatively obscure, the problematic of Neoplatonism, we need some understanding of the issues and interests of the Neoplatonists, but all that means is that we need to understand the particular way in which the Neoplatonists framed perfectly ordinary philosophical arguments. How did they conceive of time and space, for example, or what were their views on the nature of the mind? We can discover the answers to these issues by examining their work, and then we can ask the question, surely the key question, which is how significant their answers are philosophically. If their answers are only of historical importance then this means that they had nothing interesting or new to contribute to the debates on traditional philosophical issues, and I do not think that is true. Let me give an example.

The philosophy of language of ibn Rushd is especially rich and interesting. Let us look here at his argument that there are experts in the use of language, and the ultimate experts are philosophers. This is because, he suggests, philosophers understand the logic that underlies language as a whole, and so they are the best people to resolve issues where language seems to be obscure and ambiguous. What he has in mind here are really theological issues, where we are in difficulties understanding the meaning of texts, and we wonder what sort of interpretation ought to be applied. We could ask ordinary people, we could ask theologians, and we probably would ask all these people, but ultimately it is those who understand the logic that lies behind such texts who are the people who really know. Ibn Rushd is basing his view on the theory that ordinary language rests on logic, and so those who understand logic, understand the structure of ordinary language. One of the ways he defends such a view is by pointing to the logical arguments which lie implicit in language, and he also suggests that we assess such language in terms of its capacity to prove a point, to allow us to derive a conclusion validly from premises.

This argument itself has a long history in Islamic philosophy, starting with al-Farabi and being developed in a variety of ways. Do we need to understand that to understand the argument? No, indeed we are familiar with this argument from modern times, and might have no idea of its long history. Let us look briefly at what ibn Rushd takes to be supporting arguments for his thesis. He suggests that we go to a physician because we ourselves do not have the medical knowledge to cure ourselves, and we go to a lawyer because we do not have the legal knowledge to resolve our legal problems by ourselves. That is, we need to find an expert in a particular area, and we ask that expert to solve our problems. In just the same way that in particular areas of life we need the help of experts, so in the case of language itself we need expert assistance, when problems arise, and the experts here are ultimately the philosophers. Now, it is an interesting

biographical fact that ibn Rushd was both a doctor and a lawyer, and so his reference to these areas of discourse were prepared with this in mind. How is our understanding of his argument improved by this knowledge? Not at all.

Ibn Rushd's argument becomes more complex, because he puts together two views of language which might seem to be contrary. On the one hand he says that logic underlies language, and even poetry has as its basis logic. On the other hand he suggests that there is nothing wrong with using language in loose and imaginative ways, i.e. where its logic is thoroughly concealed. In fact, that is how we use language most of the time, and this is perfectly acceptable since our activities on the whole do not require precision. When those activities do not require precision, precision actually gets in the way of comprehension, and should be avoided. We are all capable of being precise in our own area of expertise, and so for everyone, or almost everyone, there is some particular activity that they really understand. The philosophers understand the logic that underlies all language, but this does not mean that they grasp the practical skills involved in linked activities. It does not even mean that they are capable of resolving disputes in those different areas, since it could be that while they understand the underlying logic, they are unable to work from the deep to the surface structure, as it were. To take an example that was familiar at the time, the philosopher and the prophet know the same things, but only the prophet has the practical skill to get that knowledge over to the public that needs to receive it. So to a degree everyone can be an expert in his or her own area of interest and experience, and what the ordinary person knows is real knowledge, albeit less exact perhaps than other people's grasp of the area.

What ibn Rushd uses this theory to show is that different members of the Islamic community may have different understandings of the Qur'an, but these are all different understandings of the same text, and ultimately these represent different approaches to the same conclusion. All these approaches are valid, as one would expect, since it would be unfair for God to create us differently and then provide us with unequal access to the truth. On the other hand, it would be appropriate for God to allow different people to see different things, in just the same way that some people are long-sighted, some are short-sighted, some can see well in the dark, and so on. (The problem of people who cannot see at all should be consigned, presumably, to the problem of evil!) The philosopher understands much better than anyone else how to interpret difficult passages of scripture, but the basket weaver knows much better than anyone else how to make baskets. Clearly in many situations the latter form of knowledge would be much more valuable than the former.

Now, what ibn Rushd wants to use this theory for is to argue that there is no essential incompatibility between Islam and philosophy, that these are both routes to the truth, and indeed it is the philosopher who has a perspicuous grasp

of religion itself, since it is the philosopher and not the theologian who can interpret securely difficult passages in the religious books. This is because at the time he was writing the work of philosophy was often attacked as being opposed to religion, as offering an alternative and contradictory version of the truth to Islam, and he wanted to present an argument to defend philosophy. While this is interesting additional information, does it play any vital part in the argument? It does not play a vital part; the argument works or does not work perfectly well without it.

Within Islamic philosophy and art there are arguments and themes which are impossible to understand without doing history since they are written or represented in ways which are unfamiliar to those who are unaware of the history. Part of what might be called history is of course the religion of Islam, and many arguments and forms of representations are written and drawn within the language or style of those religions. It does not follow, however, that those arguments and forms are predominantly religious.

Why is religious philosophy often presented as more a function of religion than of philosophy? To a degree it is because it is generally practised by those who are professionally involved in the religion, and it is in their interest to present the arguments in a religious guise, since then it looks as though the material is appropriately organized for their treatment of it. It also means that the material can be presented in a way that might inspire an audience to action or belief, and for this the inclusion of a range of specifically historical and religious literature is useful. The fact that the argument can be presented in this way does not prove that it has to be, and indeed it does not.

Is this not though a form of philosophical imperialism, the idea that there is just one kind of philosophy and different religions and historical periods present the same sorts of arguments in slightly different ways, but with no essential differences? It is then the philosophers who have the job of clearing the confusion away and getting at the real roots of the issue, not a role at which philosophers feel shy, but still perhaps not a task they should wish to undertake. It is as though the philosophers are saying to every other discipline, 'You in your muddled way are trying to express general ideas and arguments which we as philosophers, and only we, are competent to deal. You will obviously seek to understand the ideas and arguments by linking them with particular historical periods and systems of local thought, while we will take a much broader view, and will examine the structure of the arguments themselves.' That seems to be the only conclusion which can be drawn, and again we can remind ourselves of the analogy with the intentionalist fallacy, where the assumption is that the primary task is understanding the art, a secondary task is putting it within some sort of context. To give an analogy, putting on a play requires a set, a stage, somewhere for the audience to sit, and so on; it requires, in short, what is called

stage setting, but the stage setting is not an essential part of the drama itself. In fact one can read the play while sitting in an armchair or lying in the bath, so the stage setting cannot be essential at all.

So far we have looked at the links between philosophy and history, but what about the links between philosophy and its own history, the history of philosophy itself? It is often said that it is a great error to leave out the contribution which Islamic philosophy made to philosophy itself, so that the large gap between the Greeks and then Descartes, which is largely filled with Islamic philosophy, needs to be acknowledged. Human thought did not have a rest for a couple of thousand years from the time of Plato and Aristotle until we get to early modern philosophy. The characterization of medieval philosophy, or indeed later Greek philosophy, as primarily religious is just wrong, and we need to look beneath the actual language of that period of philosophy to examine the arguments themselves before we can realize this. Indeed, when we examine much of this period we cannot fail to notice that most of the philosophy within it has absolutely nothing to do with religion at all. What do we miss if we fail to follow the sequence of thinkers and philosophical schools from ancient Greece to the Europe of a few hundred years ago? We miss a lot of interesting material, and some notion of how ideas actually move from one stage to another. When Hegel describes the progress of Spirit he is careful to link philosophy and its history chronologically as well as qualitatively. But we are not all Hegelians now, and we might wonder at the point of this. If we think there is a pattern to the development of philosophical theories and the arguments attached to them then it will be important to understand the history of philosophy in order to understand philosophy, but on the whole we do not believe this and why should we? What would count as evidence for it? We ask our students to assess arguments, not explain why the particular argument arose and what preceded it. Perhaps what we are doing is wrong and we should be paying more attention to the history of philosophy in order to raise these biographical and cultural issues. I remember when I was on a car maintenance course listening to a very long lecture from the instructor on spark plugs, which he admitted at the end had absolutely nothing to do with any spark plugs that we would ever encounter. His lecture was actually about a much older type of spark plug, and how you tested for the electrical charge which runs through them. The test was apparently how high one jumped when touching them. Now, this is doubtless interesting historically, but it does not help us with modern spark plugs. It would help us understand how spark plugs over the ages have developed, but we could have that sort of knowledge and be unable to tackle modern car problems.

There is a stronger view of the significance of history of philosophy and it takes this sort of form. The history of philosophy forms the context within which philosophy itself has meaning, in just the same way that a sentence is the

structure within which words have meaning, and a particular form of life or series of actions constitutes the environment in which a sentence has meaning. Philosophy does not spring out of nowhere, even Athene came out of somewhere (Zeus' ear), and unless we know where it came from, we do not understand what it is. This view makes the excellent point that indeed philosophy does not emerge from nowhere, it has a history and that history is not exclusively one created by dead white males. But once we have made that point it is difficult to see where to go with it. Yes, philosophy has a history, but how does understanding the history help us understand the philosophy? One of the things to notice is that good history of philosophy is often not good philosophy. One thinks of many of the recent excellent works which have appeared describing aspects of the history of philosophy, and they are very well done from an historical point of view, they also identify and highlight particular philosophical issues, but even their greatest admirers would not claim that they added anything to our understanding of the philosophical arguments themselves.

Let us return to the central issue, and ask what role the understanding of the history of philosophy should play in the understanding of philosophy itself. The answer seems to be not much, at least not much if philosophy is understood primarily in terms of arguments. It is true that history is often important in understanding what the arguments are about, since without a grasp of the context within which the arguments are produced one often just does not understand those arguments. But once the understanding issue is resolved, history really does retire to the position of underlabourer. The arguments themselves have a life of their own quite apart from their history; they break out of the corset of that history if they are of any general significance. And if they are not of any general significance then they are only of historical interest, and not philosophically in the first division as arguments.

Art and philosophy are very similar in this respect, and so is the philosophy of art. As I have argued throughout, the sorts of work that are generally characterized as Islamic art are perfectly accessible aesthetically without any especial understanding of the cultural context within which those objects were and are produced. That is not to say that such contextualization would be vacuous, for it would help orient the viewer or listener to what was before him, and this is surely very helpful. Yet the issue is how essential this would be for *aesthetic* understanding of the material, and the answer given here is that it is not essential. All that is essential is that the individual is able to adopt an aesthetic attitude to what is before her, and in fact the sort of contextual information that is often provided can be an obstacle to such an attitude. For if one thinks of the object historically, culturally, theologically and so on then it might be harder to think of it with the requisite distance for that way of thinking to be aesthetic.

In the mosaics in the Dome of the Rock and the Great Mosque of Damascus there is a blend of the artificial and the natural. Plants and trees in the former and gardens and buildings in the latter are decorated with jewels, leading Ettinghausen and Grabar to comment on the 'non-realistic use of realistic shapes and anti-naturalistic combination of natural forms'.[65] As Doris Behrens-Abouseif suggests, 'It reveals the same principle behind the arabesque, which is the synthesization of a vegetal motif, transcending nature with artifice and fantasy'.[66] There is the suggestion here that these paradigm examples of Islamic art are intent on producing something very different from that which preceded it. The design is heavily influenced by religion, by Islam itself, as though it would have been thought to be unIslamic to have the portrayal of gardens, buildings, plants and trees as just gardens, buildings, plants and trees. But in what we call Islamic art we find many examples of gardens, buildings, plants and trees often completely unadorned with jewels. In other aesthetic traditions we also find precisely those subjects adorned with jewels, with no reference at all to religion and certainly not to Islam. Islamic art does sometimes seek to transcend nature, as Behrens-Abouseif suggests, but also often provides us with very accurate and naturalistic representations of nature. Artifice and fantasy are no more appropriate to Islamic art than to any other art form; we see just as much artifice and fantasy in art as a whole as we do in Islamic art. It is difficult to get away from artifice and fantasy in art; one might think that that is what art is all about. The moral is that we should treat Islamic art as ordinary art, as an important cultural tradition in the history of art, but not as involving any very peculiar and specific rules in order to be understood. All art requires interpretation and Islamic art does not stand out here, it is just like any other kind of art. Once we appreciate this we can start treating it as such and get rid of the mystification which surrounds the topic. Indeed, if the arguments in this book have been successful, then they show that there should not be books entitled 'Islamic aesthetics'.

Notes

1. Nasr, *Science and Civilization*, p. 21.
2. Grabar, *The Mediation of Ornament*, p. 232, also Basil Gray's *Persian Painting*, has a resolute determination not to speculate on aesthetic issues.
3. Grabar *The Mediation of Ornament*, p. 255.
4. Miskawayh, *Traité d'Ethique*, pp. 301–3.
5. Hillenbrand, *Islamic Art and Architecture*, p. 244.
6. Bakhtiar, *Sufi*, p. 68.
7. Ibid., p. 87.
8. Ibid., p. 100.
9. Critchelow, *Islamic Patterns*, p. 8.
10. Ibid., p.192.
11. Hillenbrand, *Islamic Art and Architecture*, p. 195.
12. Grube, *The World of Islam*, p. 11.
13. Sa'adi, *Bustan*, V, lines 133–35.
14. Schlamminger in *Arts and the Islamic World*, p. 28.
15. Ali, *The Arab Contribution to Islamic Art*, pp. 15–16.
16. Allen, *Five Essays*, p. 54.
17. Ibid., p. 34.
18. Ibid., p. 35.
19. See Soucek, 'The Life of the Prophet: Illustrated Versions', pp. 193–218 in *Content and Context*, ed. Soucek. Also, on prayer rugs, Ettinghausen, 'The early history, use and iconography of the prayer rug', *Islamic Art and Archaeology*, pp. 282–97.
20. Jami, *Divan i-kamil*, p. 265, no. 345.
21. Ettinghausen, *Islamic Art in the Metropolitan Museum of Art*, p. 5.
22. Grabar, 'Notes on the decorative composition of a bowl from Northeastern Iran', p. 91.
23. Talbot Rice, *Islamic Painting*, p. 175.
24. Ettinghausen 'Al-Ghazali on beauty', p. 184.
25. Grube, *Arab Painting*, p. 186.
26. Golombek, 'Towards a classification', pp. 23–34; p. 32.
27. Stacy Hollander, quoted in *SKY*, December 2002, p. 28.
28. Ettinghausen, 'The Bobrinski kettle', p. 330.
29. Khatibi and Sijelmassi, *Splendor*, p. 167.
30. Ettinghausen, 'Taming of the horror vacui', 1305–18.
31. Piotrovsky and Vrieze, *Art of Islam*, p. 129.

32. Ibn Rushd, *Talkhis Kitab Aristutalis fi al- Shi'r*, p. 250.
33. Khatibi and Sijelmassi, pp. 169–70.
34. al-Ghazali, *Ninety-Nine Names*, p. 68.
35. Welch, *Arts of the Islamic Book*, p. 50.
36. Pendlebury, *Yusuf and Zulaykha*, p. 171.
37. Arnold, 'Decorative arts and painting', p. 289.
38. Piotrovsky and Vrieze, *Art of Islam*, p. 26.
39. Ibid., p. 26.
40. Kamal Abu Deeb is by far the leading interpreter of Adonis, and his work is very useful in helping us understand this complex poet. My approach to Adonis is often not the same as Abu Deeb's but undoubtedly owes a lot to his pioneering work.
41. Nasr, 'Islamic Aesthetics', p. 453.
42. Ibn Taymiyya, 'K. al-sama'wa l-raqs' ('Book on music and dance'), p. 295.
43. Lewisohn, 'The sacred music of Islam', pp. 10–11.
44. Fairchild Ruggles, *Gardens*, p. 221.
45. Abu'l Fazl ibn 'Allami, *Akbarnama*, vol. 3, p. 835.
46. *Sir John Chardin's Travels in Persia 1673–1677*, p. 161.
47. Abdul Rehman, 'Garden types', p. 166.
48. Fairchild Ruggles, 'Humayun's tomb', p. 173.
49. Dickie, 'The Islamic Garden in Spain', p. 105.
50. Brookes, 'Gardens of Paradise', pp. 21–2.
51. Ibid., pp. 23–4.
52. Ibid., p. 24.
53. Ibid., p. 23.
54. Petherbridge, 'The House and Society', p. 197.
55. Grube, 'What is Islamic Architecture', p. 13.
56. Nasr, 'Forward', *The sense of unity*, p. xiii.
57. 'Islamic and Japanese Traditional Houses and their social medium', p. 273.
58. Grabar, 'The iconography of Islamic architecture', p. 53.
59. Ibid., p. 55.
60. Ettinghausen, 'The Man-Made Setting', *The World of Islam*, p. 70.
61. Gonzalez, *Beauty and Islam*, pp. 28–33.
62. Ibid., p. 91.
63. Ibn Rushd's example of the *halal* knife in *Fasl al-maqal*, 3–4.
64. Said Nursi, 'Twenty-Fifth Word', *Risale-I Nur*, pp. 443–4.
65. Ettinghausen and Grabar, *The Art and Architecture of Islam (650–1250)*, p. 34.
66. Behrens-Abouseif, *Beauty in Arabic Culture*, p. 46.

Bibliography

I have indicated English translations where possible.
The year of publication is often not the year in which the text that the book is about was originally published.

Abdel Haleem, M. (2001) *Understanding the Qur'an: Themes and Style*, London: I. B. Tauris

Abu-Zayd, N. (1998) *Al-ittija al-'aqli* (The rational line in exegesis) Beirut: Dar al-tanwir

—— (1998) *Falsafat al-ta'wil* (Philosophy of interpretation), Beirut: al-Markaz al-thaqafi al-'arabi

Abu Deeb, K. (1998) 'The Contradictory Visons of the Unified but not Unitarian Self: A Contradictory Study of Adonis', Jihat al-Shi'r (http://www.jehat.com/english/studies–1.htm [last accessed: 15 September 2003])

Adonis, (1971) *The Blood of Adonis*, trans. S. Hazo, Pittsburgh: University of Pittsburgh Press

—— (1980) *K. al-Qasa'id al-Khams taliha al-mutabaqat wa'l awa'il* (Book of Five Poems followed by opposites and beginnings), Beirut: Dar al-'Awda

—— (1998) *Orbits of Desire*, trans. K. Abu-Deeb, Newcastle: n.p.

Ajami, M. (1984) *The Neckveins of Winter*, Leiden: Brill

—— (1988) *The Alchemy of Glory: The dialectic of truthfulness in medieval Arabic literary criticism*, Washington: Three Continents

Ali, W. (1999) *The Arab Contribution to Islamic Art: From the Seventh to the Fifteenth Centuries*, Cairo: American University of Cairo Press

Allahwirdi, M. (1949) *Falsafat al-musiqa ash-sharqiyah* (The philosophy of eastern music), Damascus: Ibn Zaydun

Allen, T. (1988) *Five Essays on Islamic Art*, Occidental, CA: Solipsist Press

Amini, M. (1993) 'Islamic and Japanese Traditional Houses and their social medium', *Islamic Quarterly*, xxxvii, 4, pp. 266–80

Ardalan, N. & Bakhtiar, L. (1973) *The Sense of Unity: The Sufi Tradition in Persian Architecture*, Chicago: University of Chicago Press

Arnold, Sir Thomas (1928) *Painting in Islam*, Oxford, UK: Clarendon Press

Arts and the Islamic World, 3, 3, Autumn 1985

Austin, J. (1962) *How to Do Things with Words*, ed. Urmson. J. and Sbisá, M., Cambridge, MA: Harvard University Press

Bakhtiar, L. (1976) *Sufi: Expressions of the Mystic Quest*, London: Thames & Hudson

Basu, K. (2003) *The Minitiarist*, London: Weidenfeld

Batchelor, D. (2000) *Chromophobia*, London: Reaktion Books

Behrens-Abouseif, D. (1999) *Beauty in Arabic Culture*, Princeton: Markus Wiener

Bernstein, M. & Studlar, G. (2002) *Visions of the East*, London: I. B. Tauris

BLINK (2002) London: Phaidon Press

Brookes, J. (1987) *Gardens of Paradise: The History and Design of the Great Islamic Gardens*, New York: New Amsterdam

Burkhardt, T. (1998), *Sacred Art in East and West*, Louisville: Fons Vitae

Carver, A. (2002) *BLINK*, London: Phaidon Press

Cresswell, K. (1946) 'The lawfulness of painting in early Islam', *Ars Islamica* XI–XII, 159–66

Critchlow, K. (1976) *Islamic Patterns: An analytical and cosmological approach*, New York: Schocken

Danielson, V. (1996) 'Nightingales of the Nile', *Popular Music*, 15, pp. 299–312

Denny, F. (1989) 'Qur'an Recitation: A tradition of oral performance and transmission', *Oral Language*, 4/1–2, 5–26

Derrida, J. (1974) *Of Grammatology*, trans. G. Chakravorty Spivak, Baltimore: The Johns Hopkins University Press

Dickie, J. (1976) 'The Islamic Garden in Spain' in *The Islamic Garden*, Washington, DC: Dumbarton Oaks, pp. 89–105

Erdogdu, A. (2002) 'Picturing alterity: Representational strategies in Victorian type photographs of Ottoman men' in *Colonialist Photography: Imag(in)ing race and place*, E. Hight & G. Sampson (eds), London: Routledge, pp. 107–25

Escher, M. (1989) *Escher on Escher: Exploring the Infinite*, New York: Abrams

Ettinghausen, R. (1972) (ed.) *Islamic Art in the Metropolitan Museum of Art*, New York: Metropolitan Museum of Art

—— (1974) 'Arabic Epigraphy: Communication or Symbolic Affirmation?' in *Near Eastern Numismatics, Studies in Honor of George C. Miles*, Beirut: American University of Beirut Press, pp. 297–317

—— (1976) 'The Man-Made Setting' in *The World of Islam*, ed. B. Lewis, London: Thames & Hudson, pp. 57–72

—— (1984) *Islamic Art and Archaeology: Collected Papers*, Berlin: Gebr. Mann Verlag

—— (1984) 'The early history, use and iconography of the prayer rug' in *Islamic Art and Archaeology*, pp. 282–97

—— (1984) 'Decorative arts and painting' in *Islamic Art and Archaeology*, pp. 274–92

—— (1984) 'The Bobrinski kettle' in *Islamic Art and Archaeology*, pp. 315–30

—— (1984) 'The taming of the horror vacui in Islamic art' in *Islamic Art and Archaeology*, pp. 1305–18

—— (1984) 'Al-Ghazali on beauty' in *Islamic Art and Archaeology*, pp. 180–5

Ettinghausen, R. & Grabar, O. (1987) *The Art and Architecture of Islam (650–1250)*, New York: Viking Press

Fairchild Ruggles, D. (1979) 'Humayn's tomb and garden: typologies and visual order', ed. Petruccioli, *Gardens*, pp. 173–86

—— (2000) *Gardens, Landscape, and Vision in the Palaces of Islamic Spain*, University Park, PA: The Pennsylvania State University Press

Fitzgibbon, K. & Hale, A. (1988) *Ikats, Woven Silks from Central Asia: The Rau Collection*, Oxford: Blackwell/Crafts Council

Frankfurt, H. (2001) *Some Mysteries of Love*, The Lindley Lecture, University of Kansas

Gaut, B. & Lopes, D. (2002) *Routledge Companion to Aesthetics*, London: Routledge

Al-Ghazali (1957) *Ihya' 'ulum al-din*, Cairo: Dar al ma'arifa (vol. 2 on *sama* [music])

—— (1960), *Kimiya-i Sa'adat* (Alchemy of Happiness), Tehran: Kitabkhane-i Markazi

—— (1997) *The Ninety-Nine Beautiful Names of God (al-Maqsad al-asna fi sharh asma Allah al-husna)*, trans. D. Burrell & N. Daher, Cambridge: Islamic Texts Society

Golombek, L. (1972) 'Towards a classification of Islamic painting' in Ettinghausen (ed.) *Islamic Art in the Met*, pp. 23–34

Gonzalez, V. (2001) *Beauty and Islam*, London: I.B. Tauris

Goodman, N. (1969) *Languages of Art*, London: Oxford University Press

Grabar, O. (1972) 'Notes on the decorative composition of a bowl from Northeastern Iran' in Ettinghausen (ed.), *Islamic Art in the Met*

—— (1988) 'The iconography of Islamic architecture' in P. Soucek (ed.), *Content and Context*, pp. 52–60

—— (1995) *The Mediation of Ornament*, Princeton: Princeton University Press

—— (2001) *Mostly Miniatures*, Princeton: Princeton University Press

Gray, B. (1961) *Persian Painting*, New York: Skira

Grube, E. (1967) *The World of Islam*, New York: McGraw–Hill

—— (1977) *Arab Painting*, New York: Rizzoli

—— (1987) 'What is Islamic Architecture?' in G. Michell (ed.), *Architecture of The Islamic World*, London: Thames & Hudson, pp. 10–14

Hattstein, M. and Delius, P. (eds) (2000) *Islam, Art and Architecture*, Cologne: Koenemann

Hawting, G. (1999) *The Idea of Idolatry and the Emergence of Islam*, Cambridge: Cambridge University Press

Hillenbrand, R. (1999) *Islamic Art and Architecture*, London: Thames & Hudson

ibn 'Abd al-Wahhab (1901) M. *Majmu'at al-tawhid*, Mecca: n.p.

ibn 'Allami, Abu'l Fazl (1973) *Akbarnama*, ed. H. Blochmann, trans. H. Beveridge, 3 vols, Calcutta: Royal Asiatic Society of Bengal, 1877–86, rept. Delhi: Ess Ess Publications

ibn al-Jawzi (1935–38) *Talbis Iblis* (The Deception of the Devil), trans. D. Margoliouth, as 'The Devil's Delusion', *Islamic Culture*, vols IX, X, XI, XII, 1935–1938

ibn Khaldun (1958) *The Muqaddimah*, trans. F. Rosenthal, Princeton: Princeton University Press (abbreviated as M)

ibn Khallikan (1970) *Wafayat al-a'yan wa anba' abna' al-zaman* (Obituaries of eminent men), trans. De Slane, *Ibn Khallikan's Biographical Dictionary*, 4 vols, Beirut: Libraire du Liban. The translation is 1982–71 and the original, thirteenth century

ibn Rushd (1973) 'Talkhis Kitab Aristutalis fi al- Shi'r', *Fann al-Shi'r* ed. A-R. Badawi, Beirut: Dar al-thaqafa

—— (1976) *Fasl al-maqal* (Averroes on the Harmony of Religion and Philosophy), trans. and int. G. Hourani, London: Luzac

ibn Taymiyya (1966) 'K. al-sama'wa l-raqs', in *Majmu'at al-rasa'il al-kubra*, Cairo: n.p., vol. 2

Ikhwan al-Safa (1957) *Rasa'il*, Beirut: Dar Sadir

The Islamic Garden (1976) Washington, DC: Dumbarton Oaks

Jami (1962) *Divan-i kamil*, Tehran: Payruz

—— (1980) *Yusuf and Zulaikha: An Allegorical Romance*, ed. and trans. D. Pendlebury, London: Octagon Press

Jones, O. (1986) *Grammar of Ornament*, London: Studio Editions

Kadkani, M. (1952) *Ansu-ye harf wa saut*, Tehran: n.p.

Kemal, S. (1991) *The Poetics of Alfarabi and Avicenna*, Leiden: E. J. Brill

—— (1996) 'Aesthetics' in Nasr & Leaman (eds), *History of Islamic Philosophy*, pp. 969–78

Kermani, N. (1999) *Gott ist schön: Das aesthetische Erleben des Koran*, Munich: C. H. Beck, 1999

Khatibi, A. & Sijelmassi, M. (2001) *The Splendor of Islamic Calligraphy*, London: Thames & Hudson

Lassner, J. (1993) *Demonizing the Queen of Sheba: Boundaries of Gender and Culture in Postbiblical Judaism and Medieval Islam*, Chicago: University of Chicago Press

Leaman, O. (1997) *Averroes and his Philosophy*, Richmond: Curzon

—— (1999) *Brief Introduction of Islamic Philosophy*, Oxford: Polity

—— (1999) 'Nursi's place in the *Ihya*' tradition', *Muslim World*, 89, pp. 314–24

—— (2001) *An Introduction to Classical Islamic Philosophy*, Cambridge: Cambridge University Press

—— (ed.) (2001) *Companion Encyclopedia of Middle Eastern and North African Film*, London: Routledge

—— (2003) '"No poetry after Auschwitz". How plausible is this idea?' in *Philosophical Perspectives on the Holocaust*, ed. G. Scarre & E. Garrard, Aldershot: Ashgate, pp. 247–56

Levi-Strauss, C. (1948) 'La vie familiale et sociale des indiens Namiwara', *Journal de la société des Américanistes* (NS) 37, 1–131

Lewis, B. (ed.) (1976) *The World of Islam*, London: Thames & Hudson

Lewisohn, L. (1997) 'The sacred music of Islam: Sama' in the Persian Sufi tradition', *British Journal of Ethnomusicology*, 6, pp. 1–32; see also his translations on this topic in (2001) *The Wisdom of Sufism*, Oxford: OneWorld

Madigan, D. (2001) *The Qur'an's Self-Image: Writing and Authority in Islam's Scripture*, Princeton: Princeton University Press

Massignon, L. (1921) 'Les méthodes de réalisation artistique des peuples de l'Islam', *Syria*, 2, 47–53, 149–60

Massoudy, H. (1986) *Calligraphe*, Paris: Flammarion

Maupassant, G. (2001) *Bel-Ami*, trans. M. Mauldon, Oxford: Oxford University Press

Mawdudi, A. (1963) *Tajdid-e-Ihya-Din*, Lahore: Islamic Publications

Meisami, J. & Starkey, P. (eds) (1998) *Encyclopedia of Arabic Literature*, London: Routledge

Miskawayh (1969) *Traité d'Ethique*, trans. M. Arkoun, Damascus: Institut français de damas

Nasr, S. (1968) *Science and Civilization in Islam*, New York: New American Library

—— (1979) 'Forward', Ardalan & Bakhtiar, *The Sense of Unity*

—— (1997) 'Islamic Aesthetics', ed. Deutsch, E. & Bontekoe, R., *A Companion to World Philosophers*, Oxford: Blackwell, pp. 448–59

Nasr, S. & Leaman, O. (eds) (1996) *History of Islamic Philosophy*, London: Routledge

Neçipoğlu, G. (1997) 'The Suburban landscape of sixteenth-century Istanbul as a mirror of classical Ottoman garden culture', 32–71 in *Gardens in the Time of the Great Muslim Empires*, ed. A. Petriccioli, Leiden: Brill

Nelson, K. (1985) *The Art of Reciting the Qur'an*, Austin: University of Texas Press

Ni'mat, F. (1976), *Umm Kulthum wa'asrun min al-fann* (Umm Kulthum and the age of artistry) Cairo: al-hay'a al-misriyya lil-kitab

Nursi, Said (1992) *Risale-I Nur, The Words*, trans. Ş. Vahide, Istanbul: Sözler Neşriyat

Pamuk, O. (2001) *My Name is Red*, trans. E. Goknar, New York: Knopf

Parker, A. & Neal, A. (2002) *Hajj Paintings*, London: I. B. Tauris

Pendlebury, D. (ed. and trans.) (1980) *Yusuf and Zulaikha: An Allegorical Romance*, London: Octagon Press

Petherbridge, G. 'The House and Society', *Architecture of the Islamic World*, ed. G. Michell, pp. 193–204

Petruccioli, A. (ed.) (1997) *Gardens in the Time of the Great Muslim Empires: Theory and Design*. Leiden: E. J. Brill

Piotrovsky, M. & Vrieze, J. (eds) (1999) *Earthly Beauty, Heavenly Art: Art of Islam*, Amsterdam: De Nieuwe Kerk

Puerta Vilchez, J. (1997) *Historia del Pensamiento estético árabe: Al-Andalus y la estética clásica*, Madrid: Ediciones Akal

Qabbani, N. (2003) *Nizar Kabbani, Republic of Love: Selected Poems*, trans. N. al-Kalali, New York: Columbia University Press

Racy, A. (1982) 'Musical aesthetics in present-day Cairo', *Ethnomusicology* 26, 3, pp. 391–406

—— (1991) 'Creativity and ambience', *World of Music*, 33, 3, pp. 7–28

Rehman, A. (1997) 'Garden types in Mughal Lahore', ed. A. Petruccioli, *Gardens*, pp. 161–7

Rosenthal, F. (1971) 'Abu Hayyan al-Tawhidi on penmanship', *Four Essays on Art and Literature in Islam*, Leiden: E. J. Brill, pp. 20–49

Ross, S. (1998) *What Gardens Mean*, Chicago: University of Chicago Press

Rumi (1982) *The Mathnawi of Jalaluddin Rumi*, trans. R. Nicholson, London: Luzac

Rushdie, S. (1989) *The Satanic Verses*, Baltimore: Viking Penguin

Sa'adi (1963) *Kulliyat*, 4 vols, ed. M. Furughi, Tehran: Eqbal

Said, E. (1978) *Orientalism*, London: Routledge & Kegan Paul

Schimmel, A. (1994) *Deciphering the Signs of God: A Phenomenological Approach to Islam*, Edinburgh: Edinburgh University Press

Schroeder, E. (1941) *Persian Miniatures in the Fogg Museum of Art*, Cambridge, MA: Harvard University Press

Shakir, P. (2000) *Khushboo*, Luknow: Kitabi Duniya

Sir John Chardin's Travels in Persia 1673–1677 (1927) trans. E. Lloyd, London: The Argonaut Press

SKY, December 2002, p. 28

Slaoui, A. (2002) *The Orientalist Poster*, London: I. B. Tauris

Soucek, P. (1988) 'The life of the Prophet: Illustrated versions' in *Content and Context of Visual Arts in the Islamic World*, ed. P. Soucek, University Park, PA: The Pennsylvania State University Press, pp. 193–218

al-Suhrawardi (1982) *The Mystical and Visionary Treatise of Suhrawardi*, trans. W. Thackston, London: Octagon

Talbot Rice, D. (1971) *Islamic Painting*, Edinburgh: Edinburgh University Press

Touma, H. (1996) *The Music of the Arabs*, trans. L. Schwartz, Portland, OR: Amadeus Press

Welch, A. & S. (1979) *Calligraphy in the Arts of the Muslim World*, New York: Asia Society

—— (1982) *Arts of the Islamic Book: The Collection of Prince Sadruddin Aga Khan*, Cornell: Cornell University Press

Wild, S. (2001) *Mensch, Prophet und Gott*, Munster: Gerda Henkel Vorlesung

Wittgenstein, L. (1958) *Philosophical Investigations*, Oxford: Basil Blackwell

Yarshater, E. (1962) 'Some Common Characteristics of Persian Poetry and Art', *Studia Islamica* XVI, 1962, pp. 61–71

Further reading

Just as this book was finished I came across Blair, S. & Bloom, J. (2003) 'The mirage of Islamic art: Reflections on the study of an unwieldy field', *The Art Bulletin*, LXXXV, 1, pp. 152–84. This is an excellent and detailed article that gives a very accurate account of the contemporary state of play in Islamic art, and should be consulted by anyone interested in the area. It also has an extensive and very useful bibliography.

For more information on the philosophers mentioned here, some of my books on Islamic philosophy might be consulted, as might the relevant entries in the *Routledge Encyclopedia of Philosophy*, ed. E. Craig, 1998, London: Routledge, and the *History of Islamic Philosophy*, ed. S. H. Nasr & O. Leaman, 1996, London: Routledge.

For more information on the literary arts in Arabic see the *Encyclopedia of Arabic Literature*, ed. P. Starkey and J. Meisami, 1998, London: Routledge.

Ali, W. (1997) *Modern Islamic Art: Development and Continuity*, Gainesville: University Press of Florida

Ali, W. & S. Bisharat (eds) (1990) *Contemporary Art from the Islamic World*, Northampton, MA: Interlink Publishing Group

Allan, J. (1981) *Metalwork from the Early Islamic Period*, New Haven: Yale University Press

—— (ed.) (1995) *Islamic Art in the Ashmolean Museum*, Oxford: Oxford University Press

—— (eds) (2001) *Persian Steel: The Tanavoli Collection* (Oxford Studies in Islamic Art), Oxford: Oxford University Press

Asani, A. & Kamal A.-M. (1995) *Celebrating Muhammad: Images of the Prophet in Popular Muslim Poetry*, Columbia, SC: University of South Carolina Press

Asher, C. (1992) *Architecture of Mughal India*, Cambridge: Cambridge University Press

Baer, E. (1998) *Islamic Ornament*, Washington Square, NY: New York University Press

Bates, M. & Savage, E. (2003) *Dinars and Dirhams, Coins of the Islamic Lands: The Early Period*, Oxford: Oxford University Press

Bayani, M., Contadini, A. & Stanley, T. (1998) *The Decorated Word: Qur'ans of the 17th to 19th Centuries* (The Nasser D. Khalili Collection of Islamic Art, vol. IV), London: The Nour Foundation

Beach, M. (1987). *Early Mughal Painting*, Cambridge, MA: Harvard University Press

—— (1993) *Mughal and Rajput Painting*, Cambridge: Cambridge University Press

Becker, J. (1993) *Gamelan Stories: Tantrism, Islam, and Aesthetics in Central Java*, Tempe:

Arizona State University Program for Southeast Asian Studies

Behrens-Abouseif, D. (1997) *Islamic Architecture in Cairo: An Introduction* (Studies in Islamic Art and Architecture, Vol. 3), Leiden: Brill

Blair, S. (1998) *Islamic Inscriptions*, New York: New York University Press

Blair, S. & J. Bloom, J. (1991) *Images of Paradise in Islamic Art*, Austin, TX: University of Texas Press

—— (1994) *The Art and Architecture of Islam, 1250–1800*, New Haven: Yale University Press

Carboni, S. & Whitehouse, D. (2001) *Glass of the Sultans*, New Haven: Yale University Press

Contadini, A. (1998) *Fatimid Art at the Victoria and Albert Museum*, London: Victoria and Albert Museum

Creswell, K. (1932–40) *Early Muslim Architecture*, 2 vols, Oxford: Clarendon Press

David, A. (1992) *The Arts of War: Arms and Armour of the 7th to 19th Centuries* (The Nasser D. Khalili Collection of Islamic Art, Vol. XXI), London: The Nour Foundation

Degeorge, G. & Porter, Y. (2002) *The Art of the Islamic Tile*, Paris: Flammarion

Deroche, F. (1992) *The Abbasid Tradition: Qur'ans of the 8th to 10th Centuries AD* (The Nasser D. Khalili Collection of Islamic Art, Vol. I), London: The Nour Foundation

Diba, L., Ekhtiar, M. & and Robinson, B. (eds) (1998) *Royal Persian Paintings: The Qajar Epoch, 1785–1925*, London: I. B. Tauris

Ettinghausen, R., Grabar, O. and Jenkins-Madina, M. (2001) *The Art and Architecture of Islam, 650–1250*, New Haven: Yale University Press

Flood, F. (2001) *The Great Mosque of Damascus: Studies on the Making of an Umayyad Visual Culture*, Leiden: E. J. Brill

Frishman, M. & Khan, H. (eds) (1994) *The Mosque*, New York: Thames & Hudson

Grabar, O. (1973) *The Formation of Islamic Art*, New Haven: Yale University Press

—— (1990) *The Great Mosque of Isfahan*, New York: New York University Press

Grube, E. (1995) *Cobalt and Lustre: The First Centuries of Islamic Pottery* (The Nasser D. Khalili Collection of Islamic Art, Vol. IX), London: The Nour Foundation

Grube, E. & Sims, E. (eds) (1997) *Islamic Art: A Biennial Dedicated to the Art and Culture of the Muslim World, 1990–1991*, Oxford, UK: Oxford University Press

Grube, E. & Sims, G. (eds) (2001) *Islamic Art 5: Studies on the Art and Culture of the Islamic World*, Oxford: Oxford University Press

Irwin, R. (1997) *Islamic Art in Context: Art, Architecture and the Literary World*, New York: Abrams

James, D. (1992) *After Timur: Qur'ans of the 15th and 16th Centuries* (The Nasser D. Khalili Collection of Islamic Art, Vol. III), London: The Nour Foundation

—— (1992) *The Master Scribes: Qur'ans of the 11th to 14th Centuries AD* (The Nasser D. Khalili Collection of Islamic Art, Vol. III), London: The Nour Foundation

Khalili, N., Robinson, B. & Stanley, T. (1996) *Lacquer of the Islamic Lands, Part One* (The Nasser D. Khalili Collection of Islamic Art, Vol. XXII), London: The Nour Foundation

Khalili, N., Robinson, B. & Stanley, T. (1997) *Lacquer of the Islamic Lands, Part Two* (The Nasser D. Khalili Collection of Islamic Art, Vol. XXII), London: The Nour Foundation

Koch, E. (2001) *Mughal Art and Imperial Ideology: Collected Essays*, Oxford: Oxford University Press

Leach, L. (1998) *Paintings from India* (The Nasser D. Khalili Collection of Islamic Art, Vol. VIII), London: The Nour Foundation

Meinecke, M. (1996) *Patterns of Stylistic Changes in Islamic Architecture: Local Traditions versus Migrating Artists*, New York: New York University Press

Michell, G. (ed.) (1995) *Architecture of the Islamic World: Its History and Social Meaning*, New York: Thames & Hudson

Mir, M. (trans. and ed.) (2000) *Tulip in the Desert: A Selection of the Poetry of Muhammad Iqbal*, Montreal: McGill-Queen's University Press

Mir, M. in collaboration with Fossum, J. (eds) (1993) *Literary Heritage of Classical Islam: Arabic and Islamic Studies in Honour of James A. Bellamy*, Princeton: Darwin Press

Moynihan, E. (1980) *Paradise as a Garden: In Persia and Mughal India*, New York: George Braziller

Nasr, S. (1987) *Islamic Art and Spirituality*, Albany: State University of New York Press

Neçipoğlu, G. (1992) *Architecture, Ceremonial, and Power: The Topkapi Palace in the Fifteenth and Sixteenth Centuries*, Cambridge, MA: MIT Press

Nicholson, R. (1921) *Studies in Islamic Poetry*, Cambridge: Cambridge University Press

Orsenna, E. (2001) *Andre le Notre*, trans. M. Black, New York: George Braziller

Pickett, D. (1997) *Early Persian Tilework: The Medieval Flowering of Kāshī*, Madison, NJ: Fairleigh Dickinson University Press

Safadi, Y. (1987) *Islamic Calligraphy*, London: Thames & Hudson

Safwat, N. (1996) *The Art of the Pen: Calligraphy of the 14th to 20th Centuries* (The Nasser D. Khalili Collection of Islamic Art, Vol. V), London: The Nour Foundation

Schimmel, A. (1984) *Calligraphy and Islamic Culture*, New York: New York University Press

Stierlin, H. & A. (2002) *Islamic Art and Architecture: From Isfahan to the Taj Mahal*, London: Thames & Hudson

Vernoit, S. (1997) *Occidentalism: Islamic Art in the 19th Century* (The Nasser D. Khalili Collection of Islamic Art, Vol. XXIII), London: The Nour Foundation

Ward, R. (1993) *Islamic Metalwork*, London: Thames & Hudson

Welch, S. (1987) *The Islamic World*, New York: The Metropolitan Museum of Art

Wilkinson, C. (1974) *Nishapur: Pottery of the Early Islamic Period*, New Haven: Yale University Press

Glossary

adhan call to prayer
ahadith Traditions (sayings of the Prophets and his Companions)
ahl al-lisan people of the language (i.e. Arabs)
'alam al-khayal imaginal realm, realm of imagination
alfaz words
ana al-haqq I am the truth
Ash'ariyya school of theology
ayyat Allah signs of God, verses of the Qur'anic suras
baladi local, popular
baraka blessing
bari' creation
barzakh isthmus
batil vain, empty
batin closed, hidden
bid'a innovation
bismilla in the name of God
chahar bagh quartered garden
dhawq taste (experience of God in Sufism)
dhikr recollection (of God in Sufism)
falasifa philosophers
fana' ecstasy
fasih eloqent
fatwa legal pronouncement
firdaus paradise
ghazal verse form
ghina' singing
hadith Tradition (of the Prophet and his Companions)
hafiz one who has memorized the Qur'an
hajj pilgrimage

hal state

halal permissible

haram forbidden

hijab covering worn by women

Hikmat al-ishraq Philosophy of Illumination

huruf letters

ihram state of purity

ihsas feeling

ihya' revival (of religion)

Ihya' 'ulum al-din Revivification of the sciences of religion

i'jaz al-qur'an miracle of the Qur'an

ijtihad independent judgement

ikats Central Asian silks

Ikhwan al-Safa' Brethren of Purity

imam religious or prayer leader

infitah opening (of the Egyptian economy and society)

insha'alla if God wills it

ishraqi Illuminationist, philosophical school

isti'ara figurative meaning

ittihad communion

ittisal contact

jahiliyya ignorance (pre-Islamic period)

janna paradise

jaww ambience

jinn invisible beings

kalam lafzi linguistic form of the text

kalam nafsi inner form of the text

kasb acquisition

kashf unveiling

khalq creation

kitabi of the Book (i.e. one of the People of the Book)

kufr unbelief

laghw idle

lahw distracting

al-lawh al-mahfuz the Preserved Tablet

ma'ani meanings

ma'arifat allah knowledge of God

ma'arifat al-nafs knowledge of the self

makruh despicable

ma'na concept, meaning

maqam musical performance, place

Maqamat Assemblies

mashsha'i Peripatetic (philosophical school)

mu'allaqat suspended things

muqarnas elaborate three-dimensional structure added to flat interior surface or corner

muqri' reciter

musawwir creation, painter

mushrikun idolaters

Mu'taziliyya school of theology

muthul al-Aflatuni Platonic ideas

muthul al-mu'allaqa suspended ideas

Nahj al-balagha The Peak of Eloquence

Nakba catastrophe (Arab view of the creation of the State of Israel)

naskh style of calligraphy

nazm discourse

pir leader

qasida poem

qira'at al-sab' seven ways of reading

Qur'an the Reading

Quraysh the Prophet's tribe

Risala fi haqiqat al-'ishq Treatise on the essence of love

sabr patience

salafi traditionalist

sama' audition

sarh glass floor

shahada Muslim confession of faith

shari'a religious law

shaykh leader

shi'i/shi'a party (of 'Ali), minority group in Islam, giving special status to the family of the Prophet

shirk idolatry

sunna custom (of the Prophet and his Companions)

sunni majority group of Muslims

sura form

suwar forms

al-suwar al-mu'allaqa the hanging forms

tab' naturalness

taghyir novelty

tahaddi challenge

Tajdid-e-ihya-din Renewal and Revival of Religion

tajwid recitation

takalluf artificiality

talar porch

Talbis Iblis Deception of the Devil

tarab feeling acquired when listening to music

tariqa path

tasawwuf mysticism, Sufism

tasawwur conceptualization

taswir shaping

tawaf turning (around the Ka'ba)

tawakkul trust

tawhid unity

tibaq antithesis

tughra seal

umma community

ummi ordinary person (i.e. illiterate, uneducated)

wahdat al-wujud unity of being

Wahhabism followers of ibn al-Wahhab, official basis of Saudi Arabia

wajd ecstasy

al-Waqt Time

zahir open

Index of Qur'anic passages

Index